I am

Delilah Jones aka Doris Gohlke

Index
Special thanks to:
Dave Williams to get my book published
Scott Hooper for letting me use his photos
Russ Gordon: for coloring my cover photo
Ruthie Lewis, who gave me the original photos

"Living two different lifestyles"
My Daytime life and my Nightlife.

Born during WWII, and living through World War II
Growing up in war-torn Germany
Leaving Germany by Ocean Liner Seven Seas
eleven days at sea.
Arriving in Canada
Working as a fashion model
And in charge of fashion for Lorna Mae Corporation.

Coming to America to Hollywood at the age of seventeen,
at eighteen went on to become one of the most
photographed pin-up models in Hollywood.
Then entering the burlesque field

Life was good and I learned fast
Three times married and lived with the love of my life.

Life is full of surprises
QUE SERA SERA

"I am"
Delilah Jones aka Doris Gohlke

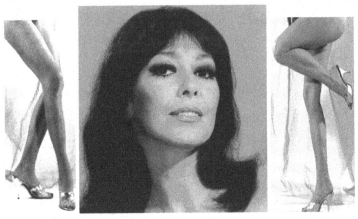

From Nazi-occupied Germany to Hollywood.
The comedies and tragedies in my life.

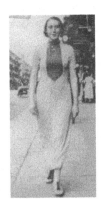

This is how it began: My mother at twenty years old. Her mother was German and her father was Russian. She was a love child. My father was German and Bulgarian, but we were only known as Germans. My mother was an accordion player in a nightclub, where she met my father. He was married at the time, got a divorce, and married my mother.

January 7th, 1941

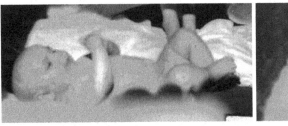

I came into this world naked.

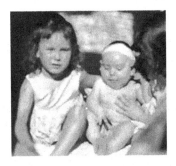

My life began at home, in Berlin, Germany with the stroke of midnight, on January seventh 1941 WWII during a snowstorm. Left: I was the youngest, with my two sisters holding me. I was born Charlotte Doris Gohlke, named after my mother. I changed it to Doris Charlotte when I was sixteen so that I would be my own person.

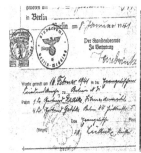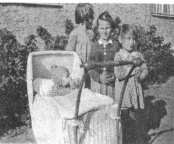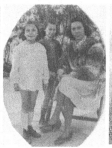

#1 My birth certificate had two Swastika stamps, showing that I was born during Hitler's reign

#2 me, in front of my two sisters and my brother.

#3 Me with my mother and Margo, right, I was about 4 then.

 My mother`s mother worked for Hermann Göring as a housekeeper. and so I received his daughter's exquisite hand-me-downs. Then Berlin got bombed while my mother bore another child, a boy. Two-thirds of Berlin was bombed and in ruins, it was supposed to be obliterated, and so we became homeless until the war was over. We fled to the nearby country of Pommem. My father became a Russian prisoner, POW, where he died. He was buried in a mass grave with about fifty others, some still alive. My baby brother died when he was six months old.

After the war, Berlin was unrecognizable, the aftermath was horrendous, and most buildings were in ruins and rubble. We scrambled through the ruins looking for food. We were given an apartment in a bomb-damaged building where we shared one toilet with three other families. which was on another floor, and we had one key for each family. Still, we were blessed. The school building was also mostly damaged. Our school food was soup, served from a large kettle. Every child had a small bucket for the soup and we all got a piece of bread. Girls were separated from boys.

At 6 years of age, I had my first taste of showbiz at one of our yearly street festivals in Berlin. People would sing, play instruments, acrobats, or do magic on the streets. It was carnival-like. I wanted to dance but I was clueless. My mother fixed up a dress made of panels of orange/yellow color chiffon. There was a fake little stage runway of nearly twenty feet.

I think it was a carpet that someone rolled out because I was barefoot. Someone gave me a light push when the music came on, and I went out to the Blue Danube Waltz. I was just twirling around because I did not know how to dance. After I finished, I received a huge applause. Goosebumps ran over my little body from the excitement.

Next: My next nude photos were taken at the nudist club in Berlin, left. CenterL With my mother at the camp and right, playing my accordion.

I learned to play the accordion and piano, at a young age, which I despised because I HAD to do it.

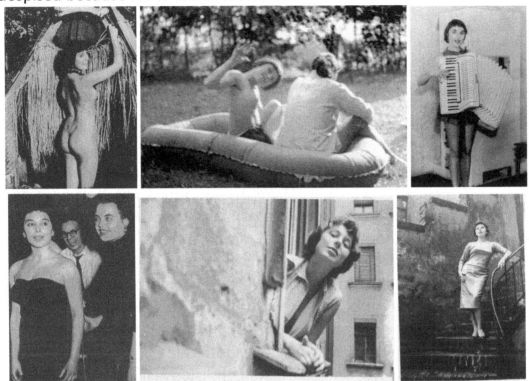

At the age of fourteen, I won my first beauty contest. Center and right: the damaged building we were living in.

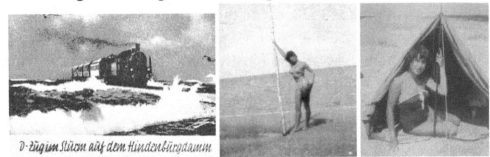

The same year I vacationed on the Isle of SYLT, through the nudist camp, where we would go by train on ebb tide only, and we stayed naked there for two weeks. We had to drive six hours through the Russian zone, with two cars and bicycles.

In my early years, I only watched American-made movies, which took me away from reality. The effect of the war stuck with me for a long time. Therefore I was always fascinated by the flawless woman on screen, especially the saloon girls dressed in fancy costumes glittering like sunshine and admired by men (cowboys) who were fussing over them. Something always drew me to the Wild Old West kind of life, like I had been there before. Germany was dark and depressing to me, one of the very few German movies I watched when I was circa 10 years of age,

with Marika Rökk a saloon dancer, dancing to the song. translated: Because of Dolores's legs, senoras can`t sleep at night. I started dreaming that this is what I wanted to be when I grew up. The same feeling I had when I was six years old at our festival. Rökk became my inspiration. I went from childhood to adulthood and never knew about any teenage years. The only happiness I had at the Berlin Zoo, where I could spend a lot of time drawing animals. I was so good at that, that one of my drawings was on exhibition at the Berlin City Hall. The Zoo Director was Werner Shroeder, who always let me in for free. One day we had a sexual encounter, but I remained a virgin. I was thirteen, fully developed and I was thrilled feeling grown-up. But in 1956 I lost my virginity to a GI, my first boyfriend Eugene Barbosa, who paid for me and my mother, (I was still underage), to come to Canada.

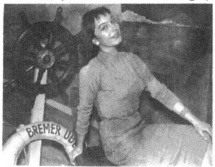 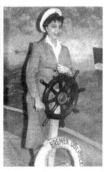

In June 1957, I was finally able to leave Berlin with my mother. We left by train for Bremen, I never looked back. In Bremen, a photographer asked me if he could snap some photos of me for postcards.

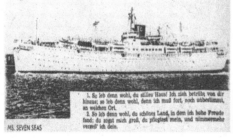

From Bremen, we boarded the Ocean Liner "The Seven Seas" to England, for paperwork, then off to Canada. We took the same route as the Titanic, eleven days at Sea. Before we arrived in Halifax we passed several Icebergs in June. I also took my two cats along. While at sea, I had a fling in the boiler room with a German Boy. I arrived in Halifax for customs with seven dollars to my name. My mother and I were greeted by my two sisters, who were already in Canada. Again, a photographer asked us to take photos for the Canadian newspaper of my family, and me with my two cats, which were kept on deck in the back of the ship

"Model" Passengers Arrive On Liner

Mrs. Charlotte Gohlke poses with her three daughters on arrival here of the Seven Seas, of Europe-Canada Line. She arrived on the ship with Doris, 16, second from right, to join Gisele, right, and Margot, who are models in Montreal. Doris was a model in Berlin and hopes to enter the fashion field in Canada.

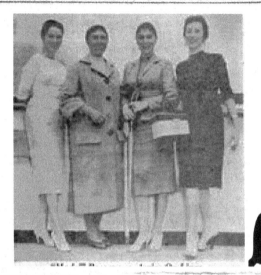

BERLIN BEAUTY, Doris Gohlke

BERLIN BEAUTY, Doris Gohlke, gets her first glimpse of Canada from the deck of "Seven Seas." The buxom model and designer, who hopes to make a hit in Canada's fashion field, is joining two older sisters who are models in Montreal. Doris' measurements are 38, 24, 38.

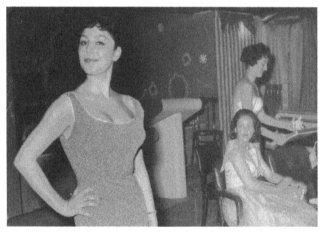 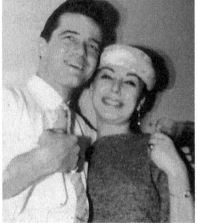

LefL: entered the Canadienne Beauty Contest with my sister Gisela. Soon I met my long time Canadien Boyfriend, Melcolm Kastner, then towards the end of 1958 I met Robert Goulet. We stayed together until I left for Hollywood, where he came to visit me before he moved to New York to appear in Camelot.

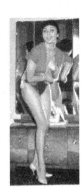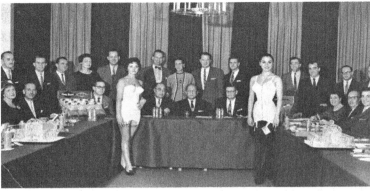

My last photo in Montreal, was at the Undergarment Convention.
Before that, I was already a fashion designer at Lorna Mae Company, at
the age of sixteen.

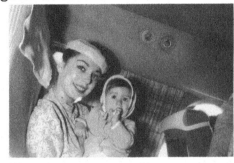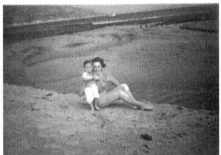

In November 1958, I arrived in Hollywood with my niece in a propelled
United Airline Plane. It felt as if I arrived in Heaven. Right: 1958 the
Pacific Ocean, Santa Monica beach with my niece.

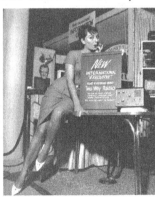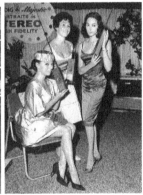

Then I looked for work. I did some odd jobs. My very first one was for
muscle builder, "Vic Tanny", a live TV show. I had to sit at their pool in a
purple one-piece bathing suit, just looking pretty. Then I did convention
jobs. The Electronic show at the Forum in Los Angeles and the Grundig
Majestic show with my two sisters. Mr. Grundig was also there. Jayne
Mansfield and Mickey Hargitay had a fitness booth across from us, for
the whole time. Kim Novak stopped by and many other celebs.
I also was able to visit the many movie studios where I met the stars.
Modeling was in my blood, but I never thought I would do it as a pinup
model. Once in Hollywood I looked for a job and went through the Los

Angeles newspaper. I found an ad for a "figure model" wanted. I miss understood, thinking it was for bathing suits or undergarments. I eagerly answered because the pay was good, but was surprised when I arrived at Aaron Scotty Spear's studio and saw only naked model images on the wall. I was startled. Scotty was very gracious, making me feel comfortable in his studio. He talked me into posing for some test shots and so he became my good friend and personal manager. He took me under his wing and connected me with many well-known photographers, and so I became one of the most photographed pin-up figure models in Hollywood.

 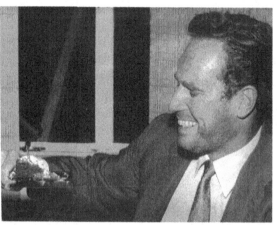

One of my first test shots. Right: Charles Heston (Moses), handed me the first piece of cake, after I jumped out of it, at KTTV studio.
 Scotty was laying out my future without me realizing it. He was a wonderful person and took great care of me. Always caring. He showed me the ropes of photography and how to develop photos in a dark room. I spent a lot of time at his studio, mostly naked and he never made me feel uncomfortable. Many of his models would also hang around and now I became good friends with Colette Berne, and lifelong friend Shirley Skates until she was brutally murdered in Hollywood.
Brigitte Baum, a German pinup model, whom I let stay free at my home while pregnant until she made enough money to go back to Germany, to have her baby. I went on and had a few dates here and there.
BERNARD BERNARD was one of the first photographers and his studio was right down the street from me, on Fairfax Ave. He also got me a job jumping out of a cake at KTTV Studio, at a Bachelor party. Where I was able to sit with Charleston Heston, who had cut the first piece of cake for us. Bernard, who had to cut the photo, because I was topless, gave me an option, my image or Heston's. I chose Heston's.
RON VOGEL one of my earlier photographers got me my first centerfold in Modern Man 1959. Then **Keith Bernard** got me another centerfold in the same year in ADAMS magazine, and then I worked for **BERNARD** of

Hollywood, another one of the brothers. In 1960 **Ron Vogel** was the still photographer for the movie "NOT TONIGHT HENRY" in which I had several small parts, he took many extra photos of me, and therefore I made it on the movie posters with several images. In 1961, now with shorter red hair, Ron and I went back to Santa Barbara at his beach house.

PETER JAMES SAMARJAN 1959 and again in 1964 and 1965 he took some photos for my new burlesque career. His studio was also on Fairfax Ave.

MARIO CASELLI was the only photographer I had an affair with. It was a mutual sexual attraction. He was best known as the still photographer from the TV Series Dallas in the 80s.

LENNY BURTMAN and **ELMER BATTERS** were friends and worked many times together. Both took "sexy" photos only, nylon stockings and garter belts along with fur stoles, very burlesque. His pictures came in handy when I became a stripper, and they got me a lot of publicity, also using my real name and my new one "Delilah", which appeared in Paris Taboo, Satana, and Garter Parade, and other magazines. I did an 8 mm stag with Burtman, as he had just finished with Bettie Page, using the same couch as a prop in his studio. This 8MM "Sexy Brunette" became a historical stag film. Burtman owned several publishing co and so he used my real name all the time, which was a blessing for me, as my real name was rarely mentioned.

SPANGLER got me a cover on Candid magazines, also in 1959 when I met Jenny Lee, she and I remained friends throughout the sixties. Most of Spangler's photos of me were sold to the UK and Sweden, and a play-card set with multiple images of me on cards.

JOHN CASTANO liked the outdoors and the Nudist Camp, and so did I.

EDWARD LEJI who got my cover of Nudist magazine.

K. LAWRENCE cover on Sunbathers magazine.

PETER GOWLAND I worked with for a weekend at his home in Pacific Palisade, had pictorial work in multiple magazines and even the Enquirer, playcards, and more. I also worked with his brother GEORGE GOWLAND in Palm Springs, where I spent a weekend..

DARYL McCumber also owned his publishing Co and used me many times with my real name.

RUSS MEYERS, we worked at the Old Ghost Town Western Movie set. He wanted me for his future films, under one condition, that I get huge breast implants. I declined, and that was the end of Russ and me.

KEN PARKER I worked with him on many occasions. He loved the outdoors, especially at the Old Western Movie Ghost Towns, pretending to relive the old Western era. **ANTHONY DiMARCO** sold my photos worldwide, in Germany, on the cover of GONDEL magazine, MEN magazine in Italy, and in an oversized Gossip paper with my real name in the pictorial. Also in the UK and US, many magazines are in nylon and garter belts. We worked in 1959 and in the early sixties.

BRUCE GILBERT Got me the centerfold of "sir KNIGHT" magazine with great publicity for me as a stripper in Burlesque for The Club Largo.
 By now I have already worked with most photographers. In the spring of 1959, while I was at the height of my modeling career, Scotty suggested that I should think about another career for my future and start thinking about becoming a burlesque dancer. That startled me because I was doing so well but never thought about my future. Eventually, I did both for some time to come. Scotty started to take some "strip" photos of me, to get the feel of it. He was very patient with me and must have felt how young and shy I was and did not speak much English.

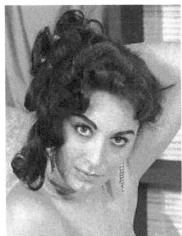

Two shots by John Castano, center, some of my covers.

Still at eighteen, my more mature photos for my new career. In some as a blonde. The photos were copied 100 at a time, to give out as souvenirs to customers. I also used photos from other photographers, so I would have a variety to choose from to send to my agents. They would then send the photos to the club owners, where I would appear, so they can use them for newspaper ads or for their shadow boxes.

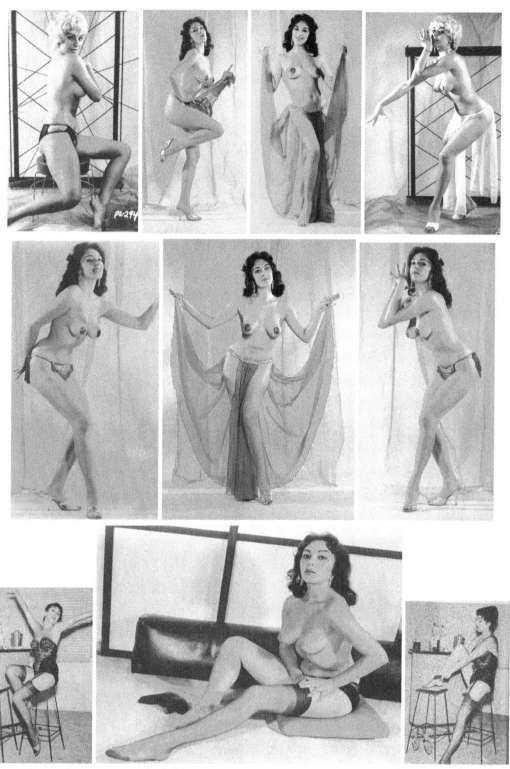

The highlight and most sex-appealing are working with stockings and garter belts. Practice makes perfect, putting on stockings, ever so slowly, taking off stockings, putting them on, taking them off, and so on. "It's all about the teasing." Most clubs had revolving stage props, or stationary ones, many of them covered in red velvet material so that the strippers could "work" on them. Some used a chair.

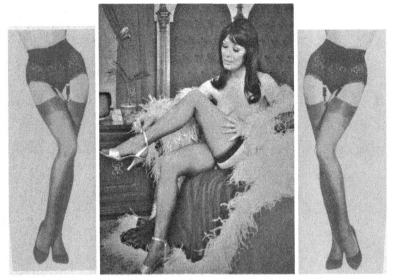

My legs were on the cover of CHERE magazine.

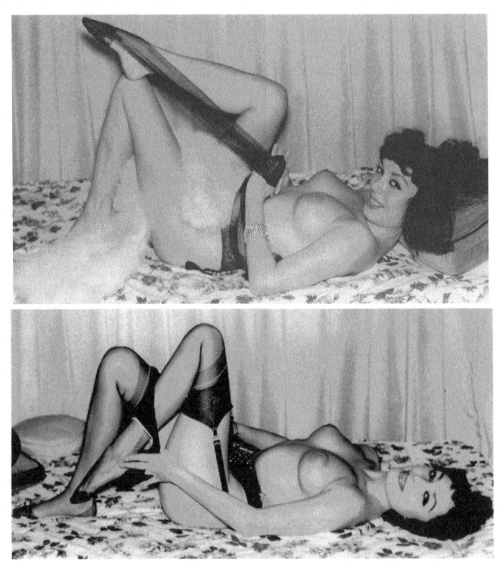

Elmer Batters / Lenny Burtman two original photos

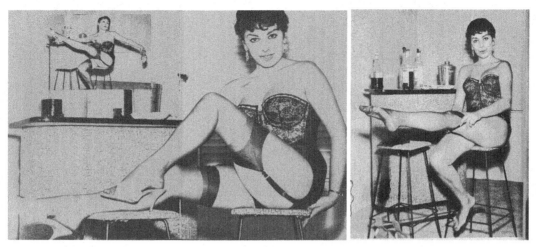

KING's MEN magazine 1959 had a centerfold and pictorial of me.

Brunette Stripper Delilah Jones 1950s

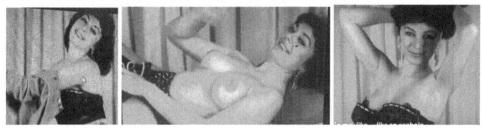

My 8mm stag movie by Elmer Batters and Lenny Burtman, made history.

The backdrops for the Temptation.

Now a historical stag film, it has been used for many ads even on Netflix, for a documentary.

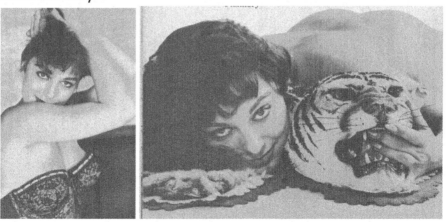

Daryl McCumber photo and Peter Gowland

 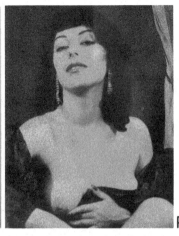 P

George Gowland. Sunday photo indoor shot.

 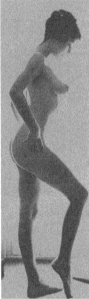 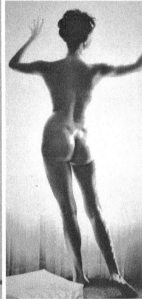

Scotty Spears Anthony DiMarco George Gowland

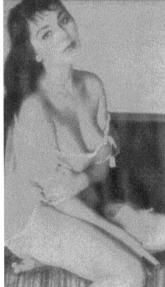 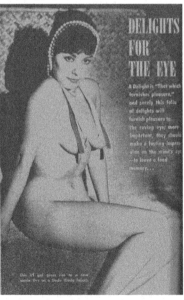

Daryl McCumber Earl Leif

14

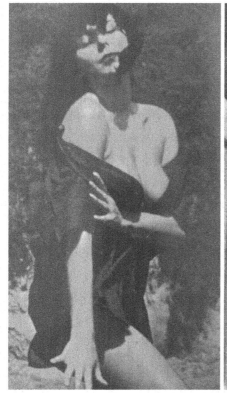

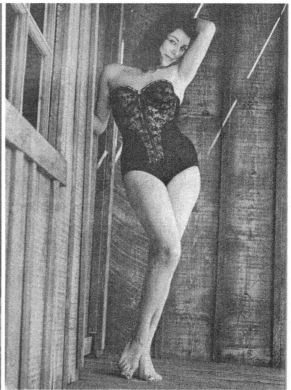

Kurt Reichert Ron Vogel

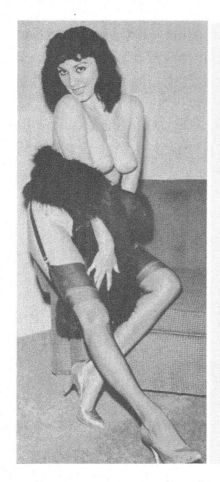

DORIS GOHLKE

Doris is a recent European Import who is making her mark in Hollywood. If you'd like to see more of Doris — and who wouldn't — get the current issue of "PARIS-TABOO" at your favorite newsdealer. Doris is featured in the latest issue of this new and exciting publication.

15

I was now ready to enter my long-lasting career and started to learn the art of being a "teaser" while stripping. It's all about the sex appeal. This was now my future profession. Scotty guided me every step of the way. He introduced me to a well-known stripper, Stacy Farrell, aka Eartha Quake, who was already a known headliner in burlesque. She was gracious and very patient, as was I still timid and spoke little English. She became my mentor and personal teacher. She showed me how to move gracefully, how to walk sexy, and how to disrobe ever so slowly. We worked many hours and practiced most every day. That was not hard to understand because of my modeling career and the stag movies I had made, but moving to music in front of an audience was another thing. This was something I had never experienced before. I also had to get some music together that fit my dancing. I needed sheet music for the musicians because all clubs had at least a live three-piece band. This was the norm until the mid-sixties. One of the most important things was the wardrobe. I needed "objects" like gloves, bras & panties, panel skirts, and stockings. This was something that I could play or kill time with while on stage because the shows used to run an average of 20 minutes, up to 45 minutes. I now needed someone to help me with my appearance. Hairdos had to be always perfect, so I accumulated wigs, which was a blessing for me, then came makeup. I had another dancer help me apply lashes for the stage, eye shadow, eyeliner, lipstick, and so on. I never had to wear makeup, and my skin was always perfect, except for a bit of powder on my nose. Stage makeup was different from pinup modeling. It took several weeks before I was comfortable with an audience. I started in small beer joints wearing a blonde wig, so no one would recognize or remember me. I was always scared that I would get deported for stripping while underage because most bars had liquor licenses.

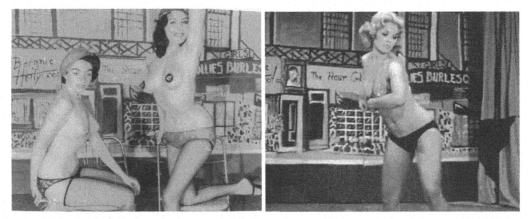

My first public image by Bernard of Hollywood and Candy Barr (right).

It was rare to be photographed by Bernard of Hollywood and get paid because most strippers or celebs paid him. I am still clueless about how this came about. I was now ready to enter the world of the old-time burlesque, the end of the fifties when the big names started to fizzle out. The first club I worked in was cozy and easygoing. I was able to practice all kinds of new moves. The bad thing was it had three 45-minute shows. Now I had to learn how to really "kill" time. It was there that I began to do floor work. Something new to me, but it eased the time. The law at the time was: full panties, net stockings, and net bra over pasties. It must have taken 10 minutes to take off my stockings that were connected to my garter belt.

My next gig was at a theater. I worked there for a week. I am trying to remember the name of it, only that it was outside of Los Angeles. Someone told me to throw my small pieces of wardrobe in the audience because patrons like that, so I did. That was the end of my items. Never to be seen again. After that incident, I kept all my wardrobe pieces together and close to me.

Then I got hired at a small club, also for a week. But, again, the floor was the stage. There, I remember I had a drink to calm my nerves.

By now, I had enough practice. I was now ready to move on to better and nicer places with more confidence. I was glad to be where I was.

Club El Rancho My first big break in Burlesque, as a stripper.
In May 1959 I arrived at El Rancho. This was a new chapter in my life.
Being at the right time at the right place, I had luck. My first great job in an all-star studded show was, starring Lili Ct Cyr. Her tall statuesque body graced the stage, while the audience was in awe. Also in the show were Gay Dawn, Caprice, and Lady Midnight, who was living with "Sis" the cocktail waitress at the time. Most importantly, the owner, Esther Wright, took a liking to me, which made me feel at ease. After all, it was my first burlesque job, and I was nervous.

WHAT, NO SAMSON!—No man in right mind would let the unspeak-
'1 beautiful Delilah out of his sight,

WHERE'S SAMSON? — Gorgeous Delilah has every man wanting to fill Samson's shoes at the West Seventh Club El Rancho, Esther Wright's plush burlesque theater, where she is a top feature act. Delilah is a former headline model and cover girl.

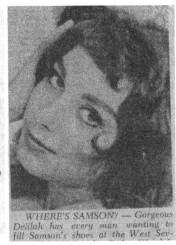

WHERE'S SAMSON? — Gorgeous Delilah has every man wanting to fill Samson's shoes at the West Sev-

I got publicity early on with my already pinup photos.

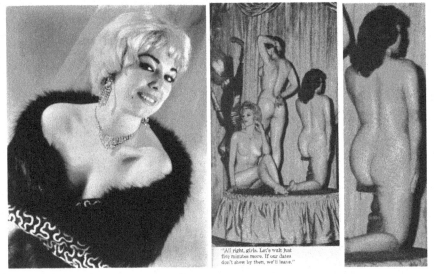

My first costume made by Gussie Gross was finished in December 1959. Center & right: A snapshot on stage for a magazine.

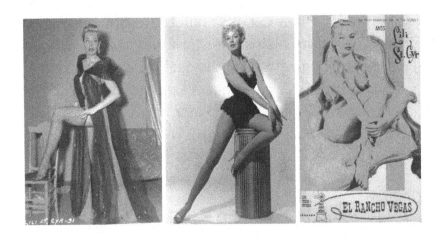

My 8x10 photos of Lili St Cyr and my original postcard from El Rancho in Las Vegas. Lili was evasive during her engagement, like a typical "primadonna" star, but at least I got to meet her and I was in the same show with her. She did her well-known "reverse" strip. Also her bath plexiglass tub. I was able to watch her closely so that I could learn from her.

Next: Tornado Tanya got her nickname "Tornado" from twirling her tassels fast in all kinds of directions. Left: In Gussie Gross gown. center on stage at the El Rancho in Los Angeles. Always telling jokes in the nude. Right, Caprice. my photos

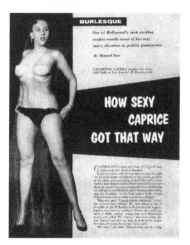

CAPRICE was well publicized already and graced many magazines, mainly known for her tremendous ribcage. Caprice with Genie and on the red revolving red stage prop at the El Rancho. She had her little daughter in the dressing room and hid her under the table, so she would not have to use a babysitter. Her name was Liza; she also became a stripper after she grew up and was known as Liza Jourdan. Caprice and I became lifelong friends. After Caprice stopped dancing, she went into the beauty shop business, doing hair in Los Angeles, then moved to Las Vegas, where she became a cashier and light tech at the World Famous Palomino and Cabaret until she passed away in Las Vegas.

Then there was Gay Dawn, a quiet one, almost on the shy side but always smiling. Her husband was the stage manager.

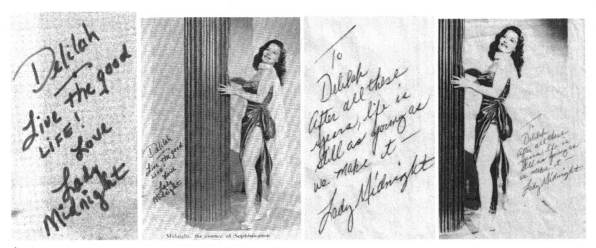

My photos from Lady Midnight.

I saw her the last time at Jane Briggeman's living legends reunion at Stardust in 2006.

The El Rancho Club had a family atmosphere. It felt good to be surrounded by friendly people. I was using the name Sunny Strip when I first arrived and in a blonde wig. Everybody thought that was corny, so they were thinking of a new name for me. As it happened, the movie "Samson and Delilah" was being re-released and advertised in the Los Angeles Times. So a light came on, and we all voted on my new name. I liked Cleopatra better, but that was corny. Also, the movie "The Man with the Golden Arm" came out around the time, with the McGuire sisters' song "Delilah Jones." And so Delilah Jones was born. At the same time, my first centerfold by Ron Vogel was published in June 1959. When the owner, Esther, saw the magazine, she was so impressed that she hung it behind the bar for everyone to see. I now felt really important. Not too shabby for my young age still at eighteen. The centerfold attracted a particular person, Bob Green, who owned a TV repair store nearby, and was a regular customer. He asked me to be a date for hire to go to another club where his soon-to-be ex-wife was a lounge singer and piano player. He wanted to make his wife jealous. Esther vouched for him, so I accepted. I agreed to join him for a drink, and as life had it, Bob, a Hungarian Jew, became my first husband, and his ex and I became lifelong friends.

California nightclubs that served alcohol had to close at 2 am; therefore, many of us would party after work, sometimes even watch a movie after hours. On Sundays, we would picnic in the morning at MacArthur Park.

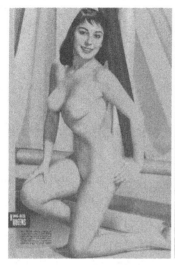 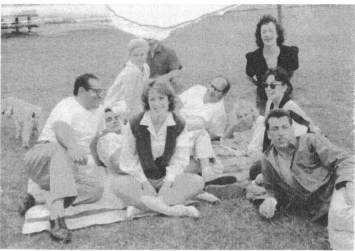

My centerfold El Ranch gang at a picnic.

Most of the cast came along, the comic Carol Abbot, Emcee Steve Gallo, Gay
Dawn, her husband, the two new dancers, Tornado Tanya and her boyfriend (front
right), Bob Green (head cut off), and myself.

I was lucky to be around the last of the golden days of burlesque, I was clueless as
it started slowly changing as the big stars disappeared. But one, Tempest Storm,
stayed on and on; she was always at the top-notch.

Several months later, I was ready to move on. Hollywood was calling me, and I felt
in my heart that I was ready. A few years later, Mickey Hargitay bought El Rancho.
He was then in Real Estate.

My first destination for two weeks was Jack Tucker`s "Tiffany Club", a classy
nonalcoholic place that featured "Strip O` Vision". I would appear in a plexiglass
box and slowly disrobe while customers would add coins into a slot. When they
stop adding coins, a curtain would come down, and no more "me".

THIS IS DELILAH!—And what
red-blooded American male wouldn't
want to play Samson! Top-flight cov-
er girl and model, Delilah was one of
best known exotic dancers in Europe,
has now lend-leased her many charms
to Jack Tucker's West Eighth Tiffany
Club, where she uncovers nightly as
an ambassador of goodwill.

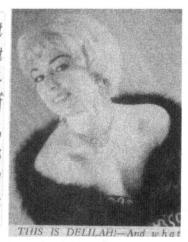

THIS IS DELILAH!—And what

STRIP CITY Western at Pico · Home of BIG NAME BURLESQUE

I had one week at Strip City,
and one week at the York Club, my agent was Lou Dorn in the sixties.

Then I took a little break and went with Bob to Las Vegas to visit his sister Ruth Raburn and her husband who worked in the Dunes Casino upstairs in the money department. We took an Amtrak train with a skyline roof, which stopped downtown at the Union Pacific railroad station.
 Back home:

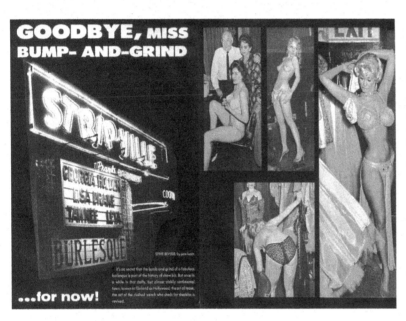

"STRIP-VILLE", on Hollywood Blvd, was my next gig. It was one of the most popular strip clubs in the fifties, but by the time I arrived, it had a lot of competition. The big headliners have become rare now.

Memo: The star of the show is the headliner, and a feature is next in line. We had co-features, and in exclusive clubs, we would have a star-studded show, where only headliners were hired all at the same time. Georgia Holden was the headliner, known for her tremendous oversized natural breasts. We stayed friends until she passed away in the early seventies from breast cancer, by then we worked at the Body Shop. I had sent her flower arrangement to the City of Hope, in California, where she was treated for her cancer, and two days later she passed away, but it made her happy for the time being.

22

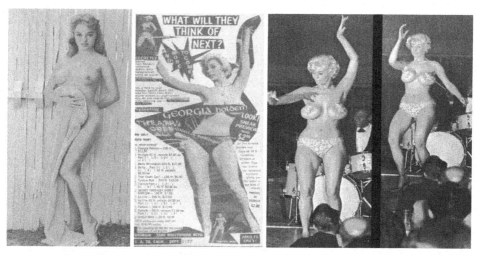

Lisa Drake was one of the features, and we would meet again in

1960 at the filming of "Not Tonight Henry". After Georgia Holden left, Rusty Lane was the new headliner. The new emcee was Herb Eden, his very first gig.

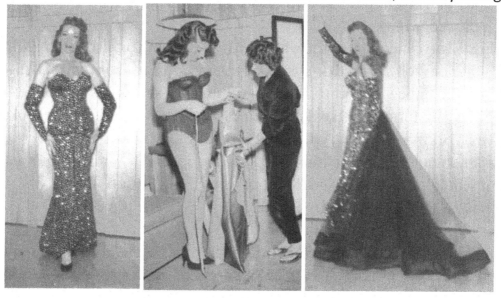

Rusty is getting fitted by Gussie Gross.

Rusty showing off her new nose, and Herb Eden saw him shortly before his death at the Palomino in Las Vegas.

Rusty Lane`s husband Dick Benedick, was always with her every night and would stay in the kitchen area where everyone would be hanging around between shows unless we stayed in the dressing room. Dick was a mellow fun

loving person. Later on, became a director on the TV shows for Hawaii Five-0 with Jack Lord and other productions.

Herb Eden. I found this photo in a garage sale. Herb and I also became lifelong friends. I saw him last at the Palomino in 1995-96 when he visited me, shortly before he passed away.

Seeing slowly the change from the olden golden days of sophisticated Strippers to the newer generation entered and took over. But nothing ever really changed, men want to be enticed by pretty women on stage. A saying went around Hollywood, at the turn of the sixties, "Your face is your fortune, and it looks like it's all spent". So the first thing we needed to do is fix your teeth, so your smile looks like a million dollars. The next thing is your nose. If it is not cute or pretty looking, it would need to be fixed. Most of us did, and important was hair, wigs came in handy. That was easily bought.

Then I arrived at the "Colony Club" in Gardena. It was one of the most popular Burlesque spots in Southern California. The dressing rooms were theater-like. I worked with many beautiful and already very well-known professional strippers. Lenny Bruce was the comic. Susie Martin was one of the dancers and so was Princess Zza Zza and Ecstacy. I remember there was a separate area for gambling. In the sixties, it burned down.

My next adventure was the
Zomba! ✦TRIPARAMA

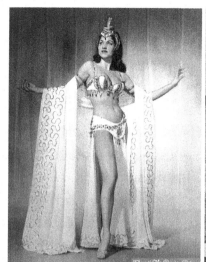 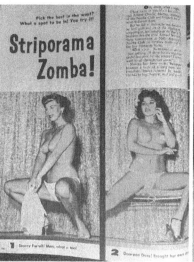 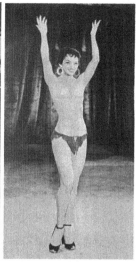

I was now working with Tana, the Persian Princess, Stacy Farrell, my teacher, and Zorita, also Daurene Dare, and many others. It changed every week.

Even though I was getting into the swing of stripping and was still new at it, I noticed that the competition was always high. Everybody wanted to outdo the other. It was all about recognition, getting noticed so the salary would grow. After working with Tana in the early sixties, we would meet again years later in Las Vegas for lunch to reminisce, along with Teri Starr, Ruthie Lewis, and other dancers. In the early 2000s, she passed away. Teri Starr and I attended her service. Zorita and I did not connect, even though we shared the same dressing rooms. Liz Renay and I worked together again in 1975 along with her daughter, who also became a stripper and was a spitting image of Liz, for a special Shriner show. The three of us shared the same dressing room. Her daughter committed suicide in 1982. Liz and I became lifelong friends.

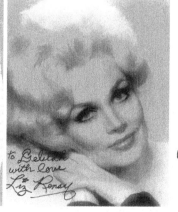

Hurry! Hurry!

Hurry and get those ballots in for your favorite burlesque queens, fellows. (Honorary members not eligible.)

Omitted from list of candidates: Zorita, Christie Anders, Marlyn Harlow!

New members now eligible: Princess Tana, Delihia, Liz Renay.

Leaving the fifties behind, now 1960, a new year, a new century, and we are now entering the "Vintage" burlesque era with new ideas. A new younger generation

brought fresh energy into the business. Many performers were underage, as I still was. I witnessed the change, including myself. But the fifties strippers could never be replaced again. The elders became icons.

While I was working nights as a stripper, I was still modeling every so often during the day and was lucky to have worked with Elmer Batters and Leonard (Lenny) Burtman, who many times worked together or used the same models and the same studio. Burtman had several publishing companies. I appeared in many of his magazines with my maiden name and my newly found burlesque name, "Delilah." They advertised and sold these photos and magazines worldwide. I got some recognition in both fields, thus giving me more confidence, constantly watching the headliner so that I could improve all the time. I would remember something impressive from each stripper, then intermingle it into a new routine for me. I learned fast, as this was my new career.

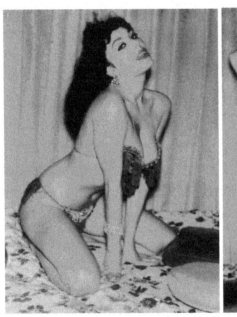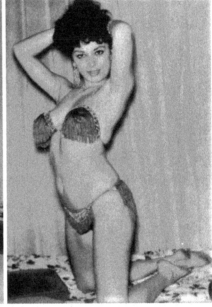

Presenting lovely Doris Gohlke, Germany's gift to the U. S. This glamorous doll is currently appearing in California night clubs as Delilah . . . an exotic dancer.

Doris "Delilah" Gohlke was born in Berlin, but now calls Los Angeles her home. She's one of the West Coast's most popular strippers.

26

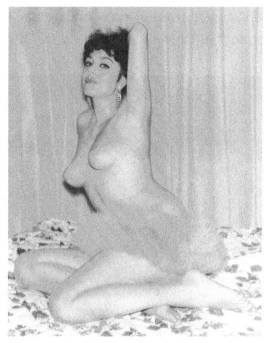
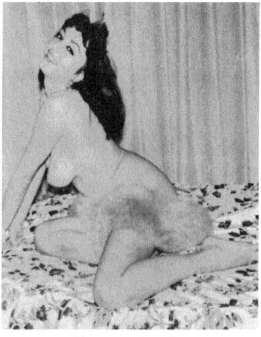

 It's no coincidence that Doris Gohlke's stage name is "Delilah." And no happen-stance that she's one of the featured models in this new issue of SATANA . . .

In 1960, I was asked to appear in the movie "Not Tonight Henry " which starred Hank Henry. I had three non-speaking parts: a Grecian statue, a cave woman, and an Indian maiden. It was common in Hollywood to be approached for a movie part at the clubs we were working in. I was cast with my friend Brandy Long, my sister Margo, Susan Woods, Lisa Drake, and Abby Leigh. Ron Vogel was the still photographer on the movie set. He took many extra photos of me, therefore I appeared on all the posters several times.

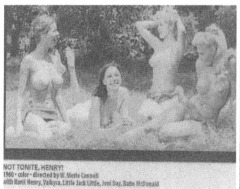

NOT TONITE, HENRY!
1960 · color · directed by W. Merle Connell
with Hank Henry, Valkyra, Little Jack Little, Joni Day, Babe McDonald

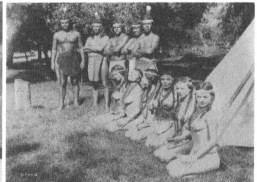

27

Susan Woods, myself, Lisa Drake, and Joyce Wagner, appear now on the back cover of the DVD. Right: A still photo by Ron in front of my trailer, and the Indians.

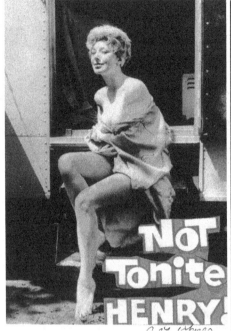 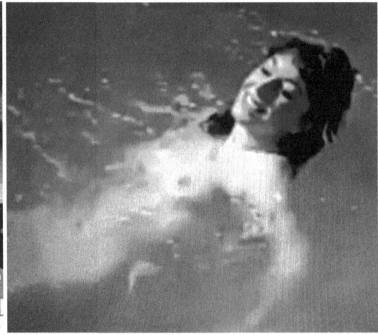

As a Grecian statue, sitting in front of my trailer. As an Indian maiden, swimming happily in the cold lake, while nippled and shriveled from the cold water.
Bottom Left: We even made it into "Playboy". My sister Margo, Susan Woods, me, and Abby Leigh are little Indians in the lake.

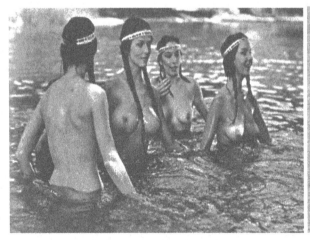 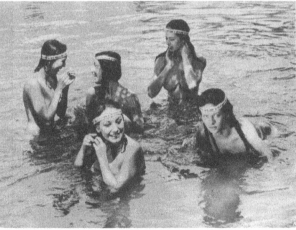

That same year I opened at the Club Largo

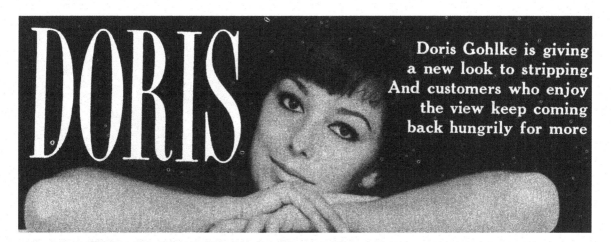

DORIS

Doris Gohlke is giving a new look to stripping. And customers who enjoy the view keep coming back hungrily for more

WITH A REPLICA of Michelangelo's nude David in the background, Doris Gohlke nightly titillates customers at the Largo on the Sunset Strip. When she starts to peel, even the most blase sit up and take notice because with her 38-24-36 beating out a fascinating rhythm she's one to put the capital S in strip.

WHERE'S SAMSON?—This is the luscious *Delilah, whose high-powered act is a nightly sensation at Chuck Landis' Sunset Strip Largo, where the menu is burlesque to the taste of a society and filmland clientele. Delilah was a top model in Europe before making her home on this side of the water. She is noted for her brilliant wardrobe, radiant personality.*

Chuck Landis liked me and told me to just parade like a Las Vegas showgirl and sexily disrobe. He also said to me " remember, Delilah, a lady does not sweat". I never forgot those words. Chuck was very choosy about who he would hire, he was a perfectionist, if I would gain a pound, or did not have a flat tummy, I would get an unwanted, unpaid vacation., so I worked hard to be perfect.

The Club Largo had a star-studded show, Miss Beverly Hills, Joani Carson, Electra aka Vicki Palmer, Babette Bardot, Exotica, Sonnia Tonic, Nancy Lewis, Diane Lewis, Sue Martin, Laura Cornell, Brandy Long, Carla Lee, Rebel Reed, Stormy Weather, who`s boyfriend was in with the mafia, she told me. Occasionally, sex between girls did happen in the dressing room, as many were gay or bisexual, everything was a go in Hollywood then, and silence was golden.

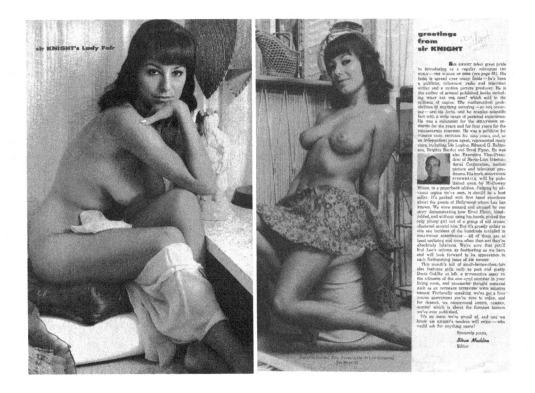

sir KNIGHT magazine, was an advertisement for the Club Largo.
Left: my Centerfold, right: the index article.

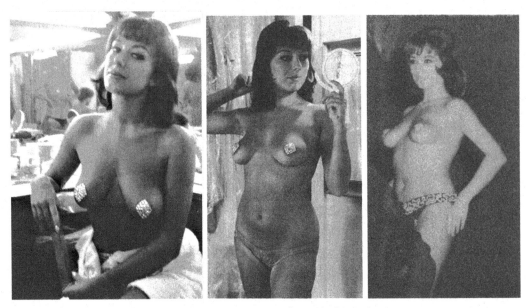

Backstage and on stage at the Club Largo.

Babette Bardot Nancy Lewis, her sister Monique, and Sue Martin

Nancy became a good friend of mine. We worked together at the Largo, at the movie "The Touchables", and at the Body Shop. We lost touch after I started to travel. The last time I saw her was in 1977 at my house. Years later I met her half-sister, Monique, also a stripper, who told me that Nancy lives now in Utah and became a hermit, a recluse, totally isolated from everyone, and Sue Martin moved to Hawaii where she died.

Exotica Sonja Sonic also appeared in many magazines

It was now obvious and very noticeable that the old "tyme" burlesque shows had changed to more modern ones. The newcomers, many of them former pinup models, brought new ideas to the business. They looked more like Hollywood starlets and brought more open sexualities into the dressing rooms. Hollywood strippers.

That attracted many celebs for sexual activities or other. We never talked about what anyone did because Hollywood was a different world. Whenever celebrities went out with any of the strippers, it was always done in good taste, unpublicized.

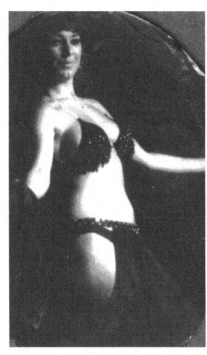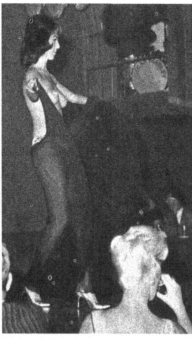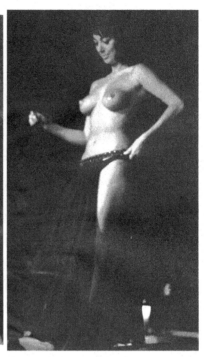

One night at the Largo while I was being announced as coming "from Germany '' The music was suddenly stopped by a big man who was in the club with his shepherd dog. As he walked towards me he took the microphone from the stage when I got a glimpse of him and recognized his face immediately, it was none other than Johnny Weissmueller, TARZAN himself. He started singing a German lullaby to me in German. It was a standing ovation after he was done singing. It was an unforgettable night.

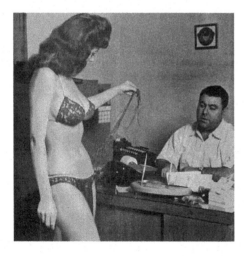

Beverly Hills was Chuck's "puppy". I do not believe that there was anything between them. Beverly was straight lace. Chuck gave her a lot of publicity for her movie career. He liked to show her off. Somewhere along the way, Beverly got married. She and her husband bought an apartment building on Fountain Ave, off Doheny Drive. She became a homebody and got away from the limelight. Eventually, Beverly moved to Hawaii, where she became a minister. She had two sons and never remarried after her husband passed away.

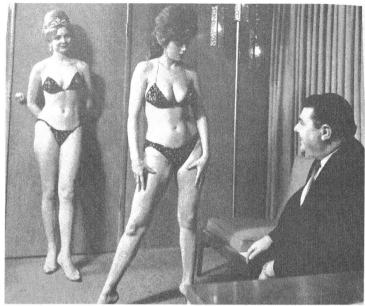
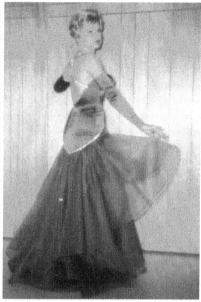

Miss Hollywood is being groomed, watching Miss Beverly Hills and Chuck Landis.

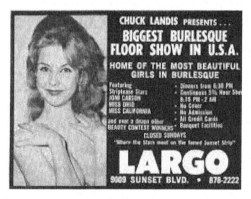

Before Beverly would leave the Largo, Chuck was priming a very young Miss Hollywood to be the next headliner for the Largo. About a year after being the headliner, she disappeared, while Bob Hope was taking care of her, and he also enrolled her in a Miss World Beauty Pageant, while he was in charge. Hope had numerous girlfriends that he took care of. But that was no secret in Hollywood back then, it was a common happening, celebs liked the pretty strippers, and they always looked their best in Hollywood.

With Karla Lee, one of our strippers, here at Santa Monica beach to catch a ray of sun, also watching that we would not get too dark.,
Karla in soft foam pink curlers, which we also used to sleep with. We also used to nude sunbathe on top of the roof of our home that Bob and I shared, to avoid stripes on our bodies.
Karla got pregnant by a young handsome guy, but a different nightclub owner took the responsibility and Karla retired.

In 1960 SPREE magazine featured a large pictorial about Club Largo`s dancers.

Famous Hollywood Night Club Where Burlesque Has Gone High Class!

The exotic, the sophisticated and the sensuous brands of stripping are all displayed at the LARGO, as exemplified above by: Delilah, Laura Cornell, and

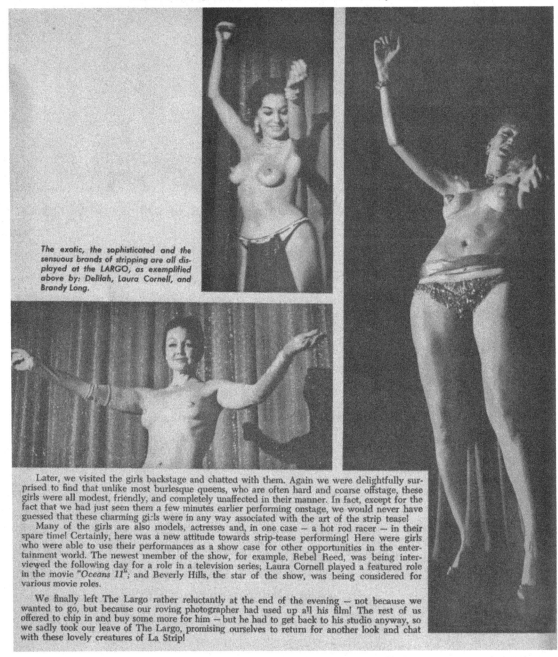

The exotic, the sophisticated and the sensuous brands of stripping are all displayed at the LARGO, as exemplified above by: Delilah, Laura Cornell, and Brandy Long.

Later, we visited the girls backstage and chatted with them. Again we were delightfully surprised to find that unlike most burlesque queens, who are often hard and coarse offstage, these girls were all modest, friendly, and completely unaffected in their manner. In fact, except for the fact that we had just seen them a few minutes earlier performing onstage, we would never have guessed that these charming girls were in any way associated with the art of the strip tease!

Many of the girls are also models, actresses and, in one case — a hot rod racer — in their spare time! Certainly, here was a new attitude towards strip-tease performing! Here were girls who were able to use their performances as a show case for other opportunities in the entertainment world. The newest member of the show, for example, Rebel Reed, was being interviewed the following day for a role in a television series; Laura Cornell played a featured role in the movie "Oceans 11"; and Beverly Hills, the star of the show, was being considered for various movie roles.

We finally left The Largo rather reluctantly at the end of the evening — not because we wanted to go, but because our roving photographer had used up all his film! The rest of us offered to chip in and buy some more for him — but he had to get back to his studio anyway, so we sadly took our leave of The Largo, promising ourselves to return for another look and chat with these lovely creatures of La Strip!

Bottom left: Laura Cornel got the dancing part in "Ocean's Eleven". After that, she left Largo and asked me if I would be interested in working with her, being a high-class call girl. That was thoughtful of her, but not my "cup of tea." it started at

$350.00 per night, a lot of money for that time.

Picture right: Brandy Long. We also worked on the movie "Not Tonight Henry", and at the Body Shop. She visited me for the last time at my home in Hollywood, on Blackburn Ave. circa 1963, after she had just undergone some plastic surgery. Then she went to Las Vegas for a show. I never heard from her again, she just disappeared

Nex: Rebel Reed, right: Stormy Weather, and Cindy Marlowe below.

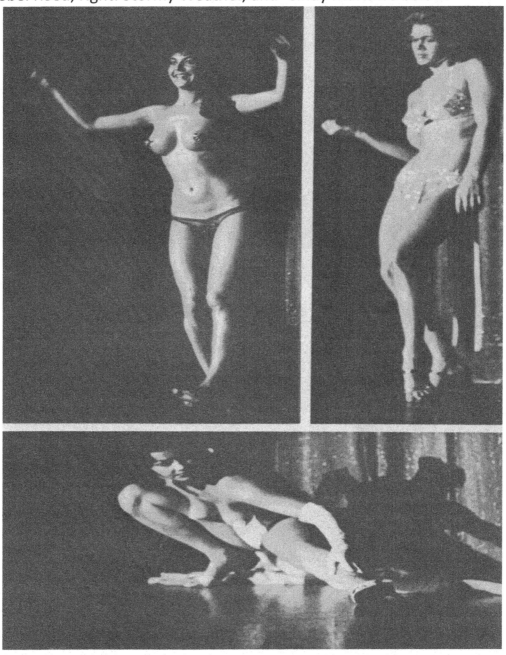

Stormy Weather, a true redhead, was the lucky girl that got a blowjob from Electra aka Vicki Palmer, on the dressing room floor, as the rest of us watched. We

enjoyed the "show". Exotica had just come off stage and caught the tail end of it. Sue Martin gave the loudest applause. She got turned on and wanted to be next. One of us watched the doors to Miss Beverly Hills' dressing room and Chuck's office. That behavior was not acceptable.

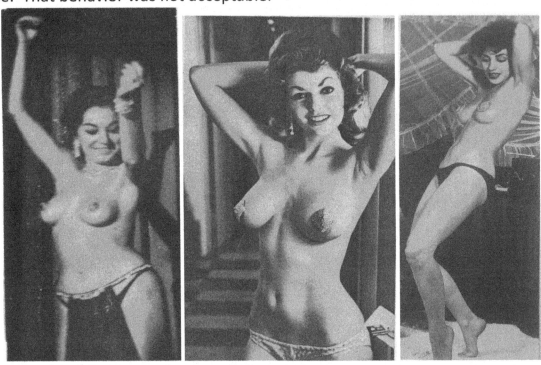

myself, Miss Beverly Hills, and Electra

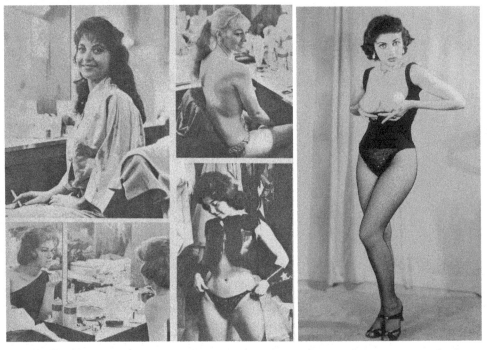

Rebel Reed and Brandy Long, Stormy Weather, Karla Lee, and Electra

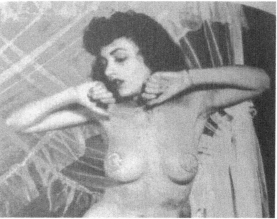

Electra aka Vickie Palmer did a fantastic fire show.

"I am the God of hell fire, and I bring you fire", the song "Fire" by Arthur Brown was her opening song. She used a revolving prop table that was open in the center. Inside was a motor and a place for her to stand. The fire was made of Yellow, Orange, and Red chiffon panels attached near the motor, so when the motor was turned on the chiffon panels would flow upwards, which gave the impression of a real fire, and Electra would stand in the middle, made it look like she burns in the fire or in hell, at the end of the show.

In 1961, Bob and I finally married. I enjoyed his company but did not love him. I thought, "Why not", marry him, but that's the wrong way to go about a marriage, even though it lasted almost 5 years. We were, however, good friends, even after we parted.

Before I married Bob, I had a short fling with Candy Barr's personal manager, Joe De Carlo, who dated Bonnie Logan before me, in the same year. We were fond of each other, that was all, but he loved showing me off to friends, and introducing me to many celebrities.

One day Jack Benny`s office called Chuck`s that he needed three girls for his TV show. I was chosen along with Exotica and one other. Instead of auditioning for the show, we spent the afternoon filled with jokes and laughter. Benny kept his violin on the table.

It was common that whenever agents or producers were in need of girls, they would contact the club owner. In this case Chuck. He was known to have the best-looking girls.

Another night at the Club Largo, some of the cast of the "Hawaiian Eye" TV show visited Club Largo. Everyone was pleasant and had fun, Troy Donahue, Anthony Eisley, Robert Conrad, but not newcomer Connie Stevens, she was arrogant. She used to be a cocktail waitress for Al Deitch at the Golden Violin, on Sunset Strip,

which was next to the Club Largo, and after she got the part in Hawaiian Eye, she would not say "hello" to her former boss, Al Deitch. Connie Stevens was one of the very few stuck-up celebs in Hollywood.

Another memorable evening was meeting Marilyn Monroe. Joe De Carlo had introduced me to her. She was in the company of male friends. Her appearance was very angelical, dressed in a floor-length beaded evening dress, with a white fur stole. Her face was like a porcelain doll and her white blonde hair blended into her skin. She was very high and could barely keep her eyes open. We did however shake hands, but her hand was very limb.

Hollywood was like a family then, you were either with them or an outsider.No one ever spoke ill of anyone's actions.

Richard Dawson and then wife Diane Dors, also visited, looking for some action. I was asked to join them at the table. I did. Soon after I was asked by Dawson if I was interested in having a sexcapade with his wife Diana Dors. She was not gay, just wanted to have one experience with another woman, just once. He offered $200.00.

I was not insulted, because Hollywood was a swinging place then. However, I declined, but Barbette Bardot accepted and took $20.00 down for the $200.00 favor, which she accidentally flushed down the toilet because she had put the bill in her g-string and forgotten about it. I never did ask Babette how it went, it was none of my business.

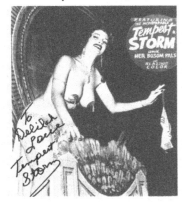 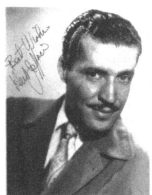 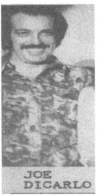

Tempest Storm me and Tempest Herb Jefferies Joe DeCarlo

Even though Tempest was gone from Club Largo, we somehow connected outside of work. I was invited to her home many times. Even after she went on the road Herb Jefferies always invited me and my sister to parties at Tempest's home, located on Sunset Plaza Drive. My sister eventually had a brief affair with Herb, while Tempest was on the road. Herb and I stayed friends throughout the seventies.

One night, during my show breaks, I went to the Villa Frascati, where I met Tyrone Power's beautiful wife Debbie Minardos. She was with a friend and invited me to her table. She approached me very gently while making a pass at me, warmly playing with the palm of my hand, and gently kissed it with a teeny lick from her tongue. When I felt her tongue, I got nervous. She was beautiful and even though I was aroused and tempted, I declined to spend time with her, maybe I was scared. I don`t know, but it was not my "thing".

I was also asked If I wanted to have a fling with Della Reese. But these scenes were not for me. What we did when we were young was no one's business, we had fun and enjoyed life. We did what felt good at the time. Never to feel sorry for something we did not do.

In 1961 I was again approached to be in another upcoming topless film "The Touchables" along with my friends Baby Bubbles and Nancy Lewis.

Nancy Lewis

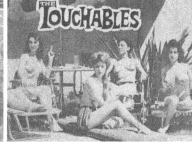
relaxing at the pool

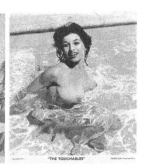
Baby Bubbles

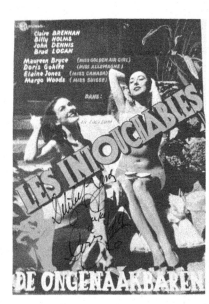
The European poster with Nancy Lewis.

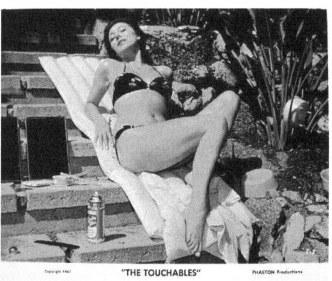
My press release photo

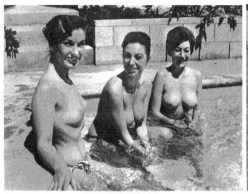
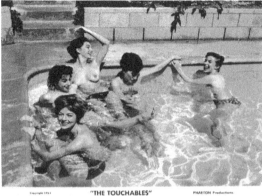

Fun in the pool with the cast.

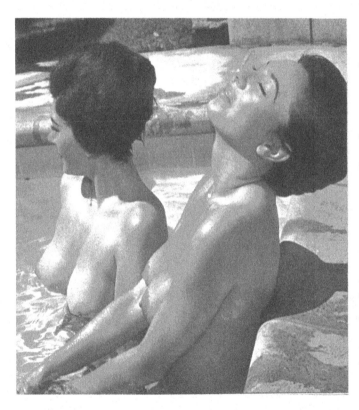

Extra shots of me appeared on posters and in magazines. While I was still working at the Largo, I would go and talk to Al Deitch at the Golden Violin. He was very fond of me and spoke about someday having his own Burlesque Club with me in it. It sounded far-fetched. Months later, as destiny had it, I gained a couple of pounds and Chuck gave me a few days off to lose the weight. That was good timing, as Al took me to Potters Steakhouse, and introduced me to Larry Potter when they started to talk business.

My sister with her daughter, Valerie, on Pamela Mason`s TV show. I took this Polaroid photo. During my time off, I modeled my sister's fashion line on Pamela Mason`s TV show. Because it was a live show, I did not get any photos. Pamela was actor James Mason`s ex-wife. I was fortunate that I met many celebs at my sister's home, like Elizabeth Scott, Tina Louise, Doris Day who became a friend of my sister, and Dorothy Dandridge, her neighbor. Later in time, my sister was a neighbor of John Wayne and was good friends with Pilar, John`s wife.
Actor Guy Williams used to come and loved playing my sister`s white piano.

40

Pamela Mason, my niece Valerie, and Gisela. A group shop with my two sisters
and niece

At my sister Gisela's apartment on Fountain Ave, which Pamela Mason owned.
She designed this outfit for Elizabeth Scott, who had it photographed for her and
gave her this photo. A similar outfit was made for me by my sister.

In 1962 Al Deitch`s dream strip club was finished, and so the Body Shop was born. I was with him from the beginning and I had a happy reunion with Caprice from El Rancho. We would pop in and out of our lives.

Soon Kim Sommers would join, she also became my lifelong friend and my closest friend until she passed. She would become my party girlfriend.

Angel Carter, from Samoa, after giving birth to a baby, which she gave up for adoption, arrived at the Body Shop in early 1963. Later that year she started dating Troy Donahue, who fathered her next child.

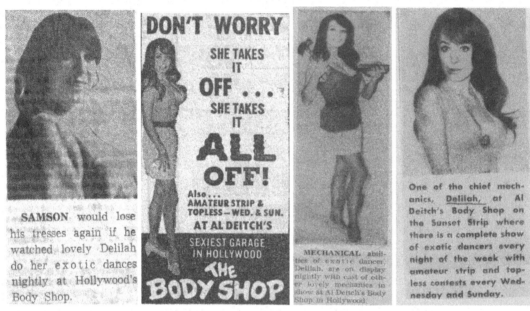

My very first Body Shop advertisement. Al Deitch went mechanical, then realized that was not flattering.

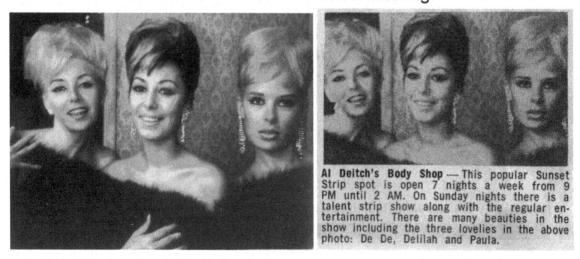

Dee Dee, myself, and Paula all wrapped in my black fox fur stole.

Left: my original photo, right newspaper ad.
At the time, we dancers had real fur stoles.

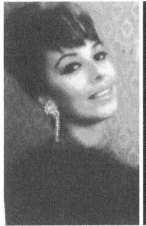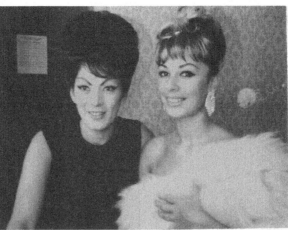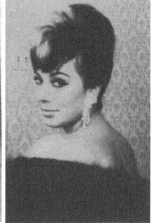

Soon Tura and her sister Kim Tani would arrive.
Tura was like a protector whom she liked, but she was not fond of Angel
Carter. One time when Tura was upset at a customer, she yelled out
"Remember Pearl Harbor" which started a lot of criticism, and she never
said it again. But in the dressing room, we used to joke about her being
Japanese and me being German, we had to stick together in war, but all in
good humor.

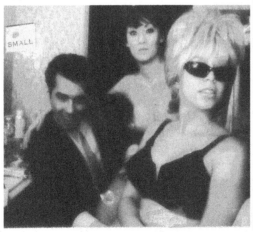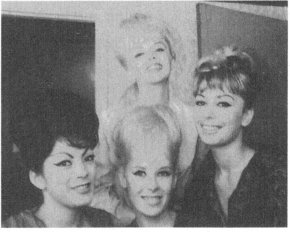

Hal Burcus, our horny drummer, was all hands, all the time, Kim Tani,
Tura`s sister, quiet like a mouse, a wonderful human being, and Paula Di
Angelo in sunglasses, was mostly high on marijuana, but never acted like a
druggie. Right: Tura, DeDe, another Paula and me.

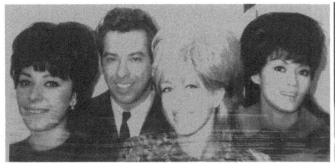 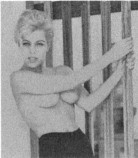

Me with Hal, Paula Di Angelo, Kim Tani, & Kim Sommers & Paula DiAngelo

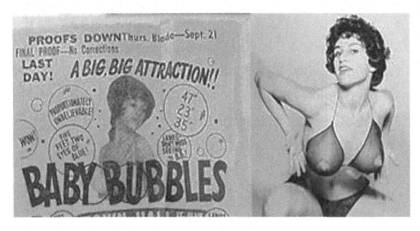

Baby Bubbles also arrived at the Body Shop. She is here in a net bra over pasties. She was a tiny girl with big boobs and was great at twirling tassels with her breasts.

In the late sixties, she studied to become a doctor at Kaisers in Simi Valley. Years later she got married to actor Dick Miller and lived a happy life.

We all lived fairly normal lives outside the nightlife. Most did not use drugs.

 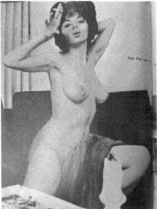 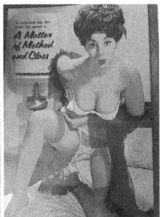

Dee`s pictures are from my magazines.

Dee Dee became Al`s girlfriend, which we kept hushed because he was married. She dyed her hair back to her natural color, a brunette.

44

Years later Dee Dee, of Mexican descent, visited me in Las Vegas, with her husband, and told me that she was going to Mexico for charity work for the poor hungry children there. Never heard from her again.

Al Deitch always treated me like one of his daughters. He had twin girls my age. He had asked me to do some publicity photos for the Body Shop and sent me to a photographer in the San Fernando Valley. He would have made me his poster child for the Body Shop but had to be careful so other dancers would not get jealous, which was common among the strippers, but we also learned from each other. If someone would copy part of anyone's show, and use the same music or name, while working in the same club, holy hell would break up.

We, dancers, had a close relationship, closer than some families, after all, we would spend six to eight hours every evening together and many hours of them naked. We were very particular with our chairs, which were always covered with our towels. No one was allowed to sit on it naked.

The Dressing room of the Body Shop had a lot of memories. So many well-known names graced that stage. And we partied. Some of the girls would smoke pot, I did not, but I always went along with everything and unknowingly, got a contact high, which was new to me. This also put some oomph into the show. Most "after-hour" parties had open sex acts, in which anyone could participate. We never tattle-tale on one another. The parties that Kim Sommers and I used to go to were mostly alcohol and hook-ups with open sex for many celebrities, those parties were in rich people's homes, in very classy atmospheres. Those were the Hollywood taboo parties with invites only. Louis Prima was at one but did not participate in any sex, just had fun and watched, he did, however, grabbed my legs gently on a staircase, while looking up my skirt. He was in his glory, it was all in fun. Another of the parties was held at Bill Dana`s home, mostly known as Jose Jimenez, a TV series. Kim Sommers, Hal, and I attended. Hal, Kim, and I accidentally got locked in the sauna totally nude. No clue why we even went in there. It had a small window looking out the Hollywood Hill, but could not escape from there, because it went straight downhill. Eventually, we were rescued by the Los Angeles fire department, while the three of us came naked out of the sauna, and everyone else was dressed in the party room. Heaven only knows the fun we had.

In 1963, some of us dancers decided to go to a beauty school to have our hair done in Bee-hives. I decided to take it a step further and also had my hair streaked. Al Deitch was proud of us, always smiled with a little sparkle in his eyes, and treated us like friends. After hours, some of us strippers went to see all-night movies, parties, or grab a bite to eat. One after-hour night, Paula Di Angelo, Kimmie, and I went to see the Beatles movie "Hard Day's Night". The theater was packed with young ones and they were screaming for excitement throughout the whole movie, so we laughed along with them.

Angel Carter was now showing her pregnancy and left the Body Shop. Troy Donahue was with Angel when she gave birth, and both decided on a name for the child and gave it up for adoption. They stayed in close contact.

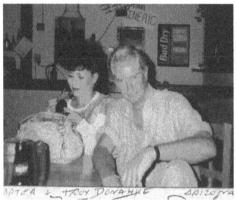

Troy and Angel in Arizona, a family snapshot. My new nose.
Springtime in early 1964 I had my nose bobbed, and wanted to keep it secret from my family, and Tura came to my rescue and offered me to stay at her home while I recuperated, free of charge, and so I became Tura`s roommate for a couple of weeks, along with Kim Sommers, Paula Di Angelo and her sister Kimmie. Only Bob, my husband, knew about my surgery. And so I shared a king-size bed with Kimmi and Paula. I slept in the middle. Oh, what fun that was. I always had eyes staring at me, no matter which side I turned. Kim Sommers had her own bedroom and Tura had the master bedroom. Her house was in Laurel Canyon, a short distance away from where now Angel Carter was living with middleweight boxer Joey Giambra. After a week or so, I came down with a head cold and my nose and face swelled up so much that it left my face uneven. We all

wanted to have pretty faces, like the movie stars, so many of the west coast strippers would have their noses redone. Especially when we often were asked to appear in movies or TV shows.

While I was still recuperating at Tura`s place, one early Sunday morning, with my face still swollen and bandaged, I walked into the kitchen topless

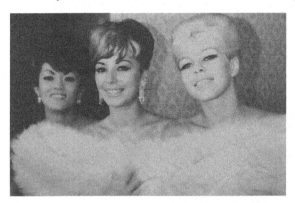

for some coffee, when low and behold there was Tony Bennett sitting at the table. I froze, standing in just my g-string and topless. Being a gent, Tony said "it's alright, come on in, I'll get you some coffee, and handed me a towel to cover. Soon Tura walked in, also topless and we all had a good laugh. She was dating Tony at the time. That was a nice Sunday morning Kaffeeklatsch. During that time, Tura thought I should work on a new routine for the show. So she worked with me on a hooker number with the song "Walk on the Wildside".

Now my show had new movements and new steps and a new walk.

Next some snapshots in the dressing room.

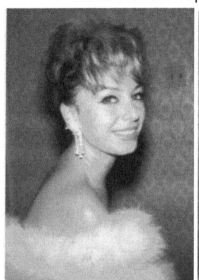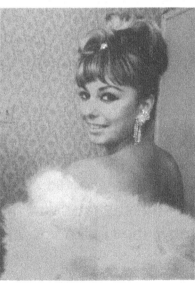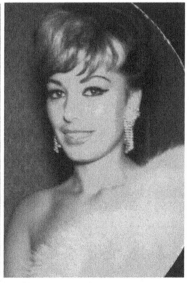

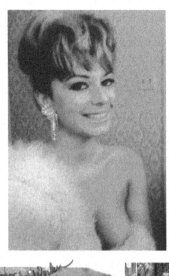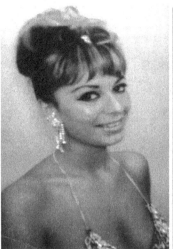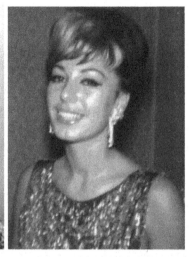

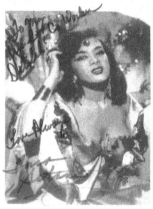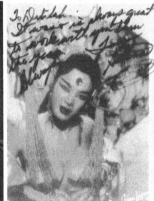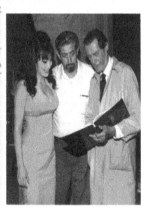

Two photos from Tura signed to me and the filming of "Irma La Douche"
Tura invited me to come to the set and watch the filming. I did.

Our dressing rooms looked like a makeup or fashion studio. Everyone took pride in what we looked like and wanted to outdo the others, but mostly be helpful to each other.

Tura with my photographer friend Sandy Fields, and actor John Carradine. In the early sixties, some of the dancers went to Mexico over the weekend and came back with larger boobs. They had silicone injections. At the time, it was a dream come true. But in time it would backfire. Angel needed the enlargement desperately, after having had two children in a short time. Her new boobs were very large now, they looked great, but that silicone almost cost her life in later years. She had to have all of her breasts removed and needed a skin graft, some skin was taken from her butt, to use for closing her chest, and she still had lumps in her armpits, which could not be removed. It took three months to heal.

48

In the mid-sixties, when the song "Danke Schoen" came out, Kim Tani dated a very young Wayne Newton. They had a friendship romance? In the motel room for almost three months, only held hands, occasionally smooching. We started to hang around PJs after-hours nightclubs. Jayne Mansfield would be often seen there. She came in tired one night and did not look her best. She had uncombed hair and her legs needed shaving. Triny Lopez was always there. Gig Young sent me a love note written on a PJ napkin, which I did not keep.

Holidays and birthdays we always celebrated with a small party in the upstairs dressing rooms, along with presents and a cake. Christmas was the best. We put the Christmas tree up in November and started to collect presents to put under the tree already at the end of November. By Christmas, we could hardly move around. The Body Shop had an upstairs and a downstairs dressing room, which was next to the stage.

The upstairs one had two separate rooms.

The 1960s being on the cover of KEY magazine was a big deal. This was the most published Los Angeles magazine of nightlife entertainment. That same year I broke out with German measles in the dressing room.

I thought the girls were playing a joke on me, I was clueless that there was really GERMAN measles, after all, I knew, I was German, haha. I was rushed to Kaiser Hospital, and placed in isolation for a few days at home and mostly in a dark room before I could come back to work.

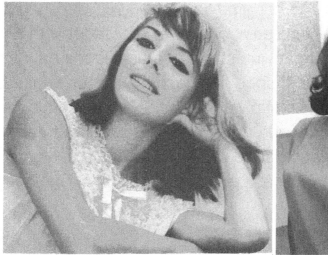

My newly streaked hair

One Sunday morning some of our Body Shop gang decided to go to POP "PacificOceanPark", Angel and live-in boyfriend Joey Giambra. our bartender, Sharon Carr, and I wanted to go on the Helicopter ride, but I chickened out. Just the thought of it made me nauseous.

I worked 6 days every year in smoke-filled nightclubs. Most nights were often filled with celebrities. One was Michael Welding, Elizabeth Taylor`s ex-husband. He would sit often in the front row, in the same seat, and would look at me and always smile. I was never able to meet him.

Najila, a newcomer, was a snake charmer. She kept poisonous reptiles in the downstairs dressing room and would show me her Gila Monster. She was married and had a child, but fell in love with a teenage boy, much younger than her. This was a no no, unacceptable. She got a divorce. When that did not work, she tried suicide but was saved in the hospital. Don`t know what happened to her afterward.

One night between shows, I pulled a joke on Angel Carter with a phony tarantula spider, which I dangled in front of her face. It scared her so bad that she jumped off her chair, tripped, and landed with her vagina on the rim of the wastebasket. Of course, she was naked. It made a cut on a large vein that had split her clitoris wide open, and blood squirted everywhere. We grabbed some towels and had to call an ambulance to stop the bleeding, which took her to Kaiser Permanente Hospital. She needed several stitches.

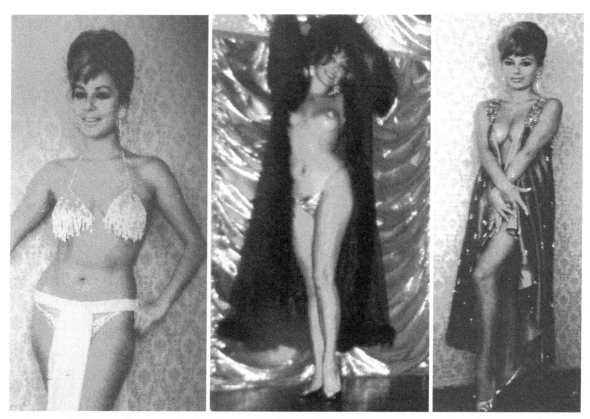

Snapshots at the Body Shop, backstage, and on stage.

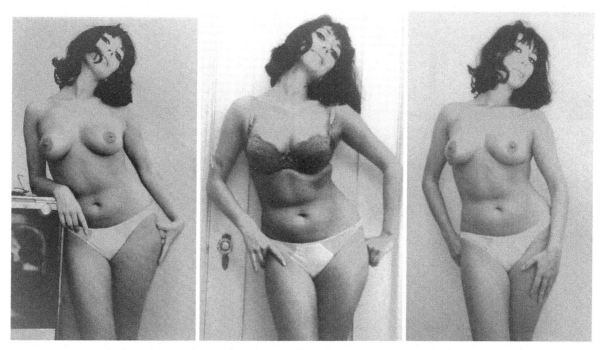

In 1964 I changed my hair color, back to the dark, cut it shoulder length, and had a totally new look.

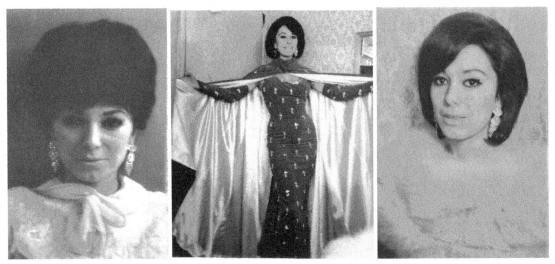

This dress-gown I made with bloody-red velvet material set off with white strung pearls, topped with a large rhinestone, and gauntlets to match.
The cape was the same material, lined in white satin.
It is currently in the Burlesque Hall of Fame museum.

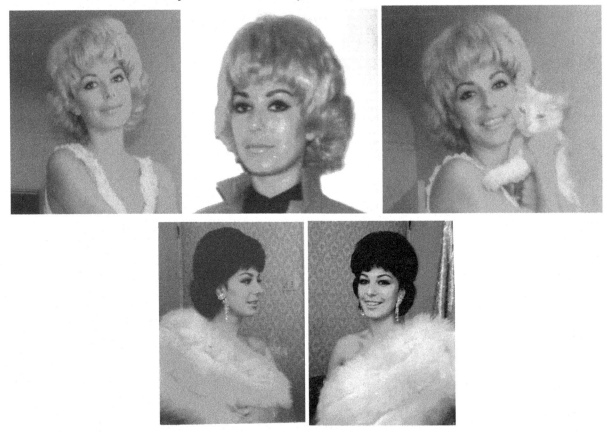

Two new wigs, a brunette, and one blonde.

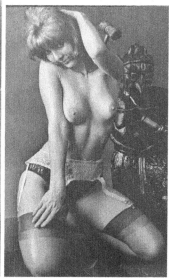

At Norm's coffee shop-my Blackie, who had seven claws-Abby Leigh

Between shows, I would go many times to Norms coffee shop, for a cup of coffee. I did not drink alcohol, nor did I take or do any drugs, coffee was my main drink. Shecky Green was a steady patron at Norm's. He was vulgar so I tried to avoid him whenever he would come in.

In 1964 I met my second husband, while I was still legally married to Bob who worked in Chicago with his brothers building nightclubs. They were known in Chicago as the Greenberg brothers.

Abby Leigh, one of our dancers and I were friends for several years, at work and in the daytime, including working on "Not Tonight Henry". She also appeared in many magazines, including covers, and most of all she was a very "clean-cut" person. In the mid-1965 Abby had a horrific car accident, where she was thrown out of her car, and the car landed on top of her, thus squashing her totally. Her funeral had an open casket. They did a terrible job on Abby. We all felt hurt and our dressing room was somber for days.

Next left: From the 25 cents photo booth, Abby and I. Right: My newspaper clip of her deadly accident.

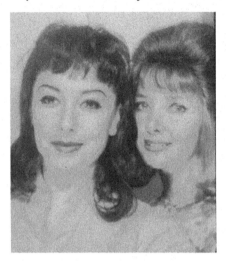 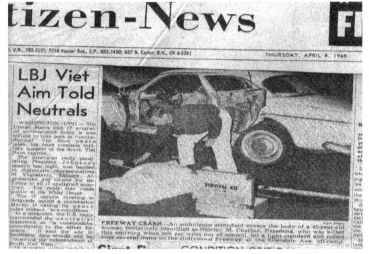

1965 brought a lot of changes to California. Tura was long gone, but her sister Kimmie stayed on. A new crew of dancers arrived: Angel Ray, Sandy Chase, Susie Wrong, Tonette, and R-Wanda, the first black dancer at the Body Shop. She was not well received by the audience but most people were polite and accepted her. We dancers, however, had a good time with R-Wanda and got along great.

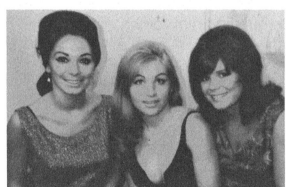 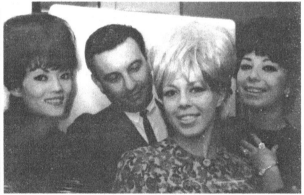

Me, Tonette, Sandy Chase- Kim Tani, Herb Eden, Paula Di Angelo, me

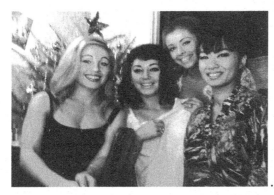 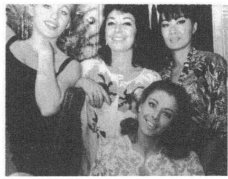

Tonette, Delilah, Susie Wrong, Angel Ray

Angel Ray and I became close friends, and towards the end of the 60s, she became my neighbor, when she bought the house next to mine. I also worked with her at "The Other Ball" and did GoGo for lunch and then back at night at the Body Shop. It did pay well and we got tipped.

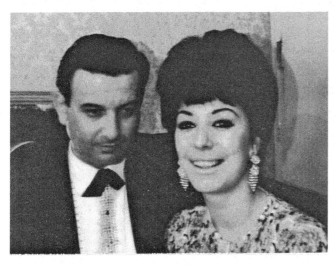

Herb and I.
When Herb Eden opened the Body Shop, we became close friends and almost had an affair, but we laughed it off. We both were married at the time and stayed friends until his death. In 1965 Herb went to Caesar's in Las Vegas. Jack Valentine took over, even though Jack was still fighting his cancer, and was still spitting up blood in the dressing room. He passed away within a short time. Herb's downfall was Las Vegas. He gambled all his salary and owed weeks of pay. He was booked for a while into Reno to pay off his debts.

Snapshot with some of the newsies. Angel and I, center.

Our special attraction at the Body Shop for one week was Gentle Ben, known for his TV show "Gentle Ben" with Clinton Howard, Ron Howard's younger brother. Gentle Ben`s name was "Bruno", a bear actor. He was a North American Black Bear male. 1962-1981

next: Sandy and I on Sunset Blvd hand-feeding sugar cubes to celebrity bear "Gentle Ben".

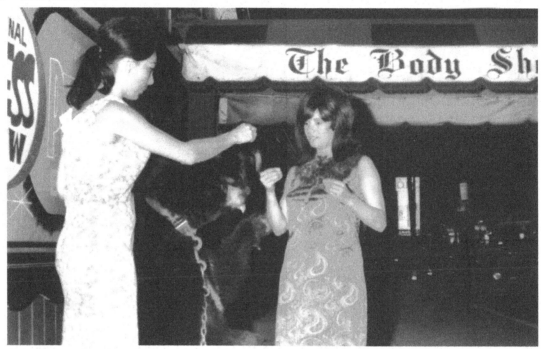

TONY DI BARTOLO-MEW, television, stage and screen actor, has been appointed sales representative with the Forest E. Olson, Inc., Toluca Lake realty office at 4400 Riverside Drive.

I moved in with Tony while Bob, my husband, got our divorce. It was clean-cut without any problems. I never asked for any money, support, or whatever, I was always independent. Bob and I stayed friends until he died when he was in his forties. As every era has its own bad habits, the 50s, and the 60s were, taking sleeping pills, and going out night clubbing drinking alcohol. I believed that killed Bob. Rumor was that Marilyn Monroe had the same problem. Doctors would give out prescriptions for 100s at a time.

Tony was a northern green-eyed Italian Hollywood actor. He had ash blonde hair, stood 6`1 and was a one-time roommate with Aaron Spelling and Carolyn Jones.

In the mid-sixties, someone accidentally tripped me with a chair leg as I walked from the public bathroom to the dressing room. I was wearing open-toed shoes and my little toe went between the chair's legs. I experienced one of the worst pains ever, for a short time, then nothing. I ran fast into the dressing room thinking I was bleeding like mad, but when I looked down, there was not a drop of blood. I checked my toe and it was gone. I panicked and nearly passed out. It was dangling in the skin under my foot. I was taken to Kaiser's hospital where I was injected with two extremely painful needles. One for pain, the other for infection. Now my toe was reset and taped to my other toe. It was a good solid even break. I had to take six weeks off from dancing, and I could not wear any shoes.

I called Jennie Lee, who has been a friend of mine since my pin-up modeling days and told her what happened. She had just formed AGVA, a union that covered strippers. She got me $50.00 per week until I went back to work. My salary at the time was $120.00 per week. I took advantage of it and visited my mother in Palm Springs with Tony. Living a clean healthy daily life, while recuperating.

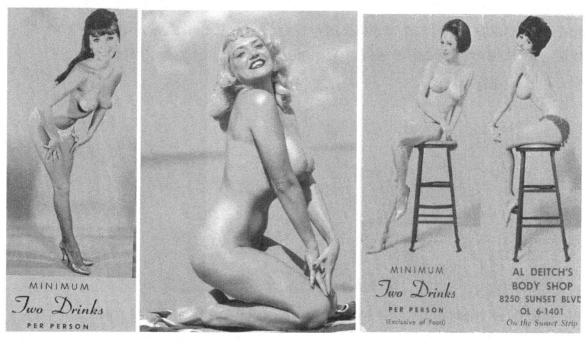

Souvenir table cards - My postcard of Jennie Lee - Angel and I

My sister Margo became a stewardess for Continental Airlines.

She met Stirling Silliphant, while on a flight. He was known for his TV series Route 66. When my sister and Stirling decided to get married, they took my sister Gisela and me along to San Francisco for their marriage.

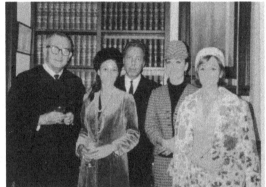

San Francisco City Hall, with a Jewish minister, my sister Margo and Stirling, me, and my other sister Gisela, the fashion designer.

 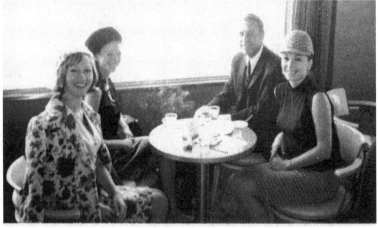

With my now-married sister Margo on Nob Hill in the Hotel room.
Right: At Fisherman's Wharf for dinner. The trip was high-class all the way.

We drove and took Pacific Coast highway, and stayed overnight in Carmel, and drove along the Pacific Ocean, the most wonderful scenery. Gisela created all our clothes.

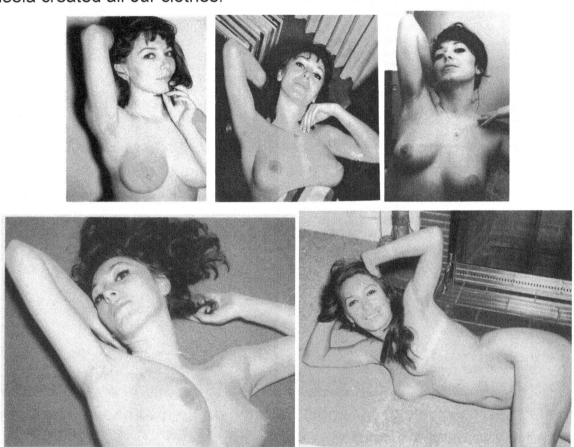

Back home, a few snapshots. Tony loved taking photos of me.

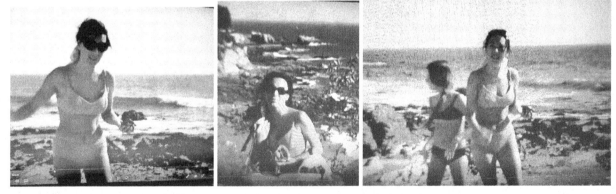

Newport Beach, with my niece Valerie, keeps my life simple and healthy.

I loved the California beaches, and the horizon, to see the end of the world. At Night, I was glamorous. I was Doris in the daytime and Delilah at night.

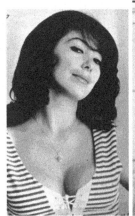

some snapshots backstage in the upstairs dressing room

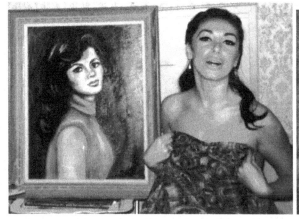

I painted several paintings for Angel Carter, here are two above. The flash blocked out some of the painting

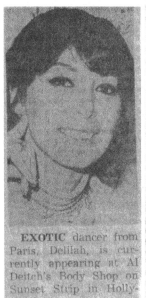

EXOTIC dancer from Paris, Delilah, is currently appearing at Al Deitch's Body Shop on Sunset Strip in Hollywood.

DELILAH is one of eight beauties at Al Deitch's Body Shop on Sunset Strip, who entertain nightly in continuous burlesque show, featuring Jack Valentine, Najila, Angel Carter, and Electra.

EXOTIC DANCER—Al Deitch's Body Shop features exotic dancer Delilah along with a cast of seven beautiful dancers every night from 6 o'clock until 2 a.m. Wednesdays and Sundays, amateurs are presented in prize-winning contests which include paid engagements at the Sunset Strip nightery.

Some ads by a photographer, taken in the dressing room.

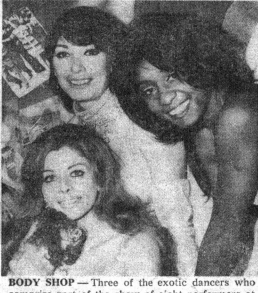

BODY SHOP — Three of the exotic dancers who comprise part of the show of eight performers at the Sunset Strip burlesque club are (l to r) Delilah, Simi Nome and Angel Ray.

With Angel Ray and Simi Nome, our second black stripper, original photo

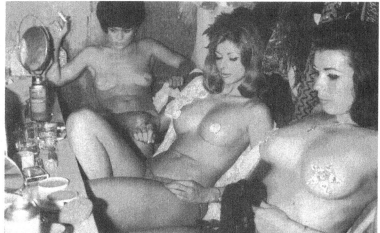

Angel Ray and Angel Carter are in the downstairs dressing room, along with another dancer, and Angel Ray on stage. That silicone did miracles.

Going forward, Jack Valentine was at the Pink Pussycat before he came to the Body Shop, where he lost his battle with cancer. This was the last photo ever taken of him. I took it with my 8MM camera in the Body Shop kitchen

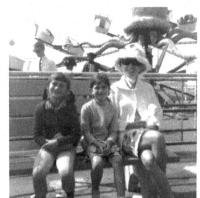

POP, Pacific Ocean Park, playing tourist with my mother, my niece, and my stepdaughter. At the Octopus ride. All this kept my sanity.

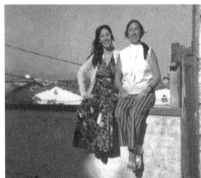 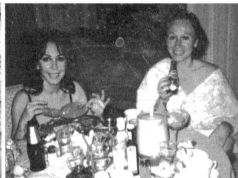

Doing dumb things was always fun. Here with my mother sitting on top of a roof in Hollywood, center: eating lobster with my sister Gisela, in Palm Springs at my mother's home, and on Appian Way my mother living with the Stirlings also, she had two homes now.

At Elke Sommers pool with my mother. Elke`s mom took the photo.

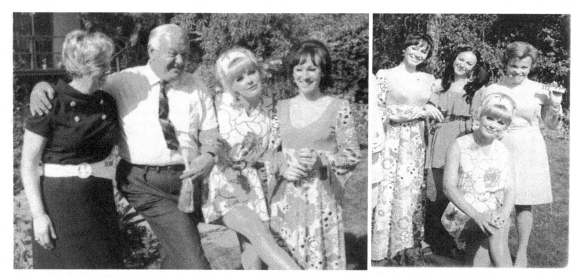

Elke and I had similar backgrounds, from WWII in Germany, and Elke and I are two months apart in age. Elke was married to Joe Hyams at the time. She was a down-to-earth girl, warm and funny. I snapped these photos, therefore I was not in them.

Elke`s mom and friend, and with my sister Margo and Gisela.

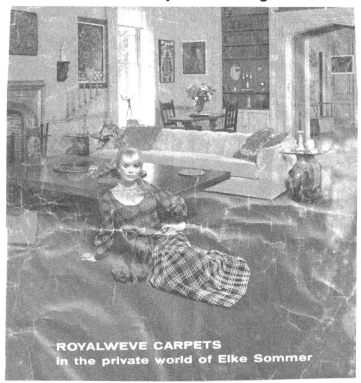

ROYALWEVE CARPETS
in the private world of Elke Sommer

My sister Gisela also made fashions for Elke, which was advertised in Beautiful Home magazine. Here at Elke`s home.

Back at night.

Backstage with Paula DiAngelo and Angel Carter for the International show. My show was "The Liechtensteiner Polka", Angel Carter did an island dance, Paula the American and Kimmie was a Geisha. After that, we had the Monster show. Lana Turner was one of the visitors with Martha Raye. Lana remembered me when we first met at a newscast meeting.

Lana invited me to join her and Martha Ray. She wanted Sharon and me to spend the weekend at her home for a double date, but again, that was Hollywood, very common to ask if someone wanted to party. No one ever was offended. Neither I nor Sharon accepted.

At the "Monster" show opening. I was Lili Monster, too bad I did not take a photo of it. Kimmie was a "Nightmare" I forgot the other ones. Don Corey was our new Sunday MC and comic.

Delila

husband. Tickets can be obtained at all Mutual Agencies. Special attention is given to theatre parties.

SPECIAL EVENTS AT VILLA FRASCATI

Gracious dining, warm hospitality, excellent cuisine and good music are the elements of a perfect evening when seeking just the right restaurant for the occasion. Villa Frascati, 8117 Sunset Blvd., situated at the "door-way" of glamorous Sunset Strip is the perfect choice for the selective diner.

The diversified menu offers the finest in Continental cuisine at popular prices. Celebrities observed recently enjoying the food and music of the Harry Fields Duo were Victor Buono currently presenting his One-Man-Show "Remembrance of Things Past" at the Le Grand Theatre. Also seen were Yvonne de Carlo with a party of friends, and Mr. and Mrs. Cornell Wilde. The younger set was represented by Pat Morrow and Chris

Among stars who attended the opening "monster night" were Lana Turner and Martha Rae.

Don Corey is the comic M.C. on Sundays. Al Deitch presents an amateur hour in conjunction with the regular Sunday show.

In 1965 Sally Rand joined The Body Shop, my table souvenir card.

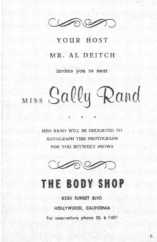

YOUR HOST
MR. AL DEITCH
invites you to meet
MISS *Sally Rand*

MISS RAND WILL BE DELIGHTED TO
AUTOGRAPH THIS PHOTOGRAPH
FOR YOU BETWEEN SHOWS

THE BODY SHOP
8250 SUNSET BLVD.
HOLLYWOOD, CALIFORNIA
For reservations phone OL 6-1401

When Sally arrived and found out that I was asked to move into another dressing room to make room for her, she said " I won't have that, Delilah

you get back in here." so we became instant friends and the two of us shared one dressing room, for the time being. One day she stood bent over in the nude, touching her toes, looking through her legs into our floor-length mirror, and said "Delilah, do you know, that the ugliest thing in the world is what I'm looking at right now." We laughed so hard. Her sense of humor was tremendous. She always proudly carried a photo of her parents, when they were in the nineties, still holding hands. We got along so great that she wanted to show me how to use her fans, just in case I wanted to use them in my shows. She showed me how to hold and move them. It is all in the wrist. Then she asked me to go on stage with Sharon, as a backup dancer. We did, and with a lot of pride, while Sally was in front of us.

Jeffrey Hunter, The actor in "King of Kings", visited Sally in the dressing room, while we dancers stayed topless. He never once looked at any of us, only came to see Sally, because his mother was fond of her. Jeffrey was quite buzzed, his eyes were bloodshot, but he had a glow in his eyes while talking with Sally.

Dwayne and Sally, Jeffrey Hunter, my publicity photo of him, and Bette Rowland with Hal, our horny hands-on drummer, but we all loved him.

Bette Rowland opened at the Body Shop after Sally closed. We also got along great and had lots of fun. For some reason, Bette was always grinning, maybe it was the wine???

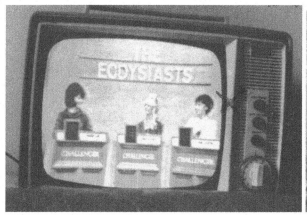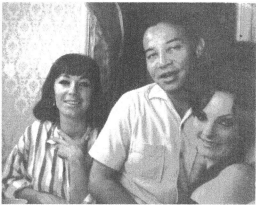

The Red Rowe show "The Ecdysiasts" contest, with Sharon Carr, Babette Bardot center, and me on the right. Top right: Dwayne, Sharon Carr, and I.

In 1965 Hollywood had changed tremendously. Vietnam brought hostility. Life as we knew it became uncertain, especially the burlesque business. The live music with the bands went out, and it was replaced with taped music, no more pasties and no more panties, just a teeny g-string. Hollywood was wide open now, a demonstration on Sunset Blvd against the Vietnam War, was led by Peter Fonda. His Father, Henry Fonda, was embarrassed by his childish behavior in politics. Someone blessed me with a raw egg, which was thrown into my chest while I was watching the demonstration, in front of the Body Shop.

Angel Carter dated Willy Davis, the pro baseball player.

Tiffany Carter (no relation) married Willy Davis's brother Tom Davis, and they have a child.

THURS FEB. 23, 1967 HERALD EXAMINER

Ballot Box Revue Draws Returns at Al Deitch's Body Shop in Hollywood

CLIMB TO FAME — Beauties pose outside Al Deitch's Body Shop on Sunset Blvd. where they appear nightly in entertaining burlesque show. Current attraction features girls in timely "Ballot Box Revue."

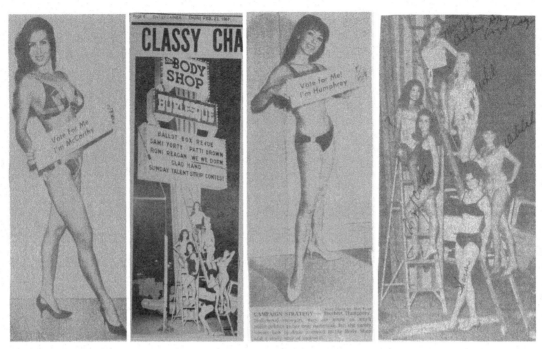

Angel and I are holding up a politician's name. On the ladder, Angel Ray, Paula, myself, Angel Carter, Sharon Carr, and our steady dancers. I was Humphrey and was the skinniest ever in my life, 114 pounds because I went on a low Carbohydrate diet. Not only did I lose weight, but I also lost my boobs.

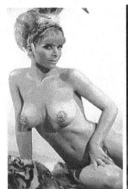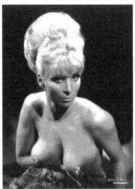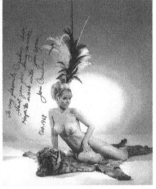

Joni Carson and Angel Carter celebrating her birthday, - Joni Carson. Because the sixties were tumultuous years, so were the people. Drummer Hal Burkus married Jonie Carson but fathered a child with Sharon Carr while married to Joni. When Sharon gave birth to a boy, she handed him over to Joni and Hal, so that the boy would be raised in a family home. Then Sharon tried to commit suicide, but Hal and I felt that something was wrong when she did not show up for work. Hal and I then went to Sharon's apartment and found her unconscious, called the ambulance, thus saving

her life. She had dolled herself up before she laid herself on the bed, showing that she meant it because she wanted to be a pretty corpse.

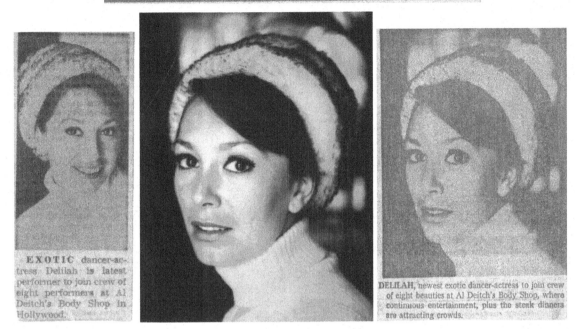

More ads. Al Deitch always made sure that I was in the newspapers.

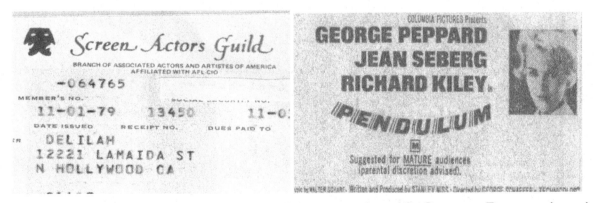

In 1967 I got a part in the Pendulum movie with George Peppard and therefore got my Screen Actor Guild card.
Peppard was obnoxiously intoxicated while on the set. He tried to show me HOW to kiss the boy that I had a kissing scene with. REALLY, I thought!.
He was a bit on the grabby side.
Jean Seberg committed suicide a few years later.

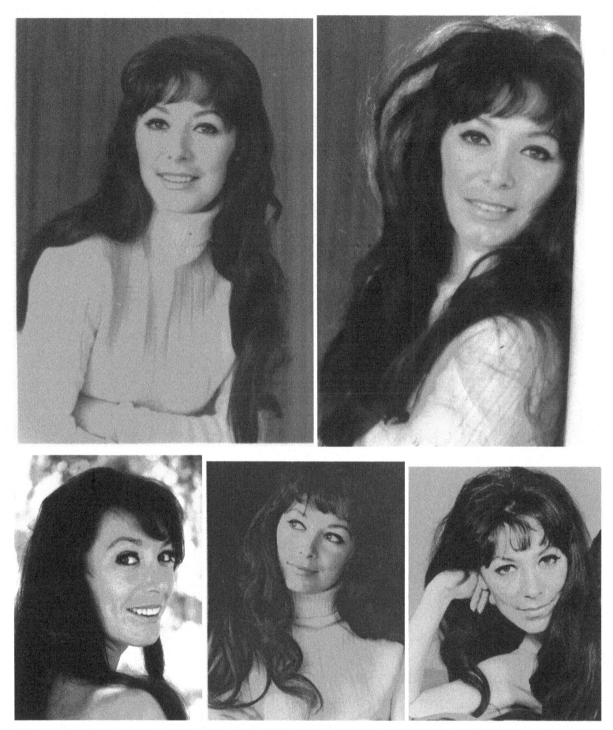

This photoshoot was shot in 1967 for the movie, I used it for my personal advertisement.

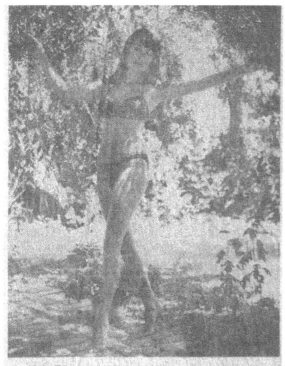

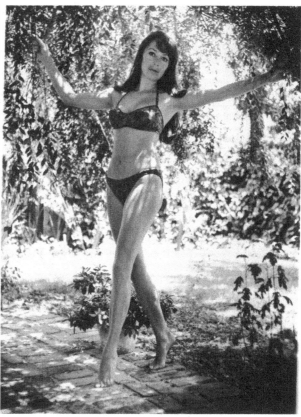

EXOTIC DANCER Delilah along with cast of seven other beauties is featured at Al Deitch's Body Shop nightly. On Wednesdays and Sundays amateurs are presented in prize-winning contests.

advertising for the Body Shop my original

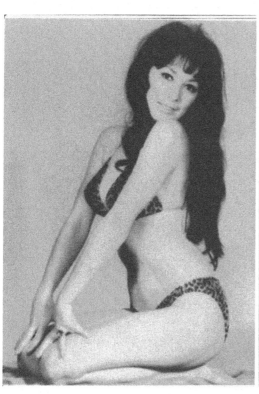

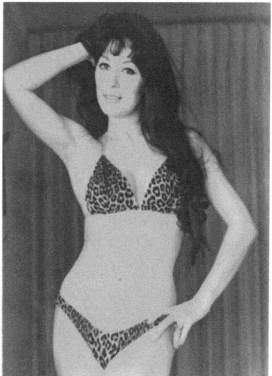

Meet AD-LIB
Pic of the Week
DELILA

IF YOU THINK GERMANY IS ONLY FAMOUS FOR VOLKSWAGONS, YOU'RE WAY OFF BASE PAL. MEET LOVELY DELILA (34—24—34) ONE OF THE FEATURED DANCERS AT AL DEITCH'S FAMOUS BODY SHOP ON SUNSET STRIP.

A PROMISING STARLETT, DRESS DESIGNER AND PORTRAIT ARTIST, THIS BEAUTIFUL FRAU-LEIN WILL GO A LONG WAYS IN HOLLYWOOD. AL DEITCH CLAIMS TO HAVE THE FINEST COLLECTION OF BEAUTIES ON THE WEST COA-ST AND WITH DELILA AS AN EXAMPLE, AD-LIB IS INCLINED TO AGREE.

SEE DELILA, ALONG WITH THE FUN ACTION, SNAKE DANCER NAJILA, COMIC JACK VALENTINE, AND GIRLS GIRLS, GIRLS, GIRLS, AND GIRLS... NIGHTLY AT THE WORLD FAMOUS...

BODY SHOP
HOLLYWOOD'S SEXIEST GARAGE

Original photo Body Shop ad

VALLEY GREEN SHEET
TUESDAY NOVEMBER 5, 1968 Mail Address

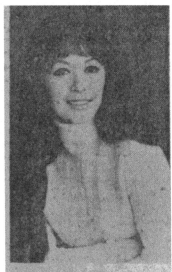

Joe Buena

L.A. AT NIGHT

Al and Rose Deitch, the West's most potent husband and wife entrepreneur team, have combined operations to present the long successful Body Shop and their new Big Al's in an attempt to corner the market with the youngest, most beautiful and sexiest showgirls in the business.

The Body Shop and Big Al's, both on the Sunset Strip, each present seven beauties who offer topless, bottomless or "stark naked" dance performances.

At the Body Shop where Al Deitch headquarters, may be found such luscious dancers as exquisite Angel Carter, delightful Kim Sommers, fascinating Delilah, the queen of the bottomless, Simone, Erika and Madie.

DANCER, Delilah, is one of several top-notch performers appearing nightly at Hollywood's Body Shop.

DELIGHTFUL eyeful, Delilah, appears in burlesque revue currently staging at Al Deitch's Body Shop on Sunset Strip.

72

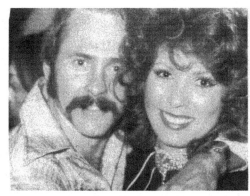 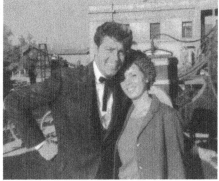

In the late sixties, while Troy had a part in The Virginian, Angel met up with him again on the set, where she met James Drury, and around that time Dale Robertson. Angel had the time of her life. A fling here and there was good for the soul. Doing what we wanted to do was our business, only.

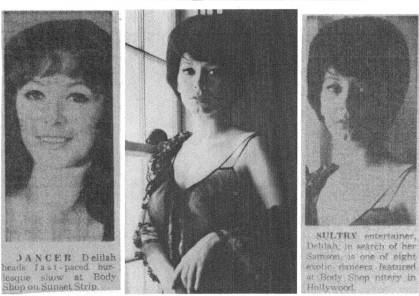

DANCER Delilah heads fast-paced burlesque show at Body Shop on Sunset Strip.

SULTRY entertainer, Delilah, in search of her Samson, is one of eight exotic dancers featured at Body Shop nttery in Hollywood.

My originals and my paper clippings.

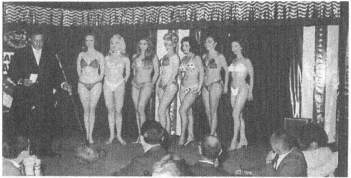

L-MC Sharon Carr, unk, Angel Ray, unk, Angel Carter, Delilah Jones and Nancy Lewis

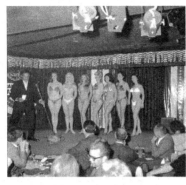 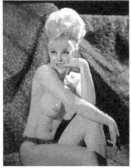 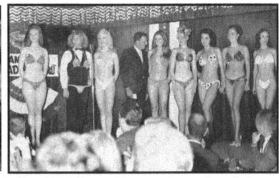

Our sixties line-up my personal photo of Michelle Lee
 SPREE magazine featured this time The Body Shop.
Don Corey was our MC, Angel Ray, Michelle Lee, Angel Carter, Delilah,
and Nancy Lewis. Dwayne was a gay comic and often spent time with his
friend actor Steve Cochran on his boat. They would also have young
females on board. He would tell me many funny stories about what went
on. It never became public. Cochran died on the boat after it caught fire.

Don Corey and I, Don, Barbara, Kim Sommers, Sharon Carr, and me.

 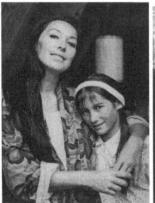

It's always good to have a great daytime life, away from the smoke-filled
bar rooms, which were legal then. Here in Big Bear with my niece Valerie.
Right: In my green crochet dress, that I had just finished, and my own hair.

My sister Gisela's new home was next door to Rosie Grier. I got to meet him, and was asked to crochet Rosie Grier's wife's wedding dress. Sammy Davis lived up the road. I used to "bump" into Sammy many times while driving those winding Hollywood Hill roads.
He always waved at me.

My new husband. I am in a Caesar Palace bed with my Chico.

In September 1966 I got married for the second time, this time in Las Vegas, and honeymooned at the then-unfinished Caesars Palace.
Herb Eden was the comic at Caesars and sent us a bottle of champagne.

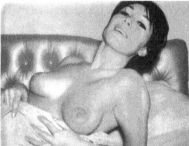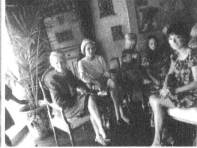

In front of the unfinished Caesars with my Chico, and back home, and my wedding shower from the Hollywood elites. My nighttime friends also gave me a wedding shower. Two separate lifestyles.

The Body Shop kitchen is always busy with celebrities. Some came to visit Al Deitch, others to date some of the girls. Everything was always hushed because most men were married. Dick Martin from the "Laugh-In" TV series, came to see Sharon Carr, he was madly in love with her. Martin

Landau was crazy about Sharon. Angel Carter had a fling with Peter Lupus, (Mission Impossible) who would come into the kitchen and wait for her. No one ever talked.

Sharon and I were asked to have our boobs cast into clay. We did and they were displayed at the Body Shop. I do not know what happened to them. Before I got married, I was living with the Silliphants in the Hollywood Hills. This was a small studio apartment on the bottom floor of the Silliphant`s home, overlooking Los Angeles. It was small but had a kitchen and a bathroom, and a fantastic view.

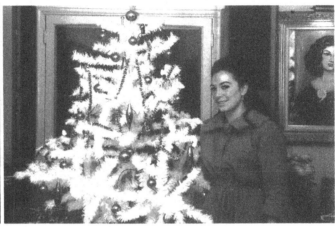

Sitting on top of the world in the Hollywood Hills, and at Christmas
To the right is an oil painting I did. Once married, I moved out, and Stirling's son, Loren, moved in. Not long after, he moved out and my mother moved in. Loren started to hang around bad boys where he got involved with drugs. Shortly after that, he was shot to death. A drug deal gone wrong.

One evening, while I was driving from my home to the Body Shop, I had to stop for six fire engines, thinking, "Boy, the hills must be burning". When I arrived at work, I was told that the Silliphant home was burning. They had an electrical fire while out to dinner. It burned the entire top floor, while my mother was still inside the house. She was not aware of the fire until the neighbors told the firefighters she was still inside the house. As it was in flames one fireman got my mother out safely. Another got bitten by one of our dobermans.

Oscar Winner's Son Slain in Hollywood

(Continued from Page A-1)

Loren, pushed him against the wall and shot him. Robert moved to aid Loren and was threatened by the suspect, who left but said he would come back. When Robert again tried to help Loren, the suspect stuck his head in the door again and said: "I told you not to move."

A witness bolted the door and Robert went out the third story window, climbed to the ground and called police. But someone else already had contacted authorities.

Police, however, said the suspect had pistol-whipped the hippie after taking him outside the apartment. Residents of the area told the pair to leave, and authorities said that the suspect led the hippie back up the elevator and purely by chance picked ___ Silliphant apartment.

LOREN SILLIPHANT
Killed for marijuana?

Oscar Writer's Son, 18, Slain
SHOT IN HOLLYWOOD

Loren E. Silliphant, 18, son of Oscar winning screen writer Sterling Silliphant, was slain today in his Hollywood apartment by a gunman who police theorize was attempting to purchase marijuana.

A single shot to the chest cut down young Silliphant in what police described as a hippy-type pad at 1784 N. Sycamore Ave., apt. 202. A 46-year-old man was once in the same building by ___ young roommate two months ___, police said. A party of ___ about 25 persons continued unin___ in another apartment ___ as homicide detectives investigated the slaying.

Silliphant was entertaining ___ guests in his apartment ___ including his uncle, Robert Silli___, Jr., of 1219 E. California ___

Ave., Glendale, when there was a knock at the door.

Police said the stranger asked those in the apartment for some "stuff."

When told there was none there, he backed the victim against a wall and shot him with a 22-caliber pistol killing Silliphant instantly. He then told the others to remain still.

___ but the others went to Silliphant's aid and as they turned him over, the gunman pointed the gun at them stating:

"I thought I told you not to move."

He then strolled out of the apartment.

Police described the gunman as Negro, about 5-feet 10-inches tall, short hair and wearing a pencil thin moustache.

A source close to the Silliphant family gave this account of the slaying:

Robert encountered the suspect in the hallway prior to the crime and was stopped by the Negro, who said: "I want the dope." "I want the dope," and, according to the uncle of the victim, seemed irrational and incoherent.

To get rid of the suspect, Robert pointed to a young man in the hallway and said: "That's who you want." Robert, who had just left his nephew's

apartment, then went on down the hall to another apartment to see two girls who were having a party.

When he returned to his nephew's apartment about 20 minutes later, the suspect was there with the young man who had been in the hallway. The 18-year-old hippy had a bloody face and later said that the suspect had pistol-whipped him.

Robert then took Loren into the bathroom and warned him that the suspect was dangerous. They agreed to ask him to leave, and when they returned to the living room, Robert said to the suspect: "Come on outside—I want to talk to you."

The suspect then turned o ___ (Continued on Page A-1, Col. 1)

Loren`s newspaper clippings.

News of the Day
WEDNESDAY, FEBRUARY 5, 1969 Compiled From the Los Angeles Times, the Los Angeles Times—Washington Post News Service

Writer Stirling Silliphant's home in the Hollywood Hills was seriously damaged by a fire that started in the attic of the large house at 8954 Appian Way. Silliphant and his wife were attending a party at the time. Damage to the house was estimated at $30,000 by firemen.

Rumor has it that the house was haunted by Errol Flynn, who used to live there. Before the fire, Liza Jourdan and Angel Carter and I would sometimes sunbathe in the nude at the pool. One day we got surprised, when Cliff Robertson walked in on us, while we were nude sunbathing.
He was working with Stirling on the movie "Charly".
That same year Stirling threw one of the biggest Hollywood elite parties, to celebrate his movie "A Walk in the Spring Rain" with Ingrid Bergman and Anthony Quinn.

BUT THE PARTY TOSSED BY STIRLING SILLIPHANT and wife Margo for his "Walk in the Spring Rain" stars Ingrid Bergman & Tony Quinn was the swinger of the weekend, and it may still be swinging for all I know. . . . It was quite unique munching Cantonese hors d'ouvres and listening to a Mexican mariachi band while everybody got grogged on Navy Grog. . . . When a rock band took over to kill the conversation, virtually everyone took to the dance floor as Tony Quinn took off his jacket to wiggle the wildest and jump the highest with his Yolanda. . . . Others shaking it up pretty good were Hugh O'Brian & Pia Lindstrom, the Bob Weitmans, the Henry Bergers (Anita Louise) Cliff Robertson, Jack Benny, the Freddie Fields (Polly Bergen), Hank & Shirley Fonda, the Herb Greenes (Carolyn Jones), Pat & Rick Jason, the Quincy Joneses Mary & Alan Courtney, Estelle & Bob Enders, Goldie Hawn with hubby Gus Trikonis, Candy & Hal March, the Alex Tuckers & the Charles Langs. . . . Guests were still arriving when we left after midnight Saturday. Word about that Navy Grog musta got around. . . .

Anthony Quinn and sister Margo, Goldie Hawn and Carolyn Jones

My sister, Cliff, Henry Fonda and Stirling-Hugh O`Brian,
Cliff Robertson, Ingrid Bergman.

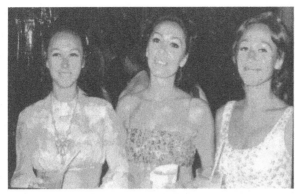 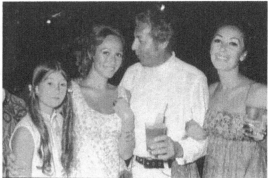

The three of us sisters my niece, my sister Gisela, Stirling, and I

Hugh O'Brian with my niece Valerie. Me with my new husband Tony.

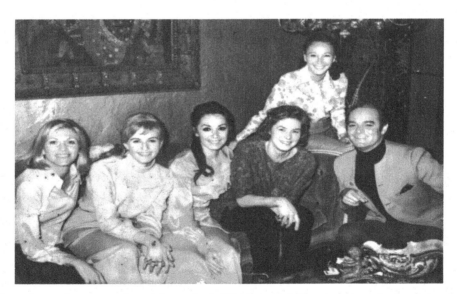

The following day, we had lunch with Ingrid Bergman, her daughter Pia Lindström, an actress and journalist, and my sister Margo at her home. The year before I had bought my first home in the San Fernando Valley. Across from me lived Peggy Lennon, one of the Lennon sisters from the Lawrence Welk show. Kitty-corner-lived Marty Engalls, who later married Shirley Jones. It was a nice neighborhood. Marty was best known for his

commercial "Parkay - Butter". Down the street was where Caprice was working in a Beauty Shop after she retired from stripping. Life was good.

My new home, my Samson, a white shepherd

During the sixties, I traded in my 1962 T-bird, for a new Mustang, which I kept for a short time then I bought a green 1965 Jaguar sedan. I had everything I ever dreamt of, and felt like I was living the American dream. I owned my new home and was so in love with my husband. I also started to collect antiques and most of all, many animals. I do not remember how I accumulated all my cats and dogs, as I have never bought any, except for Samson. My home was complete, and my nightlife was as exciting. I lived two different lives at the same time and I loved both of them.

My 1962 T-bird and holding Purtzel. My 1960s Mustang, Tony, and I.

My 1965 Jaguar in front of my home, and with my mother under the tulip tree. Al Deitch gave me a special parking place at work, to prevent any damage to my cars.

Then Stirling Silliphant won an Oscar as a screenwriter for "In the Heat of the Night". After the Fire, the Sillipants rented Rory Calhoun's house for six months, while Rory was going through a divorce from Lita Baron, and the Silliphant house was being built. Lita would come during this time and take some "stuff" out of the home, which she was not supposed to because Stirling would have to pay for any missing items. Everything was on file. The house gave me a feeling that Zorro would appear any minute, it was all in Spanish. I enjoyed the lagoon swimming pool.

The Lagoon backyard front of Calhoun's home

Stirling became one of the top writers. His movies The Slender Thread, Naked City, Towering Inferno, Charly, Long Street, and Village of the Damned. Then he worked on three more movies for MGM Studios. Stirling set up a blind date for me and William Shatner, but he was too intoxicated to show up.

We also had lunch with Sydney Poitier several times at the Lobster Barrel on La Cienega Blvd owned by Alan Hale. Alan Hale was there to greet us most of the time.

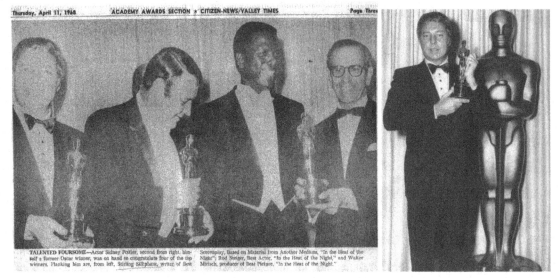

Oscar night, Stirling, Rod Steiger, Sydney Poitier, and producer. Actress Donna Reed sat next to me during the premiere.

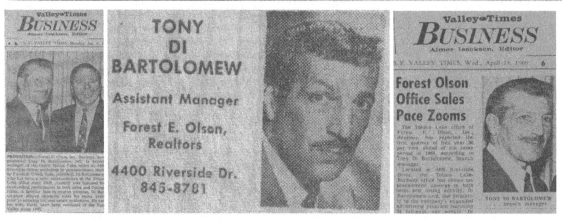

Write-up for my husband's success in real estate.

Nearing the end of the sixties, Tony was doing great in real estate with Forrest E. Olson. He became a branch manager and later on, he went on his own, as a realtor and broker.

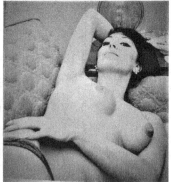

Just snapshots at my once happy home

Sometime in the later sixties, Haji would join, after she had finished the movie "Faster Pussycat" with Tura Satana. I made some wardrobe for her and had to fit her in her most private parts. We got to know one another, fast. She preferred her costume in multiple colors of chiffons. Her breasts were natural and large that she would keep hidden. She used my costume for another movie, "The Killing of a Chinese Bookie". I never saw her nude in the dressing room, unlike the rest of us. We met again in 2012 and 2013 at the Orleans for the Burlesque Legends reunion and yakked away.

She passed away in 2013 in Santa Barbara, from a sudden heart attack.

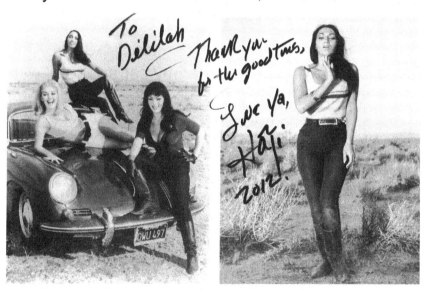

Faster,
PUSSYCAT!
KILL! KILL!

HAJI

November 8, 1969 During my break between shows, while walking on a sidewalk on Sunset Boulevard, I got hit by a drunk driver. The girls at the Body Shop went hysterical because they thought I was dead. I had no pulse when the ambulance arrived. I was out cold. The drunk hit the fire hydrant, water shut straight into the air, with heavy rain that night, the fire

department, several police units, and the water department were all at the scene. I missed it all. Kim Sommers had to cover my show. The car fender had picked me up between my legs and threw me against the street light pole. I hit my head against the pole and lost my hearing on the left side. It also caused amnesia for a while. From my neck and most of the back of my body was black and blue. I was now fighting for my life. Through months of meditation and willpower, I helped myself back to health after doctors failed me.

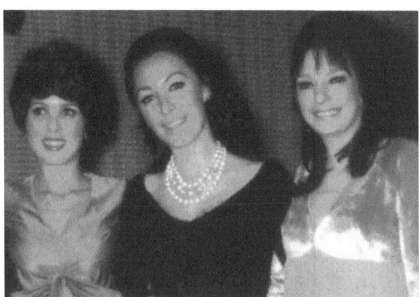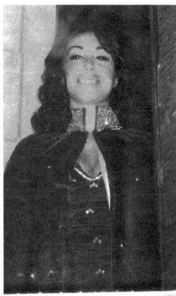

1969 New Year's Eve, my first photo after my car accident, with Angel and Kim Sommers, in the upstairs dressing room. I wore my newly-made moss green, velvet gown, matching gauntlets, and a cape with white satin lining, adorned with white strung teardrop pearls. and topped with large rhinestones, to give it extra shine. I felt reborn.

In February 1970 because of the accident, I had inner ear surgery (in the same hospital where Bobby Kennedy was), and shortly after went back to work. Two weeks later I appeared in another movie, and I was clueless about the name, or if I was topless, my brain was still foggy. I do remember that I was a harem girl and I appeared in a dream of the leading man. I was supposed to be rolling out of bed with him after he awakened from his dream with a teddy bear in his arms. It was done very cautiously because I told the producer and actor about my surgery.

Next page: Another Al Deitch Birthday Party. Left, Angel Carter with an actor, Al, and me. Right: Al Deitch, me, and Sam, the bagel man, who owned a bagel shop in Hollywood. He was in a German Nazi camp, where he got a number tattooed on his arm.84

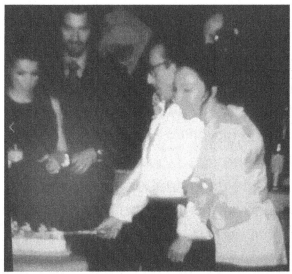 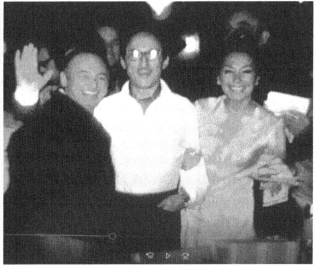

Matt Cimber, Jayne Mansfield's last husband, visited Al in the kitchen on occasion, they were friends. After her death, he visited one time with his and Jayne's child. Al had many friends and was liked or loved by many. He was one of the few club owners, not mafia connected. Cops also hung around in the kitchen and were very sociable.

One time Angel Carter got drunk and got into a fight with a cop in the kitchen, where she threw a glass ashtray at him. The cop did not arrest her and passed it off as just being drunk. At that time I was clueless that Angel had a violent alcohol problem that she eventually overcame many years later through AA meetings. Many times, when she would get violent, she would not remember anything the next morning.

Once I felt strong again, I moved around again
My first stop was the Pink Pussycat

Early ads of the Pink Pussycat and the latest ad

85

Pink Pussycat, owned by Alice Shillers and her husband. She was madam-like, while he was a big flirt with the girls, but we loved both of them. I signed up for a week. Tura Satana was already working there, so we shared the same dressing room and just yakked away. Another new dancer used lotion during her show. That was usually a huge no-no. In one of her shows, she slipped off the prop when she used too much slippery stuff. I let out a short loud laugh and that made us instant enemies. Her name was Alice, aka Alexis, a Jewish spoiled "princess", she complained to the owner about me, but that was as far as it went.

Jack Valentine worked the Pussycat for a few years, while he was terminally ill with stomach cancer. He was spitting up blood every night into a wastebasket. He was also a great "western" singer and would sing "Tumbling Tumbleweeds", nightly. Jack had a sense of humor and would also sing: "When you bend down and touch your toes, I'll show you where the wild goose goes".

Jackie Gayle was our comic. Jackie liked me and we became friends. In 1972 we reconnected in Las Vegas when he opened the shows for Frank Sinatra and Tony Bennett. He invited me backstage. One night Marlon Brando visited the club with his entourage, still wearing his ponytail from when he was filming "Mutiny on the Bounty". I sat for a brief moment at his table, just to say hello.

Then I went back to be with Al Deitsch at the Body Shop. 1970 was the beginning of road travel. My first away from home was in Oxnard, Ventura County, California. "The Flapper" was my first out-of-town engagement. It was a low-dive beer joint, not a burlesque nightclub, but they paid well and that is what it is all about. Most small clubs or small towns paid good money. The Flapper was mainly Mexican labor workers, they would get drunk and vomit, and no one would come to clean it up. Disappointed as I was, I was looking forward to my next gig, which was in Bakersfield, California, also for one week. The club was a honky tonk western kind of place, so different from the Hollywood clubs. I was glad that I got to work with the tallest stripper in the business named Ricki Covette. We liked each other and would meet for lunch at the coffee shop daily. She surprised me one day, during lunch when her blouse and boobs started to move, and all of a sudden a little head popped out of her boobs. It was her little Chihuahua named Coco. She hushed me immediately because no animals were allowed at food places.

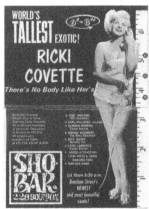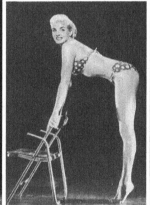

Ricki was compared to a Great Dane, because of her height. Right: me holding Rickie's Coco. Because of Coco, we developed a unique friendship. Our paths would cross again at Jane Briggeman's "Living Legend" reunion at the Imperial Palace in Las Vegas 2003 and another time at the BHoF-Burlesque Hall of Fame, 2013/14 in Las Vegas, at the Orleans. By then she was ailing and confined in a wheelchair. She was always a warm and loving person.

After that, I took off a week and then I was off to Clovis for one week.

Clovis is a small town outside of Fresno. The owner, De Luca, liked me, and let me stay in their home, so I could save hotel money. The club was average with a small stage. All clientele in small towns were simple and common people, nothing glamorous. De Lucas asked me back for the second time, when i had a co-feature. De Luca by then, had a house that they let the dancers stay in for free. I shared it with this new person. She was of Cuban descent and gorgeous. I will never forget her as long as I live, because I was raped by her with a knife pointed at my throat. She was gay, and only liked females. As I was clueless and scared, I gave in. For all the years I would never talk about it until I wrote my books.

In Clovis and holding the De Luca`s pooches, the wife liked me a lot and would take me out to the nearby lake for picnics.

Then came Lompoc, California, the field of flowers, Vandenberg Air force base, where 007 with Sean Connery was filmed. I do not remember the

name of the club, but I do remember that the owner was an ex-service person and his wife was German. The club was small beer bar, but the clientele were mostly service people, well-behaved. The stage was on the ground and the guys were sitting at a round countertop, looking down at me, that was odd

After this week I was back home again and went back to the Body Shop. A birthday party for Al with one of his twin Daughters, Sharon Carr, Barbara, and me.(pictured). After a few weeks at home, I went back to Lompoc, where I met and worked with Diane Love. She was traveling with her boyfriend, with whom she fought continuously. During one nasty fight, I offered her to stay at my motel, which she did. One night after work, we stopped by another club for a nightcap. Her jealous boyfriend followed us and confronted me with a gun pointed directly at me, telling me that I interfered in his life. My heart dropped to the floor. Cops were called, and when they arrived, they only scolded that little punk, did not arrest him or handcuffed him, and then Diane went back to him, so much for helping someone in need.

The next morning at 4 am, my whole room shook like a huge earthquake. A missile was launched at Vandenberg, just a short distance from my motel. I nearly had a heart attack. The whole ground was shaking like a jelly bowl. All I knew was that I would never go back there again. I did, however, manage to get a tour through the inside of Vandenburg, near the launching pad but was not allowed to take pictures, That made it all worthwhile.

Somewhere around that time, my first time away from California, I signed up for a 6-week tour with Angel Rae through Guam, Cambodia, Viet Nam, Saigon, and South Korea. Not sure what other cities were, but it was around the time when Bob Hope's camp was bombed and all trips were canceled. Too bad. I was looking forward to this trip.

I was now looking for ideas about variety shows. I took up classes for belly dancing. This was tough but good for my body. I learned how to do stomach rolls, while laying on the floor, and how to use finger symbols. This was art, a different type of dancing.

While I was at the Body Shop, Al Deitch and I would sit in the kitchen and talk about life when he threw a bomb at me. He was battling Lymphoma

cancer and had a short time to live. I was shocked and could not get a word out, clueless about what to say. I just held his hand until I went back to the dressing room. Shortly after, his cancer went into remission. We kept it a secret for a while.

Alice aka Alexis must have taken a liking to me because she followed me to the Body Shop, from the Pink Pussycat, and wanted to share the dressing room with me. As time went on, we became long-time friends. Getting anxious to travel again, I asked my agent to book me somewhere more exciting and out of California. I now started to get the urge to travel more and more, to go somewhere unknown to me and most of all, I wanted to explore America. These gigs were mostly for one week only, with options. Flights and room and board were mostly paid for.

While I was in the office of Cora Lee Agency, she received a call for an opening for a stripper in Flagstaff Arizona. How thrilling that felt to me. I asked her to give it to me, and she did. I would fly from Burbank Airport, a stop-over in Las Vegas, to the Grand Canyons. I was overwhelmed with excitement. In May 1970 I was on my way to Flagstaff with Frontier Airlines. We flew over the Grand Canyons, while the plane was shaking like a leaf, but the sight was so unbelievably beautiful that nothing mattered, I cannot describe this wonder of this world. Looking beneath at the deep gorges and the sight of enormous green pine trees reaching for the powder blue skies. It would always stay embedded in my mind. This was a dream come true.

When I arrived, Jessy, the manager of the Redwood Inn, a Navajo Indian, picked me up and drove approximately 90 miles to Flagstaff, at 90 miles per hour speed. I was so impressed with this beautiful scenery, and enjoyed the ride, even with the speed. First time away from the smogville of Los Angeles, into the beautiful Arizona vast desert. To see the red desert sand as far as I could see, with the green cacti here and there, and most of all the blue skies, which was rare to me. I only had to supply my food. Most of the time someone would take me out for dinner, lunch, or breakfast.

As soon as I arrived I had a photographer waiting for me to take pictures for the Flagstaff newspaper. And there were plenty of ads in the papers. I was only booked for a week.

My first time in Flagstaff. On stage at the Redwood Inn, and at a deer farm. I opened all the windows at my motel to catch the aroma of the humongous pine trees. Enjoying the almost 7,000 ft. high altitude with fresh air.

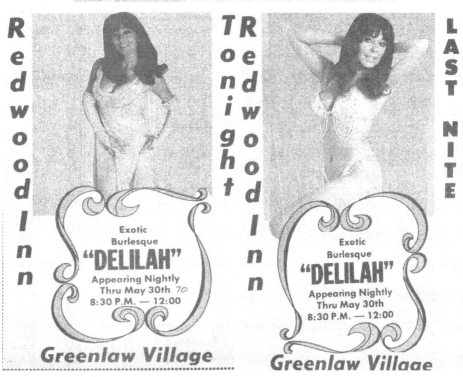

May 30, 1970 The Coconino Sun

Redwood Inn

TONight

Redwood Inn

LAST NITE

Exotic
Burlesque
"DELILAH"
Appearing Nightly
Thru May 30th 70
8:30 P.M. — 12:00

Greenlaw Village

Exotic
Burlesque
"DELILAH"
Appearing Nightly
Thru May 30th
8:30 P.M. — 12:00

Greenlaw Village

My opening night and my closing night

My opening as the first stripper in Flagstaff, was the talk of the town because they only had Go Go dancers before me. It packed the club nightly. In July 1970 I was asked to come back

The Coconino Sun The SUN, Flagstaff, Arizona Friday, July 3, 1970

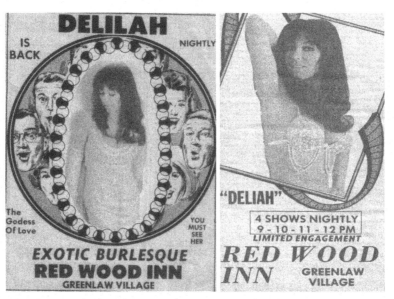

The second time, I was placed in a huge three-bedroom trailer with another entertainer, a male roommate, and his wife with 2 cats. It was Rubberlegs, our new comic act dancer as a drunk. We got along great, and we also became lifelong friends. It was here that I was introduced to peanut butter and strawberry jam sandwiches. Most of the patrons at the Redwood Inn were locals and never out of line, just happy and noisy. My boss, Jack Grant, added more attractions because of the success. The stage was a good size and very classy for Flagstaff which was a small town.

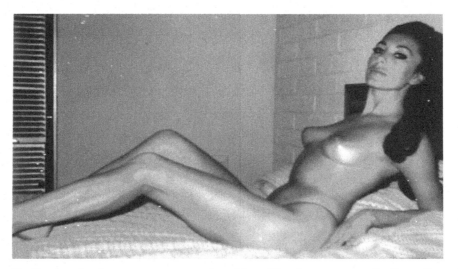

During my first week, I was approached by Dodge, a realistic oil painter. He took Polaroid photos of me and then used them for oil paintings.

In return, he painted one for me. Dodge then painted several more oil paintings to be hung in the Redwood Inn, all in my likeness, only with different hairdos and colors.

Our next attraction was Christine Jorgenson, a nightclub singer. She was the first American trans woman who became worldwide known for her complete sex change. She was a kind and friendly person, elegant and ladylike. We had some nice conversations about her transformation, and she was very open about it. She knew that I was seriously interested in her surgery. Christine had the surgery in Denmark in 1952. She passed away in 1989 from bladder and lung cancer.

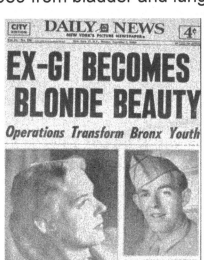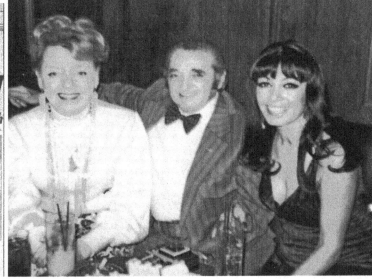

My paper clip, Christine Jorgenson with her manager and me.

At the Rodeo my motel the POW WOW the rodeo

My boss Jack Grant held me over for another two weeks and put me downtown, in a very old, but interesting unique Hotel, the Monte Vista. From there I was now able to see my first authentic Indian Pow Wow festival, which was only a few blocks away from me. It was filled with Navajos, Apaches, Zunis, Sioux, Blackfeet, and other tribes. I also visited the authentic Indian Historical Museum, and I was present at all Rodeos. Dressed in Hollywood style, I was eyed wherever I went. It helps in a way to advertise me for the Redwood Inn. As soon as I finished Flagstaff, I went home and waited for my next adventure. This was exciting, going places, having a good time, and getting paid for it. I went back to work for Al Deitch until my next gig. Al was always understanding whenever I wanted to leave or come back. He understood.

At the end of the summer of 1970, I was booked for one week into Albuquerque, New Mexico, at the Club Duke's Cave. I flew out of Burbank airport again to Albuquerque with a direct flight. When I arrived, I was picked up by someone, who took me to my hotel. I was registered in a really old historical huge corner hotel on Main St. If I remember correctly, it was called Aztec Hotel. When I entered the lobby, I saw Swastikas painted all around the ceilings and walls of the lobby. It felt like I was back in Nazi Germany. A cold chill went through my body. Shortly after I was reassured that these are old Indian icons. Now I know that the Swastikas originated from the American Indians, and where Hitler got his ideas, only he turned them around to face the other direction. and his salutes, just like the Indian Chief would do "how" ~ with a hand up in the air.

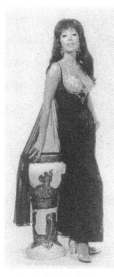 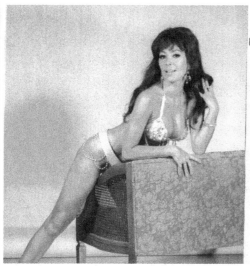 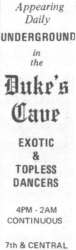 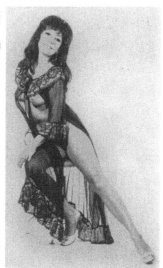

Advertising pamphlet flyers for Duke's Cave were handed out for free.

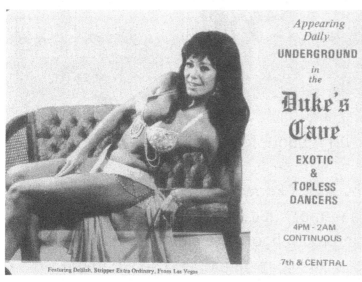 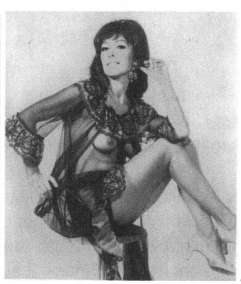

Opening night was a hit, I also was the first stripper in Albuquerque. Again, I was asked to come in a little earlier so I can meet their professional photographer for Duke's Cave ads. I was glad about that and got many new photos from that shoot and some fliers.

While in Albuquerque I got the chance to go sightseeing, the best part of traveling. Here on top of Sandia Crest, nearly 14,000 ft, where I had to take the tram and sit on a bench in Old town Albuquerque. Little did I know then, that I would sit on the same bench again, forty years later. Who knew? I also got to see Santa Fe and Las Vegas, New Mexico.

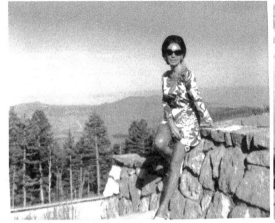
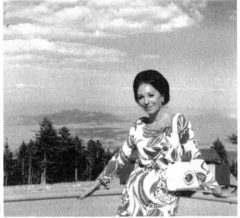

Sandia Crest

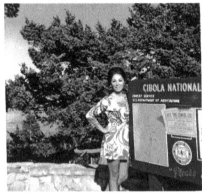

1970 Sandia Crest and Old Town Albuquerque 40 years later in 2013

On opening night, I was asked by a well-known TV show host to be on his TV show. I cannot remember his name, but it was Irish. He was sitting in the front row, on the cellar dancing room floor. The club was underground, therefore the CAVE name, I accepted his invitation, and so we made arrangements for the next morning's show. I had a five-minute spot on the show, but it went into the whole hour with him. We became sexually attracted to each other, with mutual admiration. Eventually, I would have a brief and wild exciting affair with him. Somehow I had no remorse that I was unfaithful, after all, that is what I wanted to do at that moment, and I was many miles away from home. After closing in New Mexico, while on a flight, I closed all the doors to Albuquerque and never looked back.
Once I was back home again, I called Al Deitch and stayed with him at the Body Shop for a few weeks with new photos.

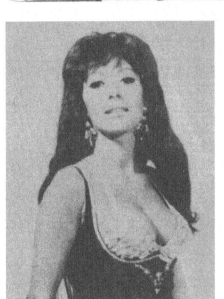

BODY SHOP: Back at this Sunset Strip strippery is the fabulous Delilah, following an extended

While at home, my husband mentioned that Angel Ray wanted to have an affair with him, while I was on the road. He was a strong believer in one life, one love, and told her no. He would never go astray. It surprised me about Angel, but I stayed friends without her ever knowing, however, the closeness of our friendship had faded. We were still working together at night, whenever I was in town. Al Deitch admitted that he did not like the change in Hollywood with the nudity and the raunchy shows, but he had to go where the money was. So whenever I was back, he let me keep my g-string on, because I never had danced nude before, and the Body Shop was now totally nude. The new generation were not exotic dancers or strippers. They were cheap total nude GoGo dancers with Fredericks of Hollywood lingerie for wardrobe. Some were unprofessional nasty girls taken off from the streets, one would even hump a beer bottle in the nude on stage. However, sometimes I wondered about these neo, they were young, ignorant and seemed to be lost souls, mentally. Hopefully, they would be able to straighten themselves out in life. All good role models were gone.

I was booked back to Lompoc for a week. On November 8.1970s while on my way I got very dizzy and stopped in a restroom in Santa Barbara.

I had a miscarriage and lost a lot of clumpy blood. I nearly passed out and was rushed to Kaiser Hospital in Simi Valley. I was having an ectopic pregnancy, in one of my fallopian tubes. I went immediately into surgery. I was laid up for six weeks. I knew then, that i got pregnant in Albuquerque. While I was recuperating, I studied for my citizenship.

On December 20. In 1970, I became an American Citizen, in a wheelchair.

97

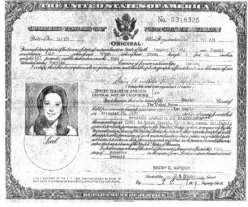

My citizenship paper congrats letter signed by Barry Goldwater

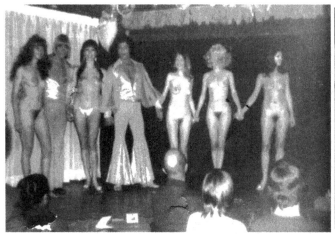
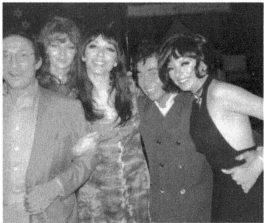

New Year, me with my g-string Birthday party for Al

The most important thing about traveling for me was going sightseeing and my well-being was always important. I used to carry a small plant with me, and a hotplate to make coffee and breakfast. Also, a AAA booklet that had motels, restaurants, and sightseeing ads inside. That was very helpful. A must-be was to carry a bag full of change, to use a telephone booth for phone calls, and I learned fast reading a map about North, South, West, or East, for traveling. Most of the time I drove through Route 66, always

stopping for off-road garage sales, which were the best, and so were the off-road home-cooked restaurants.

I stayed a while longer at home. My husband always understood and gave me space. He was a good and loving man.

Now ailing Al Deitch, his cancer came back with revenge.

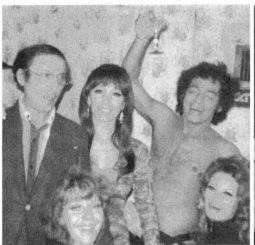 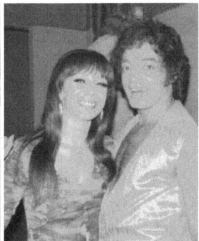

Al, me and Rubin, Barbara, Sharon, Rubin and I, our dancers, Rubin a gay guy, and Angel teamed up and went on the road to Canada as a love act.

The fabulous Delilah has just returned from a tour of Europe and the Far East and, again, stars at Al Deitch's Body Shop nightly. She picked up the title 'Miss Germany' on her journey and heads a show of eight lovelies.

ALLURING Delilah returns to Body Shop on Sunset Strip after completing tour of Europe and Far East. She heads nightly show featuring eight dancers.

Delilah makes the Body Shop one of the most exciting bistros in town.

Liberty West left. Kitten Natividad and I, in the Body Shop Kitchen in Hollywood. This was the early seventies.
A few years later, we all would be working in the same show again, only this time in Las Vegas.
In February 1971 we got struck by a devastating San Fernando earthquake, a 6.6 magnitude, and we kept shaking and shaking, we had tons of aftershocks. I wanted out, far away from Hollywood, and fast. Angel Carter and the Virginian, James Drury came to my home and we all, along with my husband, celebrated with a bottle of whisky, just being alive. I never drank that stuff, nor did anyone else, so Virginia finished the bottle bu himself, but didn't seem to be drunk.
We were all scared shitless.

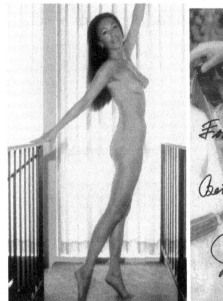

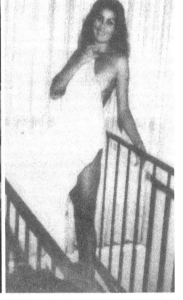

Soon after, Angel Carter, Kim Sommers, and I went to see Cora Lee agency, to sign us up for faraway places. At her office, there was an opening for August of 1971 in Mexico City, but for only two dancers. Kim and I were chosen. That meant I had to "kill" a few months before leaving. At that time I did not realize that Mexico City had stronger earthquakes. Their next earthquake was M 7.5. Angel was supposed to follow us, so we

all went to get our passports ready. At Cora Lee`s office, we were also asked to go for an audition for Dean Martin`s Gold Diggers show. That did not work out, and no Dean Martin in sight. Angel used to tan very dark and look like a black person. We used to kid her that the "black stuff" doesn't rub off because she had dated Willie Davis, Los Angeles Dodgers baseball player.

Thinking of the trip I started to prepare myself and decided to go as a redhead, these photos were taken in the Body Shop dressing room.

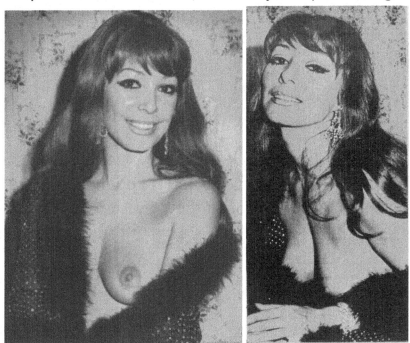

My new photos for Mexico as a redhead.

Still at the beginning of 1971. My boss Jack Grant at the Redwood Inn asked me to come back to Flagstaff. I was so glad to leave again, I agreed to stay in Arizona for a few weeks. I had a warm welcome when I arrived. My boss Jack rented a nice motel for me within a short distance from the club. After the second week, Jack asked me if I wanted to open another one of his clubs, in Page Arizona, and also to be the first stripper.

One of the regular customers, that I had gotten familiar with, was a good friend of my boss, and he owned the Conoco gas station in Flagstaff. His name was Don. He took me out for dinner and we got acquainted and offered to drive me to Page, which I accepted.

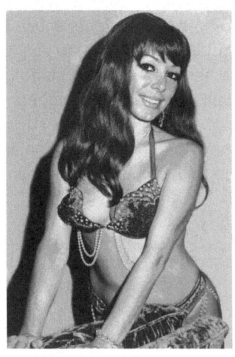 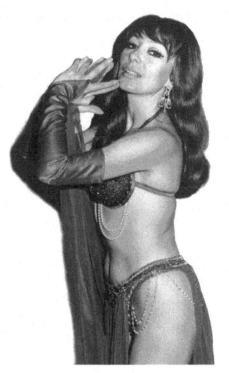

Flagstaff Arizona 1971 and in July 1971 I opened in Page, Arizona.
It was a grand opening at the Windy Mesa.

Grand Opening Featuring First Show 9pm **DELILAH** ON STAGE Wednesday & Thursday **July 7,8**

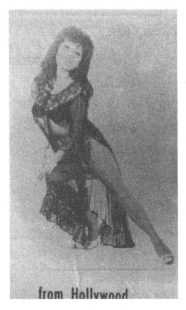

from Hollywood

It was approximately a two-hour drive and it was another wonderful ride through the Arizona Desert, and I was comfortable with Don. He was a gent all the way. Page Arizona is at Lake Powell, an indescribable site of beauty, where "The Planet of the Apes" was filmed. All reddish sand and hills or mountains, with the blue water from the Glen Canyon Dam, the blue skies, and an occasional puff of heavenly clouds.

The Windy Mesa was a honky tonk western atmosphere club, with a live band and also a jukebox. Most customers were construction workers,

or Navajo Indians. The stage was a triangle in a corner. My dressing room had a small window, and so one night, while I was on stage, an Indian climbed through the small window in my dressing room and took off with my lavender negligee, which he showed profoundly off to his friends. He loved it so much that I let him keep it. Being around REAL native Indians fascinated me, it was historical to me.

Page was just being built, a small nothing town in the middle of nowhere. It had one small dirt road, one church, one gasoline station, one motel, two bars, and one restaurant, and I loved the open air and the nothingness. I would work one or two weeks in Page and then back and forth to Flagstaff and to Page.

Then back home.I enjoyed my life and that freedom, but nothing was so fulfilling to me than my happy home, knowing I had roots there and a loving husband. Not long after, I wa once again back to Flagstaff, which became a routine.

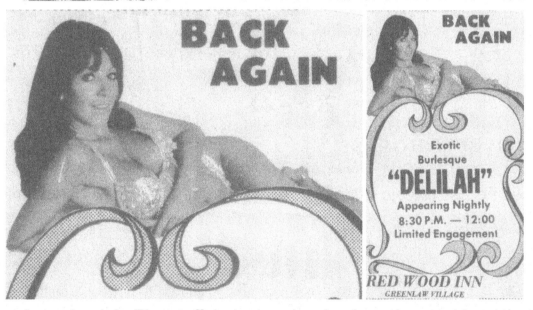

And so I was back in Flagstaff, but when I arrived, my boss told me that he needed me in Page, and so I was on my way again.

It was a quiet Sunday morning and it was a wonderful feeling being in the middle of beautiful Arizona, sightseeing at Lake Powell. Don was my escort again and I enjoyed his company. The next day, I received a dozen roses from him. I was surprised because I barely knew him. The live band, the

waitress, and I had some good times. Between my shows, I was on the floor, and sometimes I would dance with some of the guys, to the jukebox music. It was a lot of fun. I now started to like country western music and used it in most of my shows. The audience loved it and sometimes would sing along. At the end of the week, Don picked me up again and this time we took our time getting back to Flagstaff. We had all of Sunday. First stopped at Lees Ferry, at the Navajo Bridge, a National Monument. Then we drove through the Hualapai Indian Reservation. In the evening, we stopped in Sedona for dinner, then we went through Oak Creek Canyon, back to Flagstaff, where I was to open again the next day.

The sight of the Arizona desert at night when there are no clouds is indescribably beautiful. Stars are unbelievably bright and sparkle like diamonds in the sky. Any free time I had, Don would drive me to show off Arizona.

Lees Ferries Navajo Bridge, Hualapai Indian Reservation,

Monument Valley, Utah, and into Kanab, Utah, playing with a cat.

Meteor Crater Rainbow Bridge Utah

Being a stripper in the most beautiful parts of the country was great, but taking advantage of all the surroundings was the ultimate.

I was asked to stay for another week. The next weekend, the guys in the band asked me if I would like to come along for a boat ride on Lake Powel. I gladly accepted. So on Sunday morning, we filled up the boat with food and drinks and took off. We went through the humongous high and narrow red canyons, this blue-greenish water and blue sky above, some white puffs of clouds, and a bit of green on the canyons. Which gave me a chill of

happiness. Exploring the beauty of America was an unbelievable thrill for me. I was so thankful that I had the opportunity to travel and see many of the great states. The richness I felt, I recreated in my shows at night.

After I closed in Page, I finished one more week in Flagstaff when I mentioned to Don that I was signed up to appear in Mexico City. It surprised him.. The next morning, he drove me to the airport, via the Grand Canyon, to catch my flight back home to Burbank airport. My plane was delayed, so we sat at the bar and had a drink. By now I knew that Don was very much in love with me, but for me, the flirting was just exciting for me. He asked me how I would feel if he would come and visit me in Mexico. That took me by surprise, but I kind of like the idea. I was ready for anything that life offered me. I don't ever want to look back in life and think that I missed out on anything.

My plane arrived, and I was on my way back home, to Burbank, California, where I was greeted by my loving husband, and I stayed home until I left for Mexico with Kim Sommers. At the end of summer in 1971, Kim and I left LAX with AeroMexico for Mexico City. We had to stop in Mazatlan, for customs. We landed near the ocean. The view from the plane, over looked the beach which was covered with grass. Then we were off to Mexico City. I was so excited, and being with Kim made it even more exciting. When we arrived, we were greeted by our personal chauffeur, named George. He was hired to take us anywhere we wanted to go. That was such a great feeling of relief, not to worry about how to get around in a strange country. We settled in our new place,

I was anxious to see Mexico City. George took us to Las Catatcumbas club..

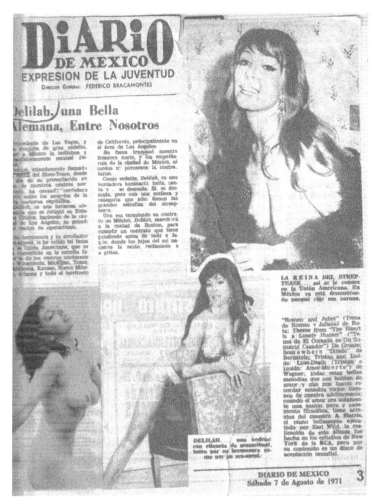

After we unpacked we got situated for our first job. We performed in two different places, one was the Iris Theatro at noon, then the Club Social at six pm, back to the theater at ten, and back to the club at midnight. Four shows a day. In between we napped anywhere we could. On Sundays, only two shows. Evening at 6 pm at the theater and 10 pm at the club. The theater had a Las Vegas-like show, where I would come down a large high staircase, with showgirls around me, and a singer serenading me with a song, and then guiding me off stage with his hand. The showgirls were dressed in spectacular wardrobes. Needless to say, IRIS theater was huge and Vegas like..

The Club Social was also fancy. It was a complete variety show. We had dancers in spectacular costumes, so fancy that I drew them on paper so I could copy them when I got back home to California.

Souvenir Flyers from the Iris Teatro were given out freely, and there were plenty of them. I cut all my pictures out, so I had less to carry on the Airplane, that was a mistake. That same night, Kim and George had a love-sex affair while we were in Mexico. Kim, knowing that I expected Don, let me have the master bedroom, which had a mirror on the ceiling. Kim was always good-natured that way.

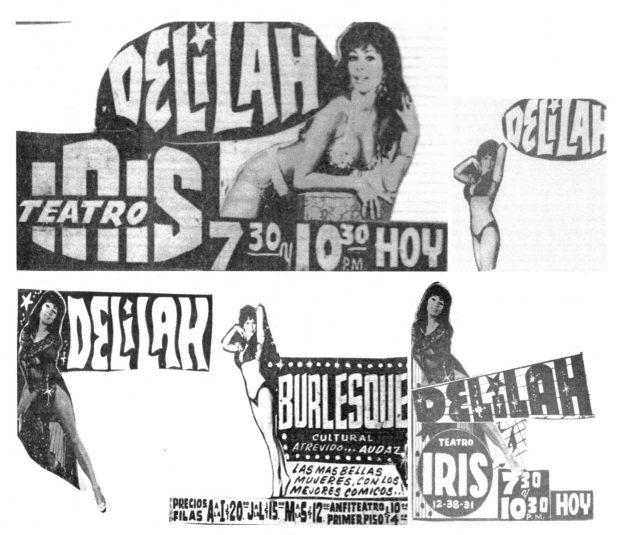

Several different souvenir flyers

The Mexican City mayor was there for opening night. One day he surprised us when he walked uninvited into our dressing room to use the bathroom, in the Club Social. I tried to stop him, after all, most of us were naked. He broke out into huge laughter. No worry, he said, I don't like women. I was surprised because I thought Mexican and Italian men are Latin lovers, but not so in Mexico. He would come into the club many times with other gay men and had asked me to join because he liked talking to me. Everyone was gay or bisexual. I was told by one that even "straight" men will go with men for money, just to support their families. How interesting. Being from Hollywood, it was acceptable to me. Some of the dancers in the dressing room were also by-sexual. Dancers were all Mexicans, we were the only imports. No black dancers either.

Opening night at the club Social.

When the time came for Don's three-day visit, George picked him up from the airport, after he dropped Kim and me off for work. That was just perfect. The same night, Don and I had our first sexual encounter. The next day we painted the town. All four of us spent every day and night together. After the three days were over, George took Don back to the airport. Then George took Kim and me sightseeing after work to see the Pyramids of the Sun, which are about 60 miles away. Kim and I slept in the car til we arrived. and after we went by the Volcano which had been inactive for many moons.

I kept many souvenirs, including pamphlets from the Pyramid, which had many snake heads. and a postcard. I always loved to play tourist. From Mexico City to Teotihuacan, is about 30 miles north of the city. It is known for its incredible architecture.

We also went through Cuernavaca city, which had many narrow streets, covered with blue mosaic on the building, and brick streets. Then we stopped at a marketplace, where artists sold their art. It was a fun and exciting trip, day or night. We also got to go another day to the Metropolitan Cathedral Square, where the Mariachi serenaded Kim and me.

When the contract was over, our boss asked us to fly with him to Acapulco. We declined. He must have been out of his mind, to ask us cold like that.

At the end of August, I was back home and was anxious to work on my new costume and go back to work for Al Deitch, who added an extra attraction named Veronica, she was a gorgeous tall blonde, very feminine, and she was a real sex change. We got along great, and so, as usual, me being curious, I asked her all about the surgery. To my surprise, she asked me if I wanted to see it. My eyes opened wide and I said yes, of course. She then sat on a chair, lifted her skirt, and opened her legs. I took a closer look and said: wow, it looks just like a vagina! She grinned and answered, of course, it is. She said every part of her penis was inverted, so she can feel the same sensation as with her dick, in other words, everything was like a woman, except that she cannot get pregnant. How fascinating, she then covered up and we both laughed, then she signed a picture for me, and business went back as usual.

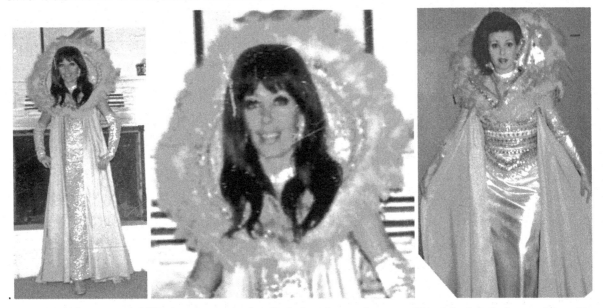

Yuma Arizona 1971 in my newly finished costume. Right: I let Angel try it out. This was in September or early October, I accepted a one-nighter to fly

110

to Fort Yuma, Arizona for a USO show for the GIs stationed there. The show was outdoors, with a good size stage, which started in the evening. It was a hot summer night with spotlights, which attracted tons of bugs, which kept flying into my face. We had a singer, a comic, and a Master of Ceremony. and two other dancers. I was anxious to wear my newly finished costume, which was a likeness of the sun, like the pyramid del sol. It was all gold and yellow. I used a wire hanger for the headgear around the back and another to hold on my shoulder.

After Yuma, I stayed home and went back to the Body Shop, and I also spent some quality time with my husband. That did not last long, as I was called back to Flagstaff. In August 1971 I arrived at the Grand Canyon. Don greeted me again at the Airport. It was a passionate reunion. My new co feature was Tiza from Las Vegas. We developed a close relationship during our stay. We also spent time in Sedona. Our time was short, and we parted sadly. She went back to the Palomino, in Las Vegas, and I went back to Hollywood. Tiza was married at the time to a cop in Las Vegas, she fell madly in love with a construction worker while performing in Page, Arizona. She eventually got a divorce, which was very emotional for her. A lot of crying during this time. She left Las Vegas, and moved to Page, Arizona, to get married. That was the last I saw of her.

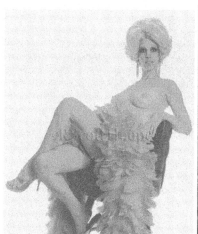

Tiza at night, and me withTiza at the Redwood Inn, me in Sedona Creek restaurant. Center: In the background is one of the paintings I posed for. A week later I was back in Flagstaff, this time with Angel Carter. My car was always half-packed. The following weekend Don asked me to fly to Russellville and Little Rock, Arkansas, over Sunday with him. I did.

We stopped at the Black Orchid strip club in Little Rock Arkansas to meet the owner, for a possible future engagement. We also stopped by the zoo. Dinner was in the Ozarks, where we spent the night, then back to Flagstaff for my show. I was surprised by another Oil painting that Don had ordered for me, also by Dodge.

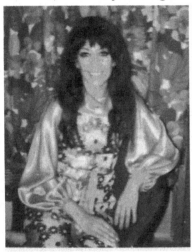 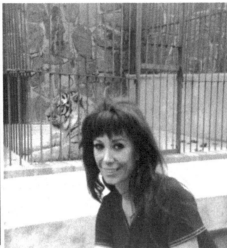

My Polaroid photo, Little Rock Zoo my oil painting,

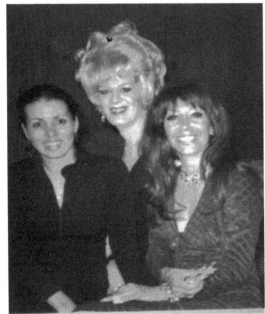 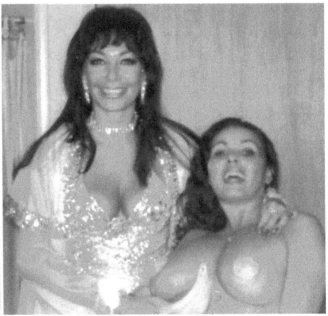

With Angel and a Female Impersonator, Angel and I before my show.
Don took me every day to see different parts of Arizona.

112

The Grand Canyons

Colorado River

somewhere in Arizona

That week my niece came to visit me from Hollywood.
Don took Angel, my niece Valerie and me to the Colorado River.

Fountain Hill, Arizona, Humongous Saguaro Cactus next to it teeny me.

 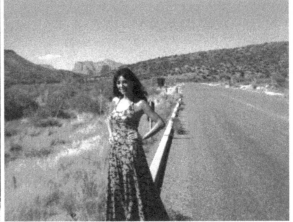

On a small boat on the Colorado River, and an Arizona highway.

Arizona mine shaft, Flagstaff Observatory, somewhere in Arizona

Jack, my boss, was a wonderful person and was married to a great looking blonde. Jack and I took Angel to Page on a Sunday, to show her around because she was going to take my place.. On the way back Jack took a long way around to show us the country.

He let Angel drive, Jack in the passenger seat, and my chihuahua Pinky was sitting in the back. We were just about passing the four corners, Arizona, Colorado, New Mexico, and Utah, when we had a head-on collision car accident, but only were side-swiped at close to 100 miles an hour. A miracle saved us. We were protected by a higher power. Being a hot day in the desert, we had the windows closed, while the air-conditioning was running. The windows imploded and glass pieces covered us all over Angel, my chihuahua, and me. Jack was sitting in the passenger side because Angel was driving, and got nothing.

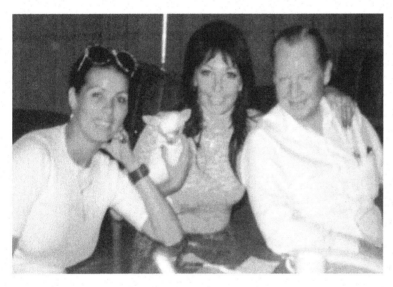

Jack then drove us to the hospital in Flagstaff where the nurses laid us on cold metal tables, just like in a morgue, and pulled out all the glass splinters one by one from Angel and me, with Iodine and tweezers, and they also cleaned my Pinky, who had blood stains on his white little furry body. We were not in pain. Just in shock, Jack let us rest that night and we went back to work the next day as if nothing happened. Because we were saved by a higher power. one more inch or two, we would have been dead.

Back in Flagstaff, with Angel, Jack, and my Pinky relaxing in the showroom of the Lobby at the Redwood Inn.

Life went back to normal. Don took me to Oatman 1971 at different times because I enjoyed it so much. Next Angel and I went to the Friar Tuck for dinner, and another weekend in Oatman Arizona.

Oatman Friar Tuck

 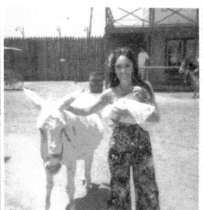

Oatman Arizona

By now, Flagstaff had a bunch of snowstorms, enjoyable at times.
I also took advantage of going into a cave in Arizona.I saw a lot of the most
unspoiled desert and historical sites of Arizona.
Then back to Page Arizona.

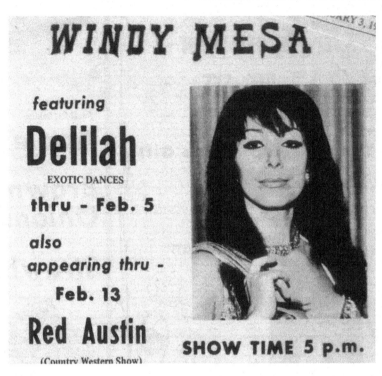

WINDY MESA

featuring

Delilah

EXOTIC DANCES

thru - Feb. 5

also

appearing thru -

Feb. 13

Red Austin

(Country Western Show)

SHOW TIME 5 p.m.

Once again I was booked back to the Windy Mesa in Page, Arizona when on this trip my life changed forever. I met the love of my life, Edwin (Ed) Beutler at the Windy Mesa. He and his friend Denny came down from Seattle to build homes in Page. Ed was 6`2, of German and Blackfoot Indian descent, and a buff-built man. He had asked the waitress for me to join his table. On my next break, I did. We had fun talking, that was all. When the next slow song played on the jukebox, he asked me for a dance. I accepted. As soon as we touched, we had an anormous unbelievably strong forceful impact that connected us deep within. Cosmic Power, perhaps? We were told that. Neither one of us remembers anything that happened afterward or our first kiss. I was aware of having spent the night with him at his place, but still clueless about how I got there. Ed became part of me for the rest of my life.

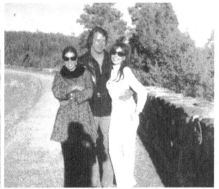

With Ed on Glen Canyon Bridge, 700 feet over the water.
Right: with Angel Carter and Ed in Sedona Arizona.

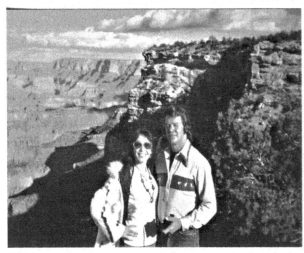
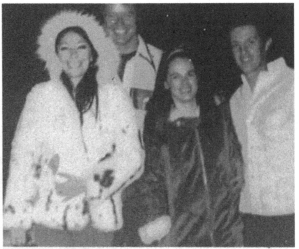

Ed and I at the Grand Canyon, me with Ed, Sylvia, and Denny
Then back to Flagstaff.

ARIZONA DAILY SUN FLAGSTAFF, ARIZONA

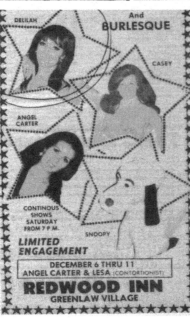

Delilah...dances...appearing at the REDWOOD INN. She is a darkhaired lovely that keeps the crowds eyes in her direction.

GOGO...she does it. Her well shaped body moves to the music in a ever so haunting manner that she will make the spirits come out in you.

She has danced internationally, from Germany--France to a recent engagement in Mexico City.

Advertising with Angel Carter, Casey Jones and me. The show got bigger. How ironic, that both Casey and Angel would die within a month of each other in 2022.

Then back home to California until I opened in Salina Kansas.
In January 1972 I flew to Salina for one week.
I had previously signed some contracts that needed to be filled.

SALINA, KANSAS, MONDAY, JANUARY 3.

118

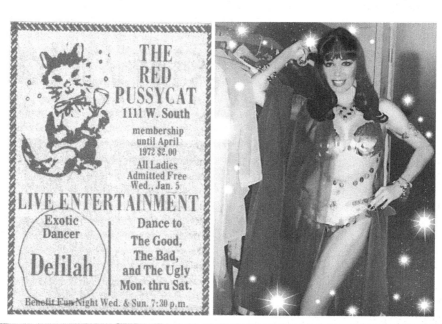

January 3/1972 I opened in freezing, snowy Salina Kansas.
After I left Burbank airport my plane was the last to arrive in Salina, due to a snowstorm. I checked into the Holiday Inn across an open field from the club, and then went to check out the club. It was a honky tonk real old western barn-like club, where the patrons would do the two-step dance between my shows. The dressing room was a liquor storage room, small and narrow. Every night I walked through the crunching snow to the club.

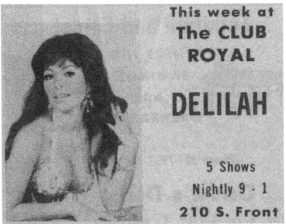

The following week, I flew to Mankato, Minnesota, to the Club Royal, also for a week, where it was really cold, below freezing. This was a college town, filled with unrestrained punks.

Then off to Lima Ohio, to the Roxy Club, for a week.

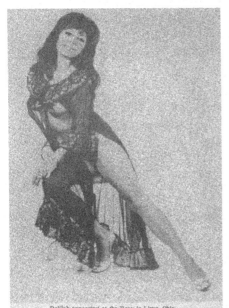

Delilah appearing at the Roxy in Lima, Ohio.

After Lima, Ohio, I flew straight to Flagstaff, Arizona, and was driven to Page.

By the time I arrived, I was extremely sick from the flu because of the cold freezing weather that I left behind, and the air conditioner in the airplane that was blowing on my head. That gave me the extra dose of flu. It was now February 3rd.1972 and I was sicker than a dog. Ed was anxious about my return and took such good care of me. I was too sick to do a show, and I had to call in sick that night. The only time I ever called in sick.

After Page, I went back to the Redwood Inn for one more week.

Ed came to see it the following weekend. By now we were heavily emotionally involved with each other.

After Flagstaff I went back to Hollywood, I worked for Al Deitch again at the Body Shop while I was home.

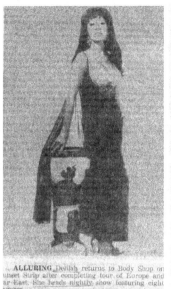

The fabulous Delilah has just returned from a tour of Europe and the Far East and, again, stars at Al Deitch's Body Shop nightly. She picked up the title 'Miss Germany' on her journey and heads a show of eight lovelies.

ALLURING. Delilah returns to Body Shop on Sunset Strip after completing tour of Europe and Far East. She heads nightly show featuring eight dancers.

The Body Shop showroom with Lisa, Angel Carter, her hubby Chace Cordell and Liza Jourdan. Right: another birthday party for Al, with Liza Jourdan, (Caprice`s daughter), me, Nick, Al, and Angel.

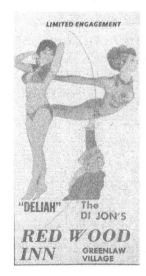

LIMITED ENGAGEMENT

"DELIAH" The DI JON'S

RED WOOD INN GREENLAW VILLAGE

Arizona Thursday, March ⅄, 1972

The REDWOOD INN is now featuring a female singer-comedienne and the dancing talents of Delilah.

A short time later, I was once again booked to open in Flagstaff and it was booming now.

The show was bigger than ever, and some of my friends worked with me again.

One huge ad appeared in the Arizona newspaper for the Redwood Inn. Left: me and the adagio act.

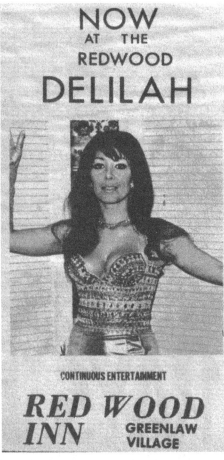

NOW AT THE REDWOOD DELILAH

CONTINUOUS ENTERTAINMENT

RED WOOD INN GREENLAW VILLAGE

New large ad for the Redwood Inn, Casey Jones as a blonde.

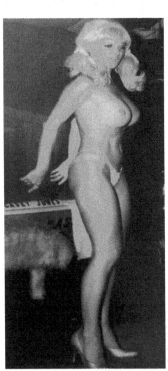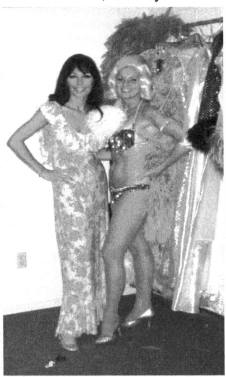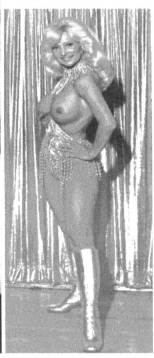

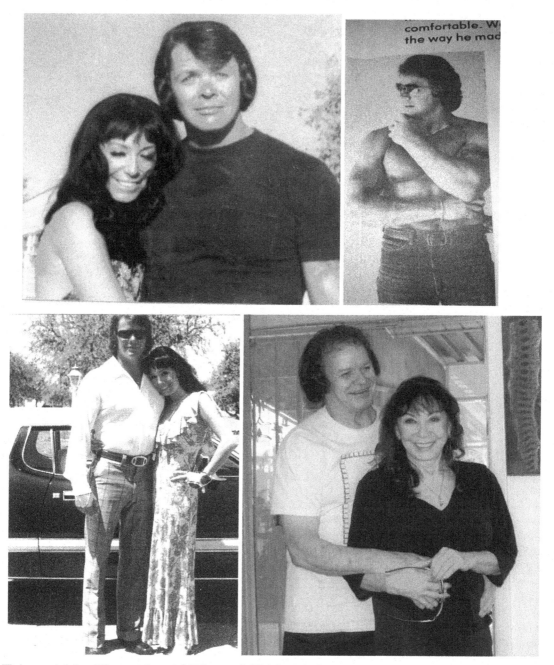

#1 Ed and I in Phoenix 1972 and Ed in "Nautilus" advertising pamphlet
#2 In Phoenix with Ed and 45 years later in Las Vegas

I never looked back to Flagstaff or Don. Even though I had exciting times with him, like making love in the open Arizona desert, it's now the past. Life goes on and never looking back, except for Ed, who was always in my heart.

With Sylvia at ancient Indian housing,

Shrine of Joseph, in Yarnell, Arizona.
Right: Angel and I with our boss Jack. This would be my last time ever at the Redwood Inn.

Now back at my beautiful California home, I was having the time of my life in Arizona. Now I noticed that my husband was aging fast. I did not realize at the time that he had heart problems. He was a chain smoker, and bottomless coffee drinker, and took a sleeping pill every night for his insomnia. While I was home, Ed moved from Page to Phoenix. I asked my agent to book me into Phoenix, and I asked Sandy to take new photos.

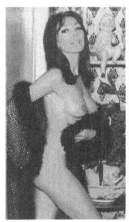 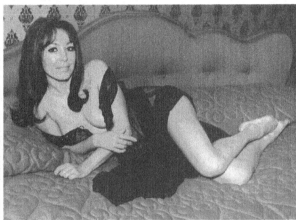 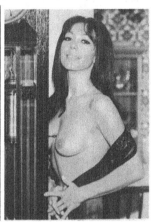

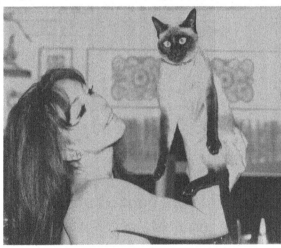 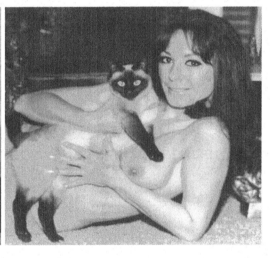

My Siamese cat Susie wanted to be in the photo. During my stay at home, I met Los Angeles TV news anchor Larry Carroll. He asked me to be in one of his commercials, and so I did. I had to say: "you ain't seen nothing yet", in my best dress. It was filmed in the "Watts" area, and I was scared, but Carroll, being black, knew everybody, so I felt safe.

 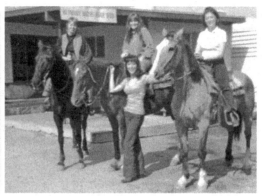

Daytime was spent wisely, and here at the Burbank stable for horseback riding. I rode an old hag that barely moved.

During the 70s the Ivar theater in Hollywood posted two pictures of me on their billboards and kept it for a few years..

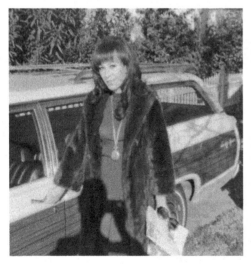

The time came, and I was booked at "The Tender Trap" In Phoenix. March 17,1972 was my opening night at the Tender Trap. I was booked for one week and I was held over for two. Being the first stripper here also, packed the club nightly. The Tender Trap was a small, and average club, with a warm atmosphere. I had a nice size ad in the Bachelor`s Beat Phoenix newspaper when I arrived.
Left: On the road again with my LTD.

126

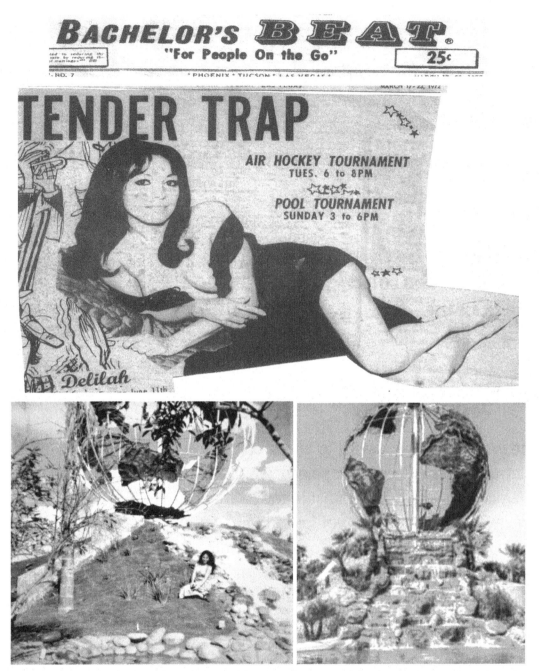

I am sitting in front of the unfinished waterfall of "Leisure World" in
Phoenix. right: the finished project, Ed was the foreman there.
A new place and a new beginning in Phoenix with Ed.
The two weeks went by fast and before I knew it, I was back home again in
Hollywood. A bittersweet feeling when I arrived home and saw my husband
again, whom I once loved so deeply, that feeling was no longer, I changed.
I went back to the Body Shop while I was at home.

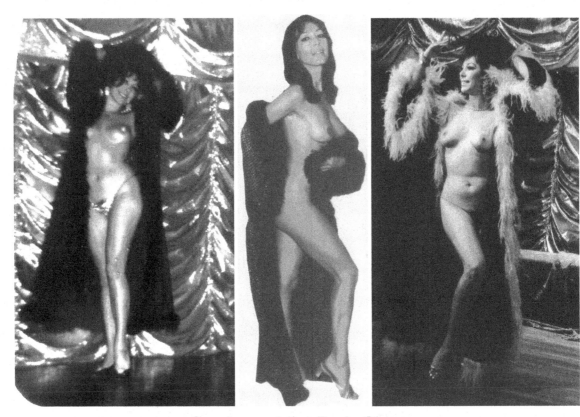

On stage at the Body Shop

As time went on, I was asked to come back to Phoenix. The business was booming wherever I went, especially, where I was the first stripper. It was a good feeling. It was mostly the little towns that did not see much glamour. Phoenix was not developed yet for strip shows. And so on April 3.1972
I was back at the Tender Trap for the second time, for two weeks. I was now driving on the newly finished Highway "10" from Los Angeles to Phoenix for six hours. No more Route 66. I lived with Ed in Phoenix, while I was still married in California, without my husband knowing.

Dancer DELILAH opens again at the TEN-DER TRAP on April 3rd ... the shapely and talented dancer is back by popular demand for another limited stint at the club...

EXOTIC DANCER Delilah has returned to the Tender Trap in Phoenix. She is one of the most popular exotics ever to perform in the valley and has been booked for a 4-week date. She does three shows nightly at the Tender Trap.

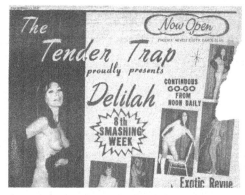

THE BIG ATTRACTION at the Tender Trap in Phoenix is dancer Delilah. The swinging exotic has been held over for another week according to club management and she is doing four shows nightly at the club.

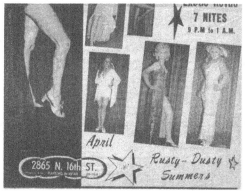

SEXSATIONAL DELILAH is in the final week of her date at the Tender Trap in Phoenix. The popular exotic will do four shows nightly with her last show on Saturday night. The club features go-go dancers and exotics from 8 p.m. to 1 a.m. nightly.

On this booking, I worked with Dusty Summers and her sister Rusty. Dusty and I became my lifelong friends, but her sister Rusty passed away a few years later. April 14,1972 still in Phoenix, held over again.

Hurry, Hurry, Hurry! Visit **THE TENDER TRAP** and view the wonders of **DELILAH**, that mythical, magical showpiece before she departs to other locations to continue her quest for fame.

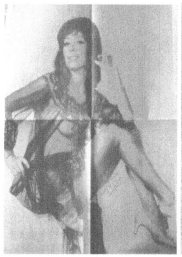
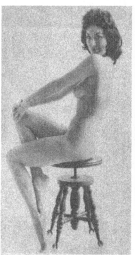
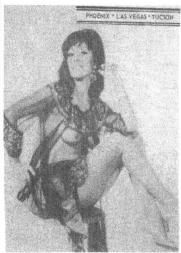

129

A surprise of a four-page ad in the Phoenix Newspaper. This was the first time one of these was published. This photo appeared in many other ads. After I finished in Phoenix, I went back home, but i opened again at the Tender Trap on April 28,1972.

APRIL 28-MAY 4, 1972 *The* Tender Trap

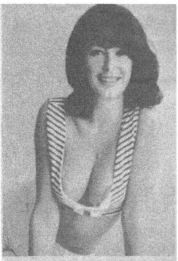

THE BIG ATTRACTION at the Tender Trap in Phoenix is dancer Delilah. The swinging exotic has been held over for another week according to club management and she is doing four shows nightly at the club.

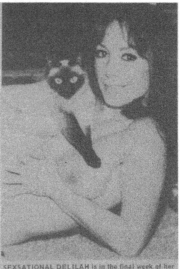

SEXSATIONAL DELILAH is in the final week of her date at the Tender Trap in Phoenix. The popular exotic will do four shows nightly with her last show on Saturday night. The club features go-go dancers and exotics from 8 p.m. to 1 a.m. nightly.

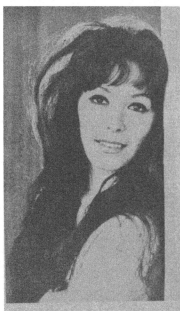

EXOTIC DANCER Delilah has returned to the Tender Trap in Phoenix. She is one of the most popular exotics ever to perform in the valley and has been booked for a 4-week date. She does three shows nightly at the Tender Trap.

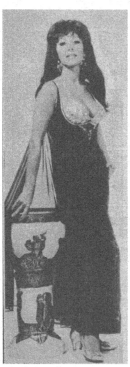

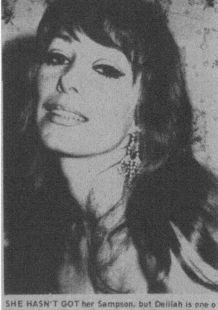

SHE HASN'T GOT her Sampson, but Delilah is one o the most popular exotics ever to appear in Phoenix. The sensuous dancer is back at the Tender Trap for her fifth engagement. She leads a bevy of strippers and go-go dancers entertaining nightly.

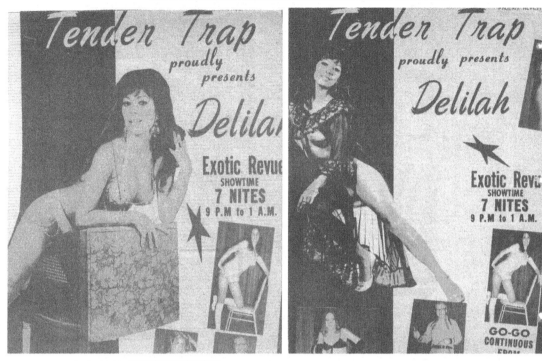

MAY 5-11, 1972 I was held over numerous times, with new ads. Most of the time they were oversized. I stayed for several weeks, then on and off, back and forth home and Arizona.

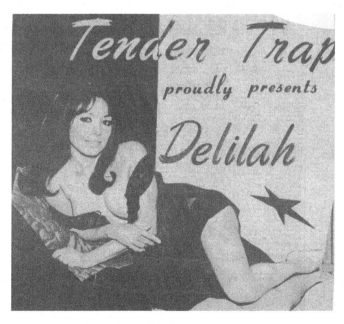

Summer was hot, 120 temps in the daytime and it would cool down to 100 at night. One night the air conditioner broke, I danced by the fan, while sweat would be pouring and make-up running. It only happened once. Next: Snapshots while on stage at the Tender Trap.
In June 1972 I was home and back at the Body Shop,
But in July back in Phoenix.

131

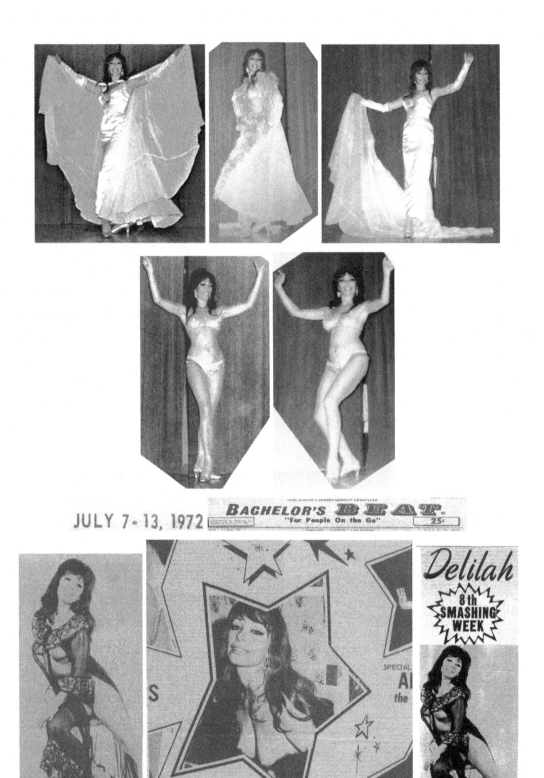

photos were often used for more than one ad.

132

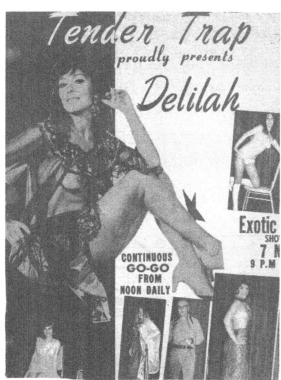 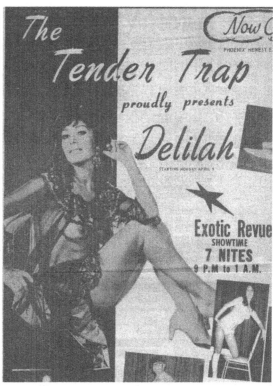

SHE HASN'T GOT her Sampson, but Delilah is one of the most popular exotics ever to appear in Phoenix. The sensuous dancer is back at the Tender Trap for her fifth engagement. She leads a bevy of strippers and go-go dancers entertaining nightly.

I closed mid-summer 1972 at the Tender Trap, then I went home. Leaving Phoenix and Ed behind always saddened me, but our love never changed. Once I was back home again, cleaned my wardrobe, checked all my music, and got ready to go on the road again to the midwest..

The Daily Times

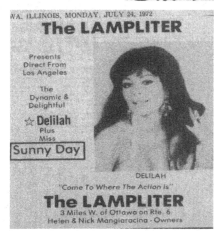 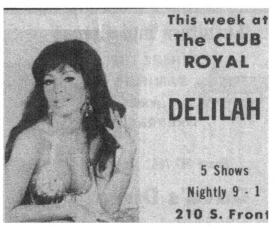

On July 24.1972 I opened at the LAMPLITER in Ottawa Illinois,
and the following week at the Club Royal for one week, also in Illinois. Then
I was booked into other clubs, also for a week, but lost track of them.
Now off to Grand Rapids, Michigan to open August 21,1972
I cannot remember the name of the club. I was introduced to the city
councilman. He suggested to the club owner that I should join with him the
junior football league, for publicity. We all agreed and it was a go.

"Delilah from California":
Dribbled but Form Was Good.

With the City Councilman, Schwaiger, along with his wife and their friends,
pictures, and center, sightseeing in Grand Rapids, Michigan.

Central Junior Boots Way to World Field Goal Title

By ROY HOWARD BECK

The "world football field goal kicking champion" is a 16-year-old junior at Grand Rapids Central High School whose immediate athletic concern was to make it through the team's first practice Monday.

Kevin Paul of 1723 Bradford St. NE outbooted all others Sunday afternoon at Aquinas College's football field by putting all three balls through the goal post from the 30-yard line.

Has Global Touch

The field goal contest was pegged as the first such international event by originator, sponsor and chief promoter 1st Ward Commissioner Richard Schwaiger. The 56 participants came from such far-away places as Ada and Sparta. The only female participant, "Delilah from California," made the contest national while a Polish immigrant and several Polish descendants lent credence to the international billing.

"At 18?" an over-30 said with a look of resignation.

"Must be legal booze and the right to vote."

Schwaiger was the first Class 3 kicker and thus took the lead with his single 25-yard shot. It wasn't until the next contestant that he lost it.

Contestants each kicked three times from their selected yard line. Accuracy trophies were given on the basis of total yardage and distance trophies for the longest successful kick

Winners Listed

Accuracy winners, with successful kicks and total yardage in parenthesis, were:

Class 1: First, Gerald Makarwicz of 771 Beaumont Ave., NW (2-40); second, John Porter of 931 Frederick Ave. NW (2-35); third, Clark Pierson of 4962 Bluff Dr. NE (1-15).

Class 2: First, Kevin Paul (3-90); second, Dan Matthews of 317 Briarwood Ave. SE (2-70); third, Dan Church of 4475 cis Ave. SE, and Henry Kruisenga, 52, of 251 Elwell St. SW, (all 2-60); third, Michael Burton of 144 Straight Ave. NW (2-50).

Distance winners with length of kick were: Class 1, Randy Randazzo of 1133 Burgis Ct. SE (20); Class 2, Denny Kruisenga of 251 Elwell St. SW, and Tom Wilson of 3649 Auburn Ave. NE, (37½); Class 3, Wayne Mohn of 420 North Ave. NE and David Walsh of 4236 Chicago Dr. SW (35).

Kevin Paul's only flaw in kicking for his top score was that he didn't step farther back. Each of his kicks made it the several extra yards into the woods. The audience and other participants burst into applause when the former Benzie County footballer kicked his third field-goal. He moved here in February and hopes to make the Central team as a linebacker.

Field Goal Special

"This was the day for the TV quarter-various ways, trading cleats, tennis shoes and work boots freely with each other to get the preferred effect. One kicker bypassed the whole ordeal and kicked barefooted.

The day ended with Robert Godlewski, of 262 Valley Ave. NW, winning the drawing for the football autographed by the members of the Minnesota Vikings.

Schwaiger, serious about the future of his contest, was already anticipating rule changes and promotion for next year: "We'll have the service clubs in charge of city and state contests as an elimination before the kickers come here.

"This can be a good source of information for colleges and pro teams about kickers. A lot of times now they have to rely on some kid walking into the camp and saying, 'Hey, I can kick.' "

He anticipates the contest could truly become nationwide in five years. Because of the type of response from professional teams this year, he feels many of the

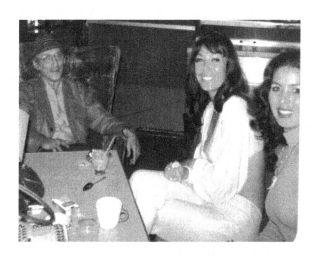

Then on my way back home to Hollywood, and back to the Body Shop. By now Al Deitch`s cancer progressed fast, and he had lost a lot of weight.
As usual, we were sitting in the kitchen talking. Here with Angel Carter. I was heavy-hearted, knowing that Al would not last much longer.

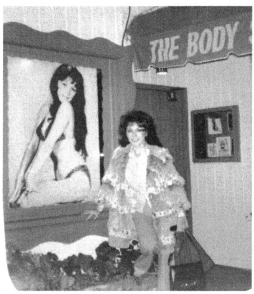

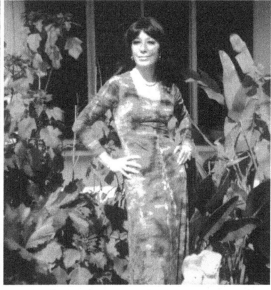

135

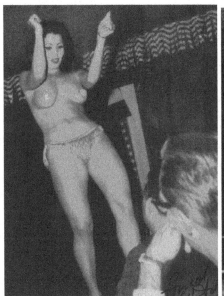 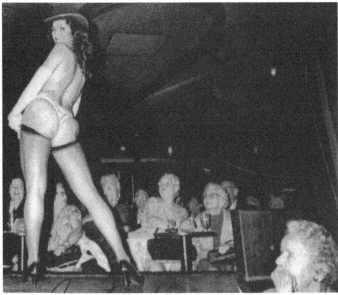

Left: Angel Carter on stage at the Body Shop. Right: The Classic Cat.

Then I decided to take a vacation with my husband and see if I can get my old feelings back for him. We left home and went straight to see Niagara Falls, so we drove toward Lake Erie and stopped in Buffalo N.Y. near Niagara Falls. Buffalo was a very dirty unkempt place, but there was only one motel where we spent the night. The next day we went down to see Niagara Falls and took the Maid of the Mist Boat tour under the waterfall. The tremendous roar of the waterfall was so powerful and unforgettable. Niagara at night on the bridge that connects America with Canada. We visited the Canadian site that day, which was clean and beautiful and full of flowers, unlike the American site, which had trash all over the streets, and buildings were old and not updated. NIAGARA FALLS night and daytime.

Niagara Falls Maid of the Mist

The Canadian side of Niagara Falls is in the back of me.
Then off to New Hampshire where one of my brother in law lived.

At my husband's brother`s home, Frank`s Shepherd, and my Pinky.

Our next visit was to Haverhill Massachusetts, where my husband was born to visit more brothers. I detected some jealousy, from their wives, who were typical housewives, and homebodies. My husband and I looked glamorous, from Hollywood, and that was understandable. My sister-in-law`s home is somewhere in Massachusetts, our next stop. This is her home. She married well and was not too fond of me being a stripper, but she treated us well and we spent the night in one of her guestrooms. Then we went back home again, but stopped in Denver, Colorado, on our way home. where Tony`s other sister lived. She was much nicer and so we spent the night at her place also. After we left, we never had any more contact with any of the sibs, except for Frank. Then we stopped in Vail Colorado for dinner and decided to spend the night there.

The next morning, we were driving slowly through the Rockies. Rocky Mountain high, Colorado. A brief stop for a snapshot with Pinky. Then through Utah, Salt Lake City, Nevada, and California, back home.

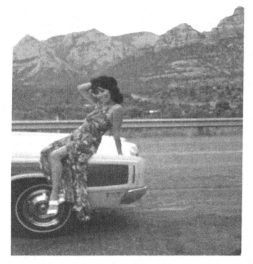

When we got home, I had a message on the phone to contact Dave immediately, my soon-to-be personal manager, for a show in Las Vegas, where I was offered the lead. It was to be the most daring show ever in Las Vegas. Wow, that was just made for me, and I accepted. But I had to go bottomless, for the first time. I was now set up for Vegas. I started to get all my wardrobe together. Rehearsal was coming up soon, but I still had some time left for my family.

In my kitchen and lunch at the Luau in Beverly Hills, where Lana Turner's daughter Cheryl was the hostess. With my husband, sister, and mother. Ready to leave for Las Vegas now with Patti Playful, one of our dancers, and would-be roommate in Las Vegas. Patti was married to the strip club owner from the Phone Booth. Once in Las Vegas, Patti and I settled down in our motel. My personal manager was the first to greet me. We were mutually fond of each other, but not sexually. We felt that we could trust each other, because of our great rapport. Dave was mob-connected from Cleveland and invested a great deal of money into the show.
We had a three-week rehearsal and a test show at the Royal Casino, topless. My show was to be a love act, and five backup dancers, totally nude. During this time, Dave asked if Patty and I would be interested to

take some private nude photos in the open desert. We both accepted and got paid well. We spent the whole afternoon near Mount Charleston in no man's land. Then to rehearsal which lasted almost three weeks and realized that I did not get along with my leading man.

That was tough for me, as I had to do a simulated love act with him.

I was also supplied with a plexiglass bathtub for my show and a round king size bed, covered in red velvet material, where the six girls and I with my leading man would do our act. We had to be apart at least one inch from each other at all times, that was the law. Our music was "Whole lotta love" by Led Zeppelin. At the sound studio, we added more moaning and groaning to it. Another morning we heard a knock on our door, and a small black guy, in pink foam curlers and bathrobe, stood in front of us. It was Picket Wilson, our next-door neighbor. He only wanted to introduce himself to us. The next day I was asked to come to the Royal Casino for a photo shoot, with Robert Scott Hooper.

Royal Casino

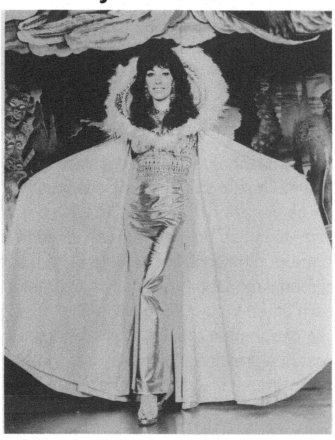

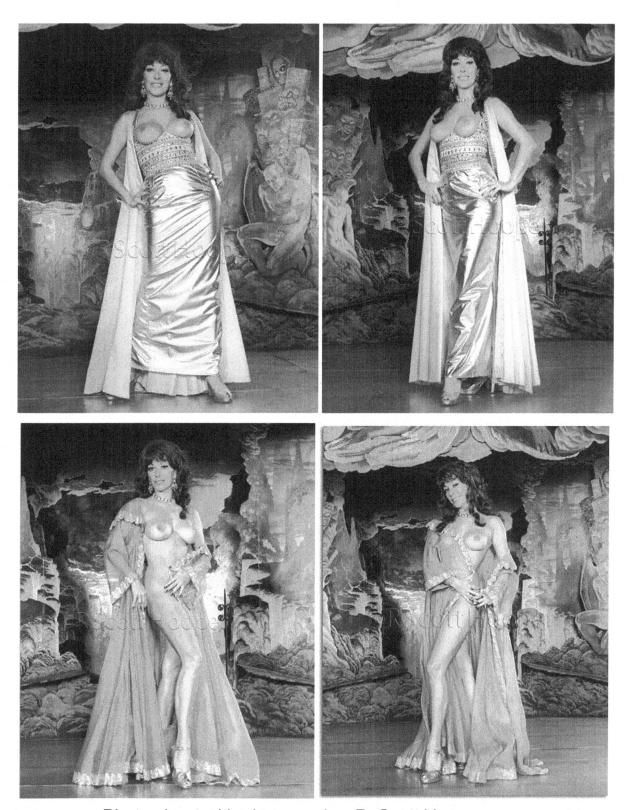

Photo shoot with photographer R. Scott Hooper.

141

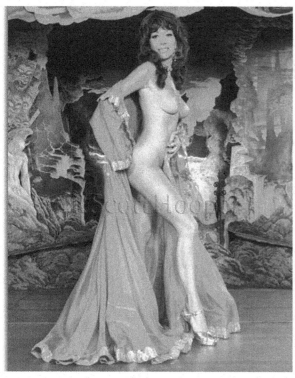
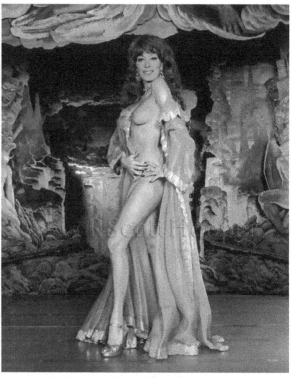
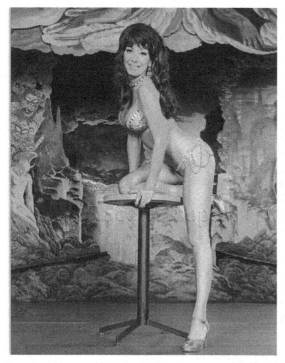

The GAY 90s in North Las Vegas was owned by Marie Floyd. It was a small club, which had gambling tables and slot machines, a bar,
 and a showroom. Paul Perry bought the club later on and turned it into the SATIN SADDLE. Paul Perry was the only one at the time, who owned the rights to a nude show in Vegas, and the JOKER club across from the Palomino. Eventually, he owned the whole block. Not only the clubs, but he also supported his "harem" girls with homes and finances. We all looked up to him and respected him. He was one of a kind, and business dealings were only with a handshake, no paper.

More photos were taken, which went for advertising.

We are now ready for the opening of the show.

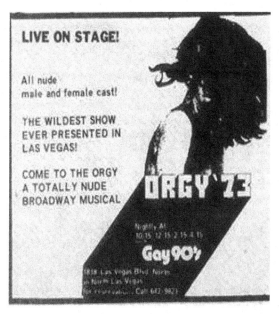

ORGY '73

GRAND OPENING October 6.1972

THE WILDEST, most sexy show ever presented in Las Vegas, "Orgy-'73", celebrates its grand opening this week at the Gay 90's, 1818 Las Vegas Blvd, North. This audience participation show makes "Oh, Calcutta" look like "Snow White and the Seven Dwarfs". It can be seen four times nitely, 10:15 pm, 12:15 am, 2:15 am and 4:15 am. Advance reservations are requested for this fantastic show.

Phyllis Diller was in the front row in a silver space suit. She applauded with her famous laugh. The room was packed and so was every night. We did three to four shows nightly, twenty minutes each. It was well advertised.

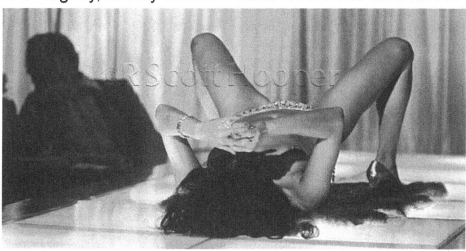

143

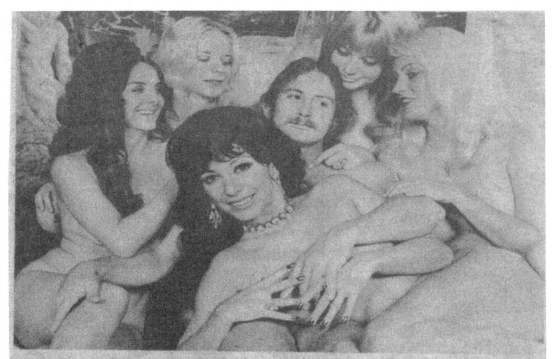

"HOW SWEET IT IS" seems to be the expression that Joel, male lead in "Orgy-73", is saying. Joel appears on stage nitely with a bevy of gorgeous nudes in the "wildest show in the west". The Gay 90's Club is 'home' for "Orgy-73", with three shows nitely and an early 8:30 p.m. show added on Friday and Saturday.

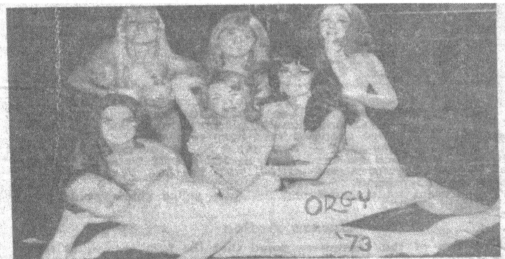

dollightful she, of the "Gay 90" big "Orgy '73," above with the drape shape of star Delilah, "Baby Lotion notion" Pat, Joan of "lark," one who raises "cane" . . . "Sugar;" dandy "Candy" & NEVER "flat-busted" Rachel, with their lightnin' "Rod" in front center. With today's wide open ways . . . "Orgy '73" may not be for your moter-in-law to see . . . but for the rest, & show-going best, it will pass the strictest test in PROVING nudes are NOT for prudes. (Don't ask about "Bobbi's" black eye, however.) Meeting & seating is Seymour while the lass of class by the front door window entrance glass is jolly dolly Laura. (Drop by & say "Hi to Marie before U see "Ogry '73," the most talked about shot in town!)

DELECTABLE DELIAH, star of "Orgy-'73", has performed from coast to coast and in Mexico City and Canada, as lead nude and stripper. She has also performed in movies and television. Her finale number has been described as the "wildest ever." "Orgy-'73" can be seen three times nitely at the Gay 90's Club, 1818 Las Vegas Blvd. No., with a special early show on Friday and Saturday.

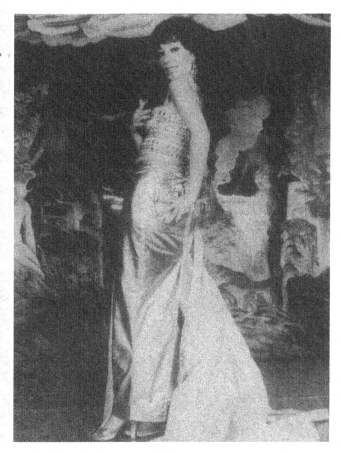

NOVEMBER 3, 1972

DELICIOUS, DELECTABLE DELILAH, is the headline in the totally nude "Orgy-'73" at the Gay 90's, 1818 La Vegas Blvd. No. Delilah and a bevy of other gorgeous doll can be seen three times nitely, with advance reservation requested.

CRITTERS, CORN FRITTERS & BIG BABY CITTERS, DEPT.:
 THERE'S now a whole lot of shakin', showin', as well as goin' on out at Marie "big deck" Floyd's jumpin' thumpin' "Gay 90's 55 hub Club in No. Las Vegas nightly. Seems she got together with LV talented show producer, Terry "bare fax" Gordon, & our local focal big realtor, Stan "I watch EVERY show" Lowe, to swing & bring the hexy sexy brand spankin' new vu of "Orgy '73" to U. You've got to see their "Gay 90's" pro-duction of "Orgy '73" to agree it is the mostest of today's bestest in the fe

male drape shape. Above are the slick chicks there-in that include the wel
stacked & packed brood & seductive mood of "I'm never 'flat' busted,'
Rachel; BIG five, as well as 'two', pointed star, Delilah; "What U see . .
is what I've got," Pat; "U bring the grin . . . I've got the skin," Joan
"trickey" Vickey (alias "Sugar") & "hep to any step, with "pep," Gai
(alias "Candy.") The FOUR times nightly go & show hale male chap o
tap, for the final "Orgy '73" closing big bath & water-bed . . . at least
think it's a water-bed, number is Joel "Rod" Miller, who also has a swee
music beat that's sure to be a feat & treat to all U audience dolls wh
don't as yet know "where it's at"! ! ! See & agree that "Gay 90's" wel
liked wheeler-deal-her Marie has quite a show of bare fact glee in "Org
'73" . . . now really bringin' 'em in, with a grin, to stray & play . . . th
"Gay 90's" way. (As top & bottomless showman Gordon would say; "It'
really a big 'bust-out'! ! ! ")

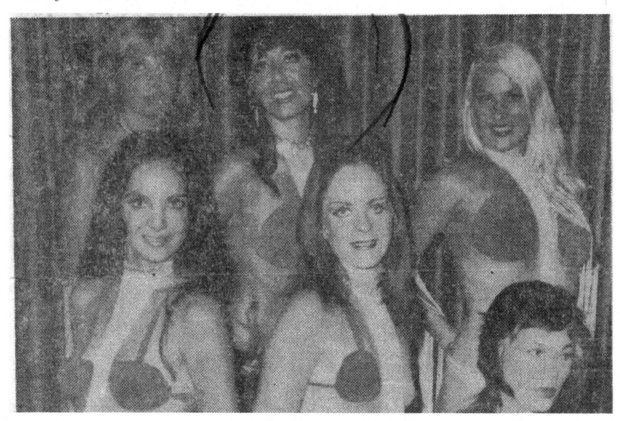

The show was advertised in every newspaper in Las Vegas, and flyers
throughout the South West, Just like expected from Las Vegas, and all new
photos courtesy by Robert Scott Hooper, it was the talk of the town.

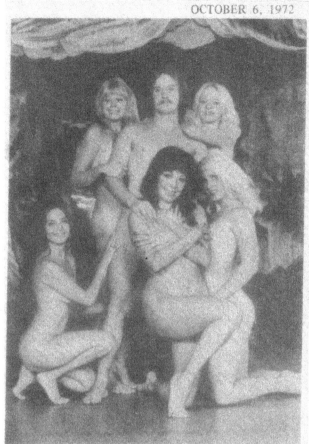

THE WILDEST, most sexy show ever presented in Las Vegas, "Orgy-'73", celebrates its grand opening this week at the Gay 90's, 1818 Las Vegas Blvd, North. This audience participation show makes "Oh, Calcutta" look like "Snow White and the Seven Dwarfs". It can be seen four times nitely, 10:15 pm, 12:15 am, 2:15 am and 4:15 am. Advance reservations are requested for this fantastic show.

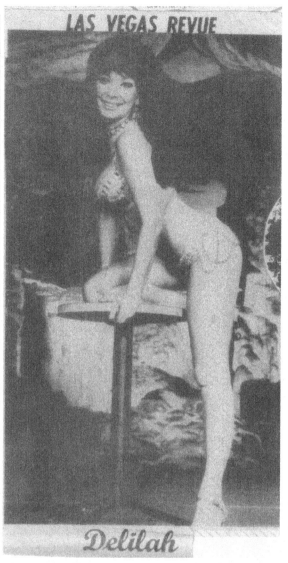

LAS VEGAS REVUE

Delilah

WHEN DELILAH DOES "HER THING" – The entire Gay 90's Club goes wild, in one of the most exciting shows ever seen in Las Vegas. "Orgy-73" features delicious Delilah, along with five other gorgeous females. Showtimes are 10:30 p.m., 12:30 a.m. and 2:30 a.m., with a special extra show on Friday and Saturday at 8:30 p.m.

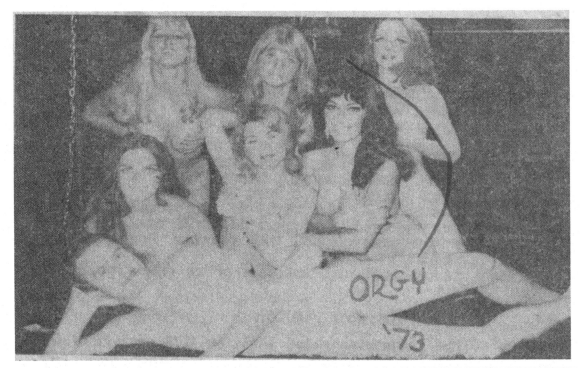

ORGY '73

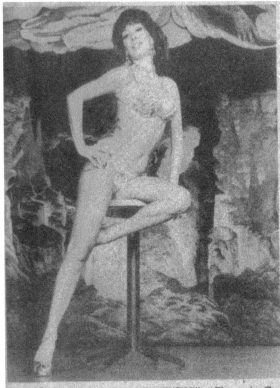

WHEN DELILAH DOES "HER THING" – The entire Gay 90's Club goes wild, in one of the most exciting shows ever seen in Las Vegas. "Orgy-73" features delicious Delilah, along with five other gorgeous females. Showtimes are 10:30 p.m., 12:30 a.m. and 2:30 a.m., with a special extra show on Friday and Saturday at 8:30 p.m.

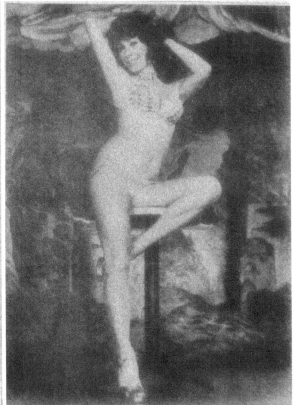

DELICIOUS, DELECTABLE DELILAH, is the headline in the totally nude "Orgy-'73" at the Gay 90's, 1818 La Vegas Blvd. No. Delilah and a bevy of other gorgeous doll can be seen three times nitely, with advance reservation requested.

148

Las Vegas As I See It

by Don Adkins

Tall and beautiful NANCY HENRY the vocalist with the most-est is currently doing a stint at the CASINO LOUNGE in the TROPICANA HOTEL. Nancy who just recently finished a successful gig at the Sky Top Rendezvous in the Landmark Hotel, sings with a flair that spell-bounds her audience. In some of the numbers that she sings, the notes catapault to the outer reaches of the realm of gravity. Besides being a top contender in the field of female vocalists, Nancy creates all of her costumes, and bakes the best pecan pie that you have ever put in your mouth. Also in the Casino Lounge is CHUY REYES, and DAVE BURTON. That's a lot of entertainment in one spot.

* * * * * * * *

MARIE FLOYD is very happy about her SEX ORGY nightly at the GAY 90's in North Las Vegas. The new show "Sex Orgy '73" is doing a landslide business with four shows nightly 10:15, 12:15, 2:15 and 4:15. Female star of the show DELILAH, told this reporter that she had never performed in a show of this nature before and that in the past had never completely disrobed in any show. Delilah further stated that the first week of the show she had been very nervous due to the uncertain feeling of whether the local officials would let an all nude sex act continue to run in the famous strip house. Marie Floyd owner of the Gay 90's, a beautiful woman in her own right, is smiling more since the opening of the show, since business has nearly trippled. This seems to prove one point, that people want to see this type of entertainment and I am not referring to just men. According to maitre'd SEYMOUR MERRIN the women are coming out to see SEX ORGY '73 in equal numbers. What ever the reason Sex Orgy '73 is doing a booming business, it could be Delilah's senuous strip, or Pat's dance with a lollipop, or the all nude dancers of the cast, or could it be the finalle when the male lead of the show JOEL MILLER and DELILAH start in a bathtub scene and end up on that fluffy-duffy king size bed with the rest of the cast? That, I will leave to you to decide.

* * * * *

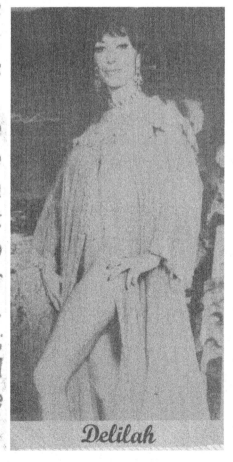

sexiest shows ever to play Las Vegas, "Orgy-'73". opens at the Gay 90's, 1818 Las Vegas Blvd. No., this week. Featuring a bevy of five beautiful girls plus a male lead, "Orgy-'73" makes "Oh Calcutta" look like a Walt Disney flick. Delilah, a top hollywood starlet and dancer is one of the featured leads. Showtimes are: 10:15 p.m.; 12:15 a.m.; 2:15 a.m. and 4:15 a.m. with advance reservations requested.

Delilah

November 24.1972

Las Vegas As I See It
by Don Adkins

MARIE FLOYD IS HAVING A SEX ORGY IN NO. LAS VEGAS EVERY NIGHT! Yep! that's right, Marie Floyd owner of the famous GAY 90's strip house in North Las Vegas has contracted with "FAR OUT PRODUCTIONS", a New York Nude Production Co. to present "ORGY '73" four times nightly at 10:15, 12:15, 2:15 and 4:15 in the wee hours. The Gay 90's is under a new policy of presenting raw all nude showcase production. When I say that it is raw and all nude, brother that's what I mean. The club has also had a face lifting in the way of decor, but your eyes will get an up-lift when you are confronted with the hostess ELINOR "SANDY" PLUMLEE cause she is nude also with only little tossels hanging over her you know what's. Sandy also comes by your table and gives you a neck back massage, that is if your wife or girl friend will allow it. As Sandy leads you to the showroom you will be greeted by SEYMOUR MERRIN your Maître'd, that is if you can take your eyes off the back side of Sandy's southern most part of her anatomy. Once inside the showroom dear friends you are in for a show like you have never seen before. It's an all new liberal movement, and the first all nude sex set to come to Las Vegas. I'm not sure how long it is going to last but for now it is one hell of a show. There are six all nude female dancers and one male lead dancer by the name of JOEL "ROD"? MILLER, and this guy gets paid for his work! The star of the female section is DELILAH, of my my DELILAH, others of the cast include SUGAR ANDRINI a red head, PATTY PLAYFULL a blonde and she can play at my house any time she wants to. CANDY JONES, another blonde, and I think some one is putting me on about these names, JOAN MONAHAN, a brunett and I believe that name. Last but by no means least, is RACHAEL SEDLACEK and that is for sure her name, it can be checked on the roster at the UNLV campus. RACHAEL is a student here and it is her first time to dance in any show, with or without clothes and after you see her with out clothes you may want to take a short course at the University youself. You will hear more about this beauty next week if they allow the show to continue. SATAN'S ANGEL who I quoted last week as retiring, did not! She can be seen in most of her glory as a cocktail waitress along with MARY LOU and little BOBBIE ROSS who is just too, too, too, too much. In all sincerity the show is put together very well. Of course I suggest that your girl friend or wife be very broad minded if you take them to see ORGY '73 because that

JOEL start it off on a king-sized fluffy duffy bed and the other five girls join in and as I said before JOEL gets paid for this kind of work. Quite frankly it would drive me out of my pea-picking mind.

Now as a reporter I have to check everything out before writing the story, therefore I have seen the show five (5) times (not including the rehersals) and naturally that was only to see how the crowds were running NATCH! and I must confess that the women are turning out for the show in great numbers, can this mean that women's lib is not working to well in the Las Vegas area? Whatever the reason, if you like your show spicy, raw, and to the POINT then whip on over to North Las Vegas and turn yourself on to "ORGY '73" at MARIE FLOYD'S GAY 90's.

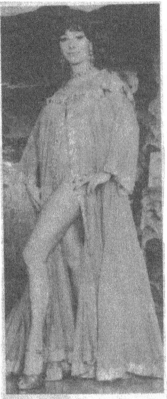

ORGY '73 – One of the most sexiest shows ever to play Las Vegas, "Orgy-'73". opens at the Gay 90's, 1818 Las Vegas Blvd. No., this week. Featuring a bevy of five beautiful girls plus a male lead, "Orgy-'73" makes "Oh Calcutta" look like a Walt Disney flick. Delilah, a top hollywood starlet and dancer is one of the featured leads. Showtimes are: 10:15 p.m.; 12:15 a.m.; 2:15 a.m. and 4:15 a.m. with advance reservations requested.

Delilah star of "Sex Orgy '73" at Gay 90's.

Lancaster can do it. A fine motion picture which I'm sure everyone that sees it will enjoy.

Delilah, star of "Sex Orgy '73" at the Gay 90's in North Las Vegas has quite a few credits behind her being a starlet on the Hollywood scene. When nudity first started in the motion picture business, one of the first was a motion picture called "Not Tonight Henry" and Delilah was in that film. She has other credits film-wise, television-wise, but currently is the star attraction of "Sex Orgy '73" in North Las Vegas.

Delilah is truly the star of this show, and performs with a flair as only Europeans can do – Delilah, of course, being of German descent. "Sex Orgy '73" is a new concept of all nude performances on the Las Vegas scene, but others are cropping up on the Las Vegas Strip. The latest being "Sex is Now" currently at

(Continued on Page 17)

THERE NEVER ever has been a live glo sho in Vegas as U can now see in "Orgy '73" at ye No. Las Vegas hoppin' poppin' bare fact packed "Gay 90's"... where everybody, with one, is now having nightly fun, WITHOUT sun. At this well liked Marie Floyd pleasure palace go &

150

Las Vegas SUN

CIRCULATION 382-3078

NEWS 385-3111

23 No. 112 LAS VEGAS, NEVADA, FRIDAY, OCTOBER 20, 1972

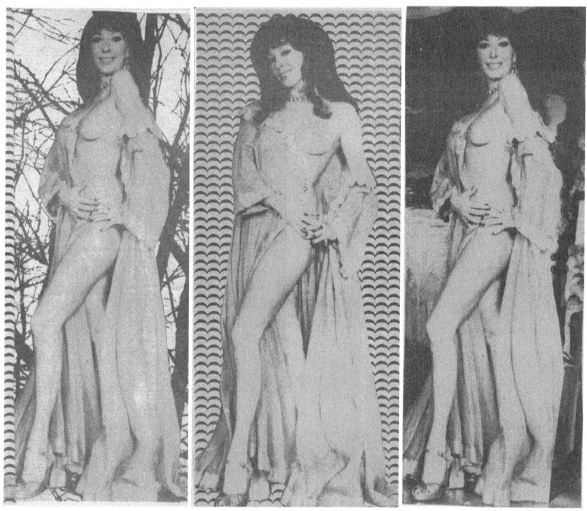

DELECTABLE DELIAH, star of "Orgy-'73", has performed from coast to caost and in Mexico City and Canada, as lead nude and stripper. She has also performed in movies and television. Her finale number has been described as the "wildest ever." "Orgy-73" can be seen three times nitely at the Gay 90's Club, 1818 Las Vegas Blvd. No., with a special early show on Friday and Saturday.

151

Las Vegas ☀ SUN

Vol. 7, No. 23 1764 Industrial Road, Las Vegas, Nevada 89102 November 24 thru 30, 1972

NOVEMBER 24, 1972

Las Vegas As I See It

by Don Adkins

There have been many jokes and funny stories about this columnist breaking his arm "deer dancing" in Salt Lake City. To correct all falacies concerning my broken arm the story goes like this: Leon Spouse, owner of Big Valley Riding Stables and Walking Horse Ranch invited me on a deer hunting trip to the High Unta Mountains near Vernal, Utah. The deer hunting trip was completed and we all got a deer. After the deer hunting trip, we went to Salt Lake City and at a club Halloween night I was dancing with a dear and fell. As I was falling I reached behind me with my right arm to try and break the fall, it resulted in four breaks in my right wrist where upon I was taken to the Utah University Medical Hospital for two days. One unusual aspect of the entire trip to Utah, that on the last day of

Burt Lancaster of "Ulzana's Raid" discusses death scene with Vegas Visitor columnist Don Adkins during shooting at Valley of Fire. Movie is currently appearing at the Cinerama Dome.

hunting, and on the way out of the Flying Diamond Ranch, I was twisting the radio dial for a good station and lo and behold who comes on nearly 700 miles away in Las Vegas but Walt Reno from station KORK. We immediately stopped the truck and began listening and KORK Radio was booming in 5 by 5. We heard the Sports Scoreboard, the Stardust Hotel commercial, and of course music. It was very enlightning being that far away from Las Vegas to pick up a home radio station. My congratulations to KORK for getting that far out from the Las Vegas area.

"Ulzana's Raid" a motion that just opened last week at the Cinerama Dome which stars Burt Lancaster, Bruce Davidson and Richard Jako was filmed in part, at the Valley of Fire near Las Vegas. This reporter was fortunate in being invited to that set this past summer to renew old acquaintances with Mr. Lancaster who starred in the film, Bob Aldredge who directed the film and Carter DeHaven who produced the film. If you see this motion picture, the first half of the film has sequences shot from location in Arizona. The last half was shot at the Valley of Fire. In the Ariz. sequences the technicolor has a brownish cast to it resulting from smog in Ariz. When the Valley of Fire sequences appear on the screen you can tell immediately that you're in Nevada. The sky is a deep blue and the Valley of Fire is photographed in its glorious beauty. For the cowboys and cowgirls or for anyone this is a rip roaring western as only Burt

Delilah star of "Sex Orgy '73" at Gay 90's.

Lancaster can do it. A fine motion picture which I'm sure everyone that sees it will enjoy.

Delilah, star of "Sex Orgy '73" at the Gay 90's in North Las Vegas has quite a few credits behind her being a starlet on the Hollywood scene. When nudity first started in the motion picture business, one of the first was a motion picture called "Not Tonight Henry" and Delilah was in that film. She has other credits film-wise, television-wise, but currently is the star attraction of "Sex Orgy '73" in North Las Vegas.

Delilah is truly the star of this show, and performs with a flair as only Europeans can do — Delilah, of course, being of German descent. "Sex Orgy '73" is a new concept of all nude performances on the Las Vegas scene, but others are cropping up on the Las Vegas Strip. The latest being "Sex is Now" currently at

(Continued on Page 17)

NOVEMBER 24, 1972

AS I SEE IT . . .
(Continued from Page 16)

the Royal Las Vegas. This not entirely all nude, b close to it. Further on o on the strip at the Hacienda Hotel is "Love of Sex" an at Circus Circus "Frenc Love Connection". I appears to this columni that the people who come t Las Vegas want to see th type of entertainmen because all of the show including the Palomino Clu are doing a landslid business. We have bell dancing at the Aladdi Hotel, so the concept seem to be that the public wan to see more nudity and mor sex. Now I'm not suggestin that all the hotels in the L Vegas area or showrooms g to all sex shows, fo certainly we need superstar on the strip to lure ou visitors to Las Vegas. Bu the trend is moving and it moving toward nudity — i fact, it has moved towar nudity. Whether this will la of course, is up to th public. If this is your ba then I suggest that you se Sex Orgy '73 at the Gay 90 in North Las Vegas. It's whale of a show and you're from out of state an your state has not come i with this type o entertainment, you probably have variou thoughts after seeing th show.

Don Adkins was a good friend of mine. He wrote articles about me several times in the Las Vegas Sun, and Revue Journal, and made sure to mention me a lot. Every place, food, or show, except House of Pancakes, was always comped for me. All I needed was to make a phone call, especially to The Stardust.

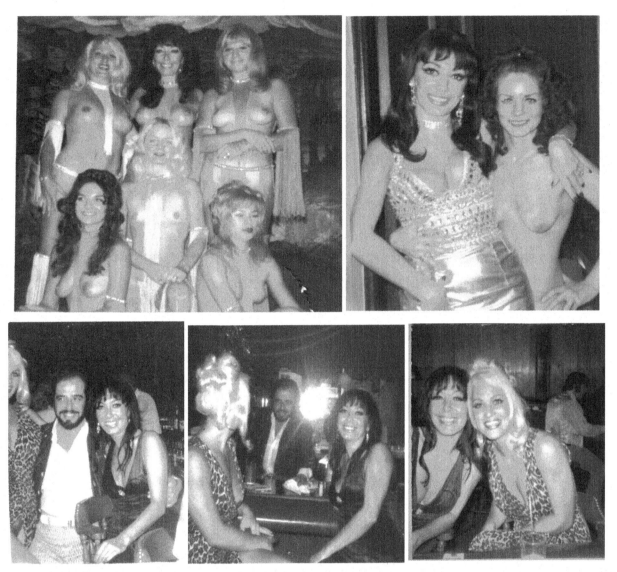

Above: my snapshots with the cast and Patti and one of the managers.

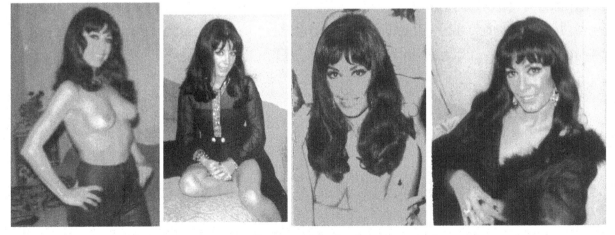

Just snapshots

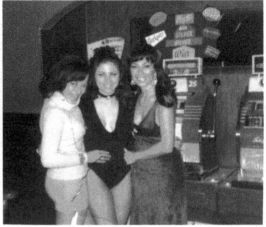

Our cocktail waitress, Dave, my personal manager, myself, and Angel Walker aka Satans Angel, was also our cocktail waitress for this show.

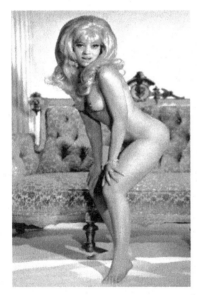

One day during the show Joe, my lead man, surprised us with his own crabs. The health department was called in, cleaned up in a hurry and everything was hushed, and the show went on like usual. I did not catch any. Joe served in Viet Nam. He was a blooming butthead.

Monica Kennedy, a high-yellow black girl, with great skin texture, would do a short show in the lobby of the Gay 90s during our breaks.

She would do her famous "banana" act, using her vagina to make a banana disappear. She raked in the money, for sure. But somehow, it was not offensive, her being so clean-cut and pretty, her vagina was shaved and fresh looking, just like a newborn, and it was just entertaining. (My personal photo of her.) Next: in front of the CIRCUS CIRCUS

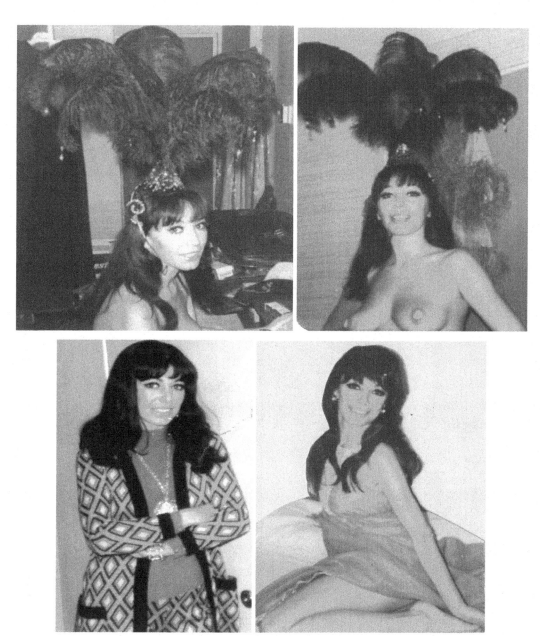

One day, I was being invited to go backstage at the Hilton Hotel when I bumped into Elvis in the hallway to the dressing rooms, with his entourage. Us being dressed similarly, both in black leather slacks and black tops, and our hair was black, we looked like we belonged together. Elvis took a brief stop, smiled at me, said hello, and then we went on our journey smiling.
 Then Patty and I were asked by Howard Senior, to pose for some advertising for his Velvet Touch, a massage parlor, and we did. And so we got huge publicity on two billboards, which nearly ran for five years, and all visitor flyers and newspapers.

 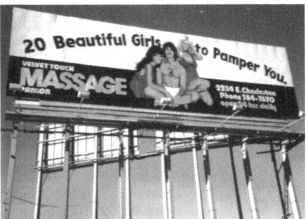

f

Two billboard ads for the Velvet Touch, they advertised for five years.
#1 Las Vegas Blvd, #2 Charleston Blvd

did the most advertising.

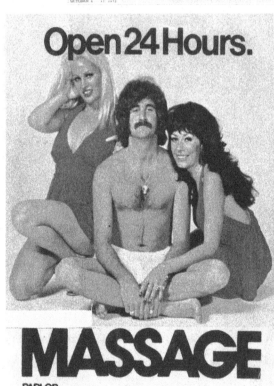 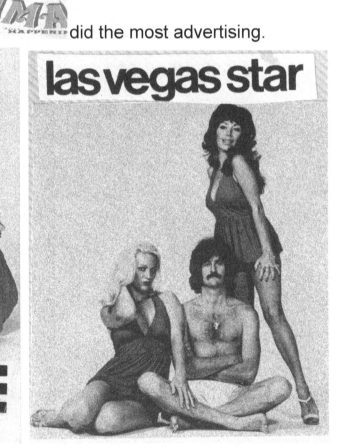

Here are ads with Patty Playful, and Tim Letourneau for the Velvet Touch.
Many images appeared all over Las Vegas. Every newspaper and tourist
flier for the whole Southwest.

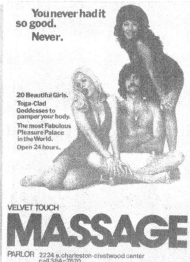

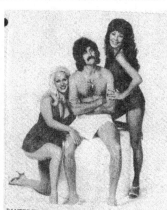

left: a double-page newspaper ad. Center: original photo, and another ad.

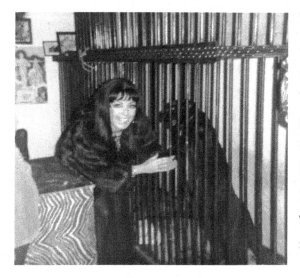

While in Las Vegas, I was introduced to Siegfried and Roy backstage at the Stardust Casino by my manager. I got to play with their black leopard, and we got to speak German. The next time Siegfried and Roy invited me to their home. Now near the end of the year, my manager Dave told me that the club will have a raid this weekend, he had some inside info because of his mob

connection. He suggested that I leave so that I would not get arrested.
So I did, and everyone who stayed was arrested the next night because
they were clueless.

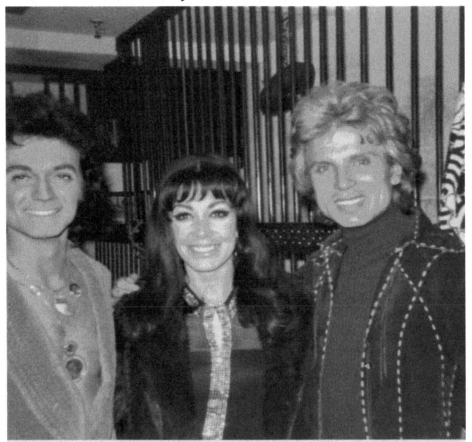

My sister filed for divorce while I was in Vegas. During this time her
husband Stirling, ghost-screen wrote the movie SHAFT.
After Las Vegas, back home to Hollywood., then Phoenix again.

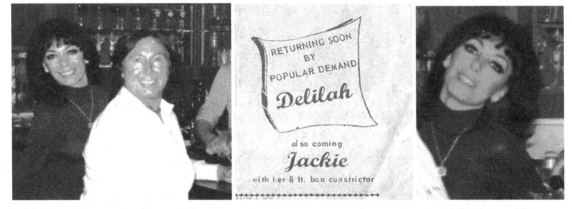

Home with my mother in California. Pre-ad on January 9. 1973 for Phoenix

TALENTED DELILAH has returned to the valley once more for a one-week stand at the Tender Trap. She will be featured at the club thru Wednesday, January 9, with four shows nightly.

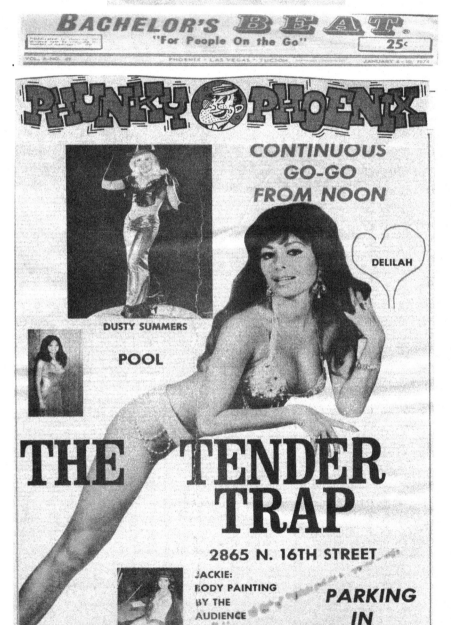

159

Again, I was held over.

DANCER DELILAH is back at the Tender Trap in Phoenix. The sultry exotic is doing three shows nightly for a limited engagement.

ONE OF THE top exotic dancers in the western U.S. is again slated for a Phoenix appearance. Dancer Delilah is currently appearing in all-nude revue at the Gay 90's in Las Vegas and is booked to open at the Tender Trap in Phoenix on December 7. According to the club management she will be at the TT for only two weeks.

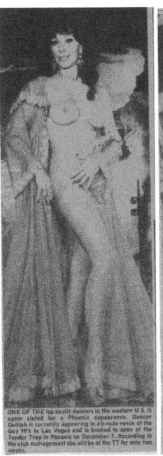

ONE OF THE top exotic dancers in the western U.S. is again slated for a Phoenix appearance. Dancer Delilah is currently appearing in all-nude revue at the Gay 90's in Las Vegas and is booked to open at the Tender Trap in Phoenix on December 7. According to the club management she will be at the TT for only two weeks.

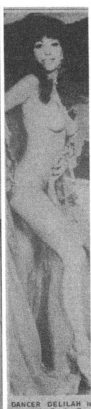

DANCER DELILAH is back at the Tender Trap in Phoenix. The sultry exotic is doing three shows nightly for a limited engagement.

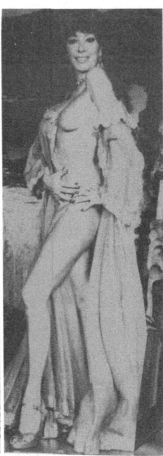

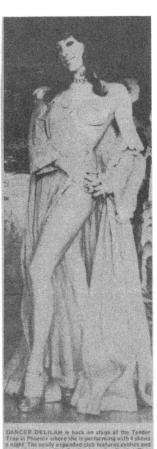

DANCER DELILAH is back on stage at the Tender Trap in Phoenix where she is performing with 4 shows a night. The newly expanded club features exotics and go-go dancers daily. On Sundays the Tender Trap hosts a pool tournament from 3 to 6 p.m.

Using all my new photos

DANCER DELILAH is back on stage at the Tender Trap in Phoenix where she is performing with 4 shows a night. The newly expanded club features exotics and

By Geoff Gonsher

THE TENDER TRAP puts in its bid for the Valley's hottest nitespot by proudly presenting a wide variety of sexy, sensuous strippers and exotics. Top billing this week goes to delicious DELILAH, who comes to us direct from her totally nude performances on the Las Vegas Strip.

160

Delilah **8th SMASHING WEEK**

Hurry, Hurry, Hurry! Visit THE TENDER TRAP and view the wonders of DELILAH, that mythical, magical showpiece before she departs to other locations to continue her quest for fame.

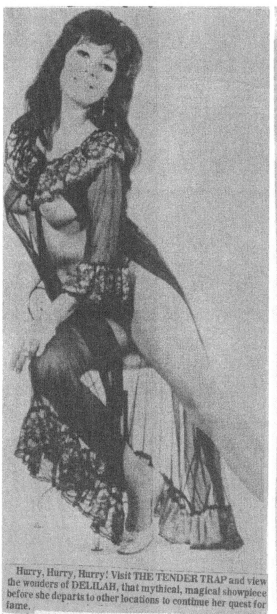

Hurry, Hurry, Hurry! Visit THE TENDER TRAP and view the wonders of DELILAH, that mythical, magical showpiece before she departs to other locations to continue her quest for fame.

TALENTED DELILAH has returned to the valley once more for a one-week stand at the Tender Trap. She will be featured at the club thru Wednesday, January 9, with four shows nightly.

Exotic dancer DELILAH closes this weekend at the TENDER TRAP and dancer DUSTY SUMMERS will be joined by her sister RUSTY to make with the featured entertainment...it's called "double jeopardy"...

With the gay couple, our cocktail waitresses, for a bike ride.

My boss, Nancy, at the Tender Trap, died when she was in her fifties. Rumors had it that it was a complications due to plastic surgery.

My last week, Ed and I spent time at the Paradise Turf race track. It was emotional. because I never knew when I would be back.

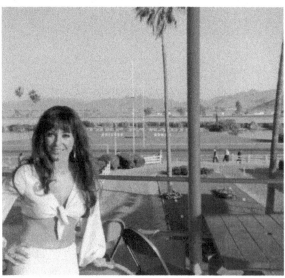

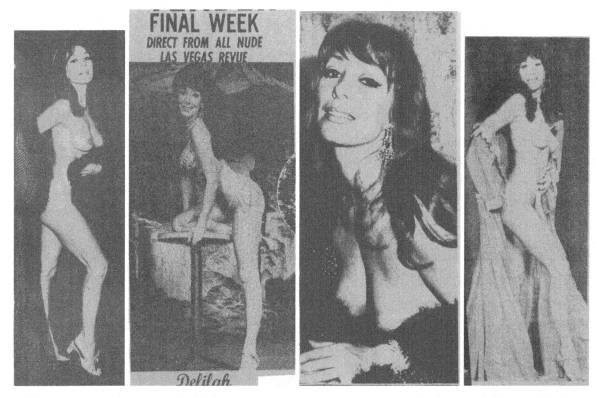

FINAL WEEK
DIRECT FROM ALL NUDE
LAS VEGAS REVUE

Delilah

At the beginning of 1973, my agent booked into a Dallas, Texas Theater. I had a small coffee klatch at my home, with Rikki Simone, Liza, and Rochelle. Rikki was booked to follow me in Dallas. I left Burbank and flew directly to Texas for one week only. Someone picked me up from the airport and drove me to my motel.

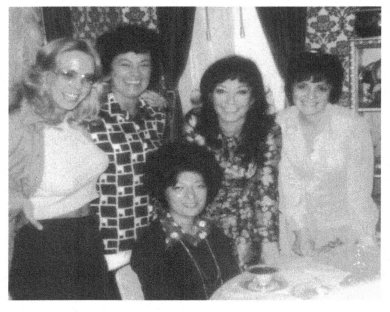

Liza Jourdan (Caprice`s daughter), Rikki, and her lover, myself. Rochelle, our cocktail waitress from the Body Shop. One last get-together before leaving for Dallas.

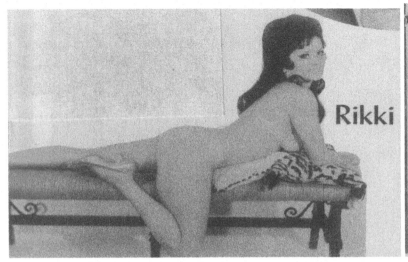

My personal picture of Rikki. My Dallas ad

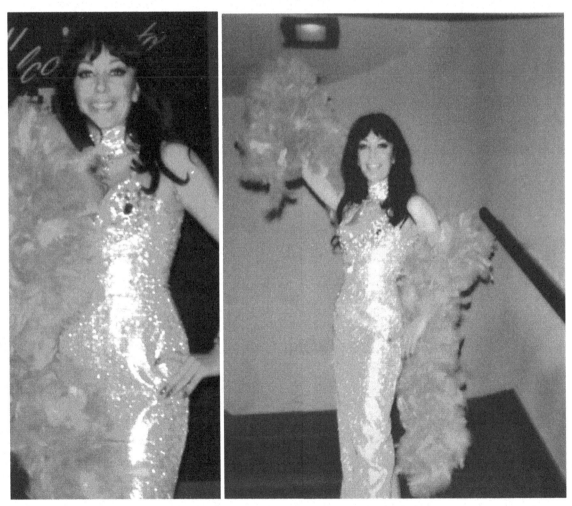

Wearing another one of my creations in the lobby of one of the Dallas,
Texas theaters, at the staircase before going on stage. .

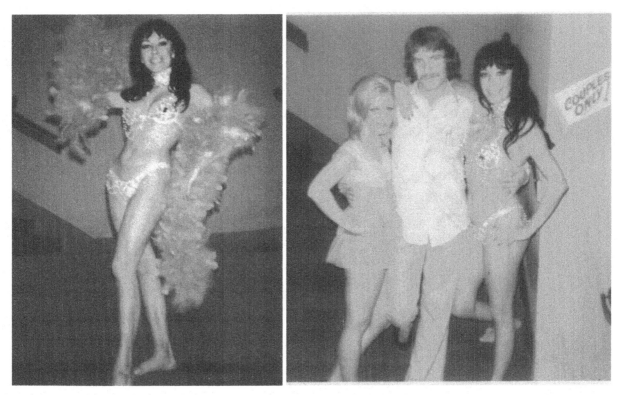

This costume was silver eyelets, set off with a hot pink boa.
The next me here with one of the managers and a housegirl

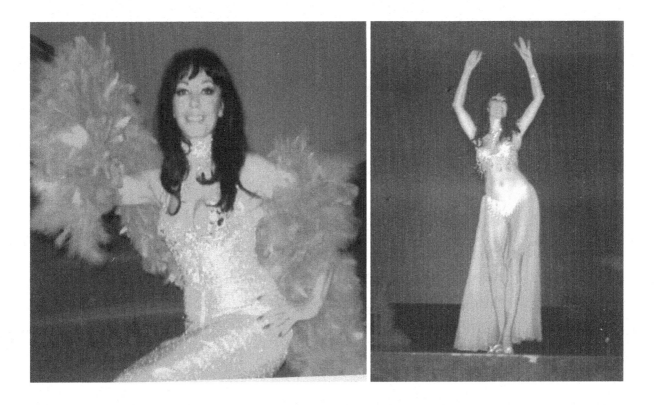

On stage at the theater in the lobby with the manager`s St.Bernard dog, an excellent watchdog who does not move when someone enters the room. While I was in Dallas a friend of the manager, a tall Texan, who dressed just like a Texan, with a cowboy hat and jeans, took me on the historical route that President Kennedy took on his fateful day. We started from the Theater where Oswald hid, and from where the supposedly fatal shot came from. A most historically memorable day.

On my last day in Dallas, with their two house girls, Rikki, and the main manager. Right: I had a pleasant surprise when Rikki Simone came early with Sharon Carr and Barbara for a visit.

With Rikki before show time and the St. Bernard puppy. My last show before flying back home to California.

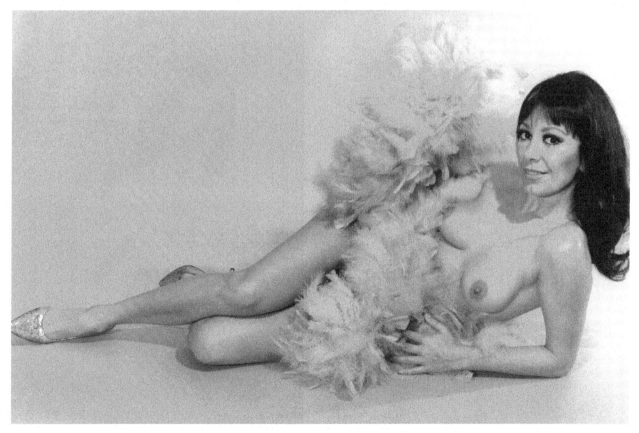

Home again.

Back in Hollywood and back at The Body Shop 1973.

Then our beloved Al Deitch finally passed away. I felt a tremendous loss. During this time all of us dancers were uptight and tensions were building up, which led to a fight between my good friend Lisa and me.

My only physical fight ever. After she had come off stage, we had a few words and one thing led to another when she decided to pull my hair from behind me, while I was sitting on my chair. I could not fight back.

Her arm was the closest thing next to me, so I bit her as hard as I could until I drew blood, and all my teeth marks were on Lisa`s arm. She let go real fast and was ever so sorry. Shortly after, we laughed it off. That should have never happened between friends, but all of our tensions were high because we lost our beloved boss. With Al Deitch being gone now, we dancers moved to the Classic Cat and auditioned for the upcoming Cabaret Show. Lisa was married at that time, but when she met Lacey Jones, a total lesbian, our guitarist, she fell in love with her. Lisa then divorced her husband and lived with Lacey. But after a few years, Lisa left Lacey and dated men again. Lacey remained a virgin, at 40 years old when I saw her last.

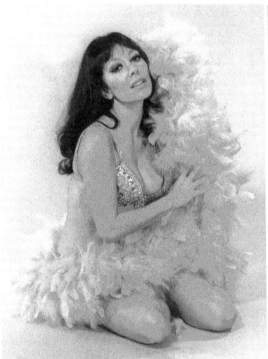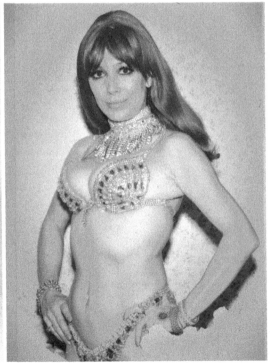

My new photos from Sandy Fields.

168

These photos for my Burlesque appearances were done as a favor for me. Otherwise, Sandy would only photograph movie stars or celebs privately in his studios. He also was sometimes asked to take photos of mobsters in Hollywood. He was very much liked and trusted in the movie industry. Forty years later we reconnected in Las Vegas and stayed close friends until he passed away-he had asked me to marry him then. Every time we dated later on in years, he always greeted me with a long stem red rose.

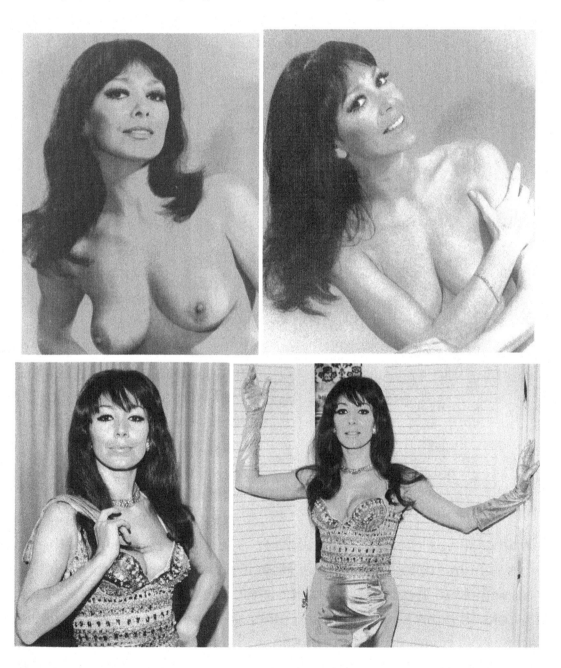

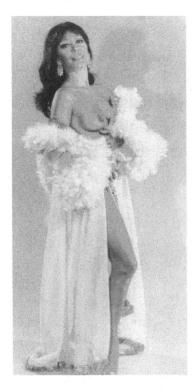

Delilah's artistry as a stripper has made her the current queen in a royal line that stretches back to Lili St. Cyr and Tempest Storm. A former Miss Berlin, the German-born beauty makes her home in Hollywood when she's not on the road. A temptress on stage, she's basically the homey type off-stage, a warm, friendly woman who loves dogs and cats and takes justifiable pride in her profession. ♡

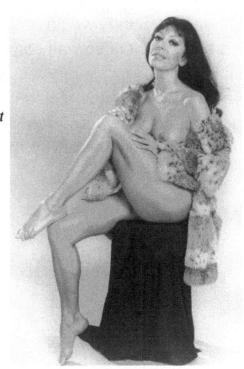

The Classic Cat entrance where we once would see "Kookie".

In 1959 I attended one filming of the show "77 Sunset Strip" with actor Lyle Bettger, my two sisters, and one of the producers.

The history of the Classic Cat: in the fifties it was used for "77 Sunset Strip" the TV series. Once upon a time, it was DINO'S, then JERRY'S (Lewis). Harvey was the owner of Dino's, whom I dated for a while. Now it's The Classic Cat. I signed a contract with Alan Wells, the current owner. We all had to rehearse for three weeks to be in sync with each other. It was a tribute to the movie "Cabaret", only nude. I made all the costumes, for each girl, each in different colors.

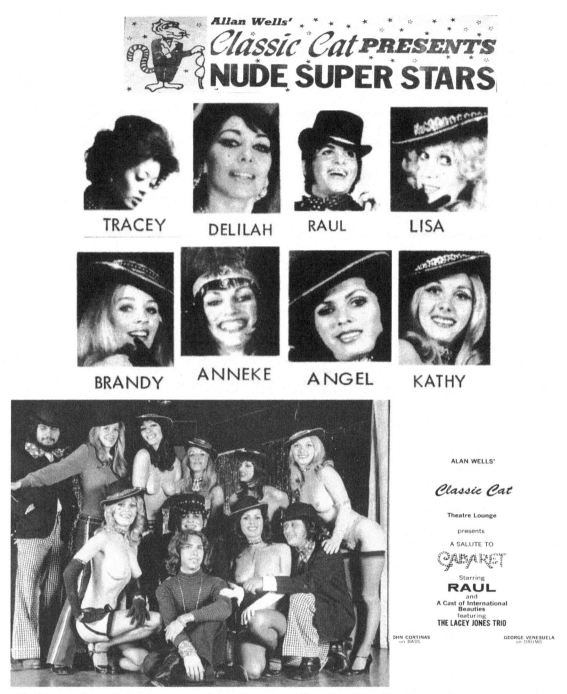

The cast, a group shot on stage by Caesar Guest. Left: Drummer George, guitarist Lacey, Delilah, Brandy, Anneke, and Kathy. Bottom: Lisa, Raul, and Angel, our choreographer, and John on bass.

Kathy was one of Bob Hope's girlfriends. He often came to see her. This was common in Hollywood and no one tattled about anyone.

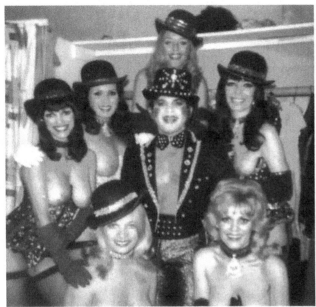

The cast, right: with Raul and Anneke.The finished costumes: mine in lime green, Anneke's in red, Angel's in white, and Kathy's in blue. We did the chorus line and on the chairs, and also comedy skits with Raul.
Then came the single strip and finale.

Delilah was one of the stars of the Classic Cat's nude version of "Cabaret" (left and

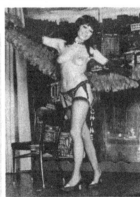

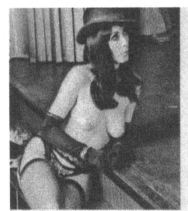 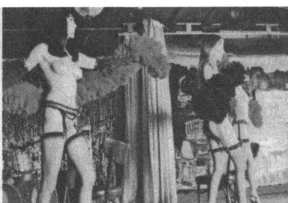 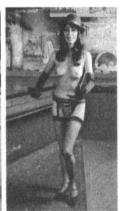

Watching closely at dress rehearsal, then showtime.

172

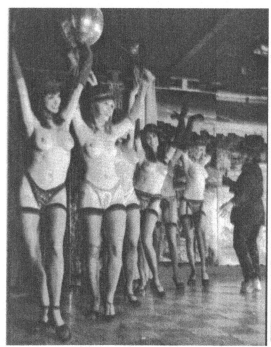
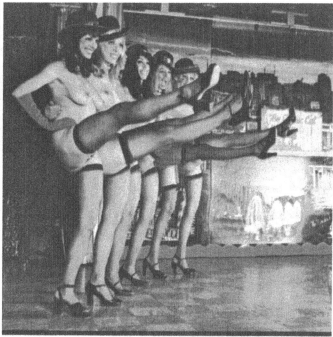
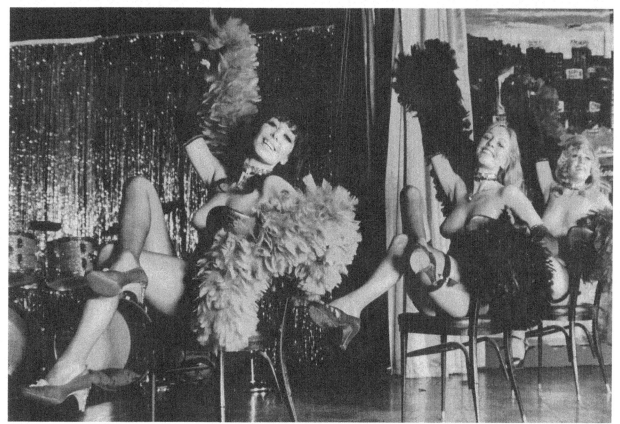

After three weeks of rehearsal, the opening show was here. Nervous and exciting as it was, here it was the Tribute to the Cabaret movie. Hollywood celebrities were present every night. Let the fun begin.

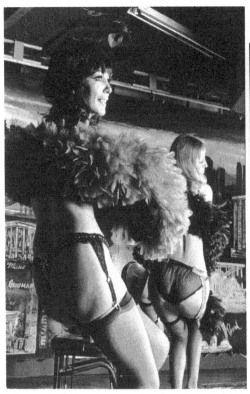

NUDE "CABARET"

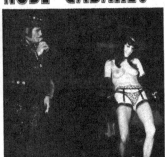

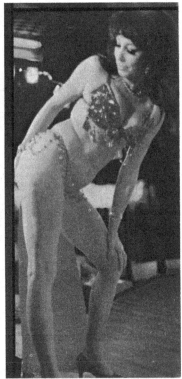

The Classic Cat on the Sunset Strip, Hollywood's classiest showcase for nude entertainment, is currently going strong with a "salute" to the hit musical "Cabaret," featuring six beautiful nude girls doing some very special things!

"Here the girls are beautiful . . . even the orchestra is beautiful," sings the Emcee in "Cabaret," the smash musical show and movie that is now being "saluted" at The Classic Cat, in the heart of the Sunset Strip, Hollywood's foremost nude entertainment club. The last musical to be saluted at the Cat was "Hair," and that was so successful it ran for two-and-a-half years. Cat owner Allan Welles is anticipating another long run with "Cabaret." And well he should. It's a good show—and the girls really are beautiful.

The chair number with Raul single strip

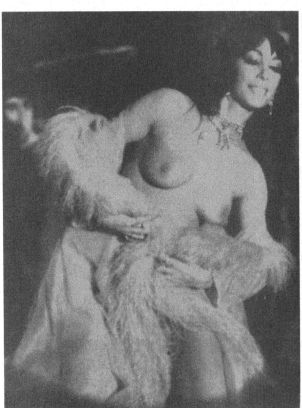

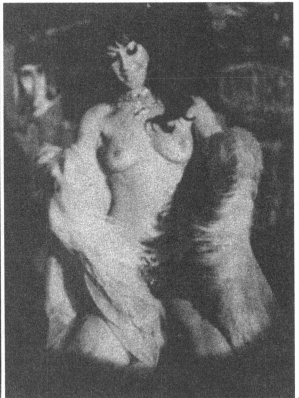

174

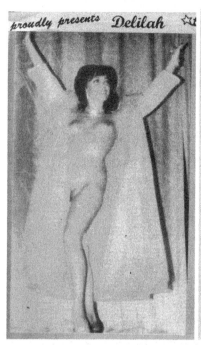

DELILAH

Meet Delilah—the reigning exponent of the Art of the Striptease and one of the top nightclub draws in Hollywood and Vegas.

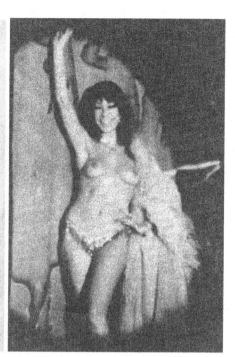

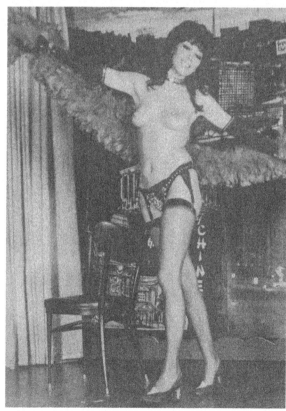

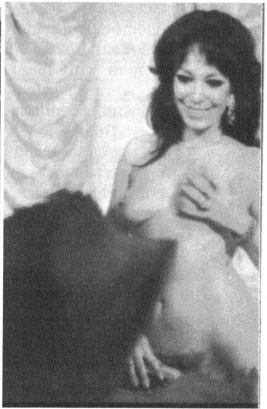

. There's Delilah Jons (covered last month in ADAM), a Germanic beauty of ultimate wit and charm whose dancing recreates the finest moments in burlesque with shades of St. Cyr. Then

175

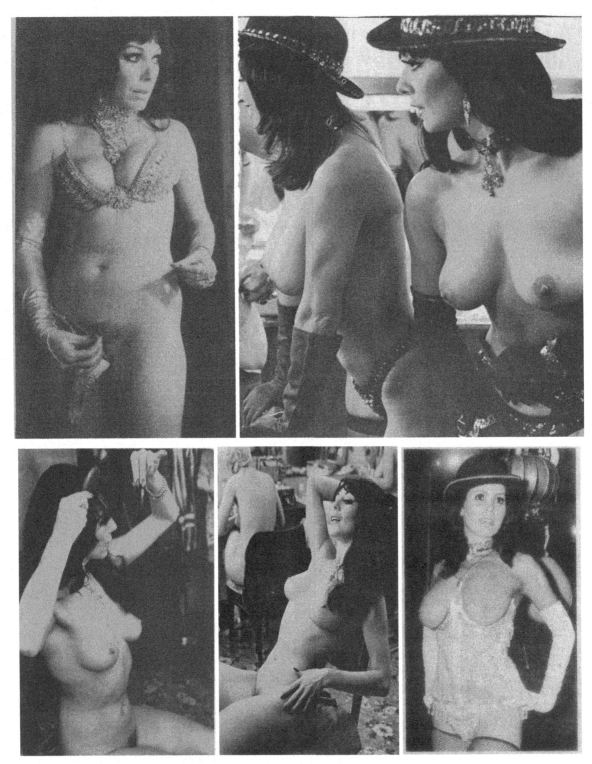

After and before showtime, backstage fixing hair, and make-up.
We spent most of the time in the dressing room in the nude.
Right, Angel is in my newly finished costume for her.
Caesar Guest took many extra photos of me for magazines with extra pay.

DELILAH

what her full name is after all — Delilah Jones. Oh, well, we've been put on before . . . or, as in this case, upstaged. Anyway, Delilah's performed in Hollywood, Las Vegas, Mexico City, Phoenix (Phoenix?), in places like the Classic Cat, the Gay Nineties, the Casino Royale — and if you've never heard of any of 'em you ought to get your head out of the freezer. She's also acted in movies — about 20 in all — likes cats and dogs, professes to be an off-stage homebody (huh?) — and still, despite innumerable and sundry distractions, she has time for her husband. That, of course, is the mark of a true professional. Three cheers for Delilah!

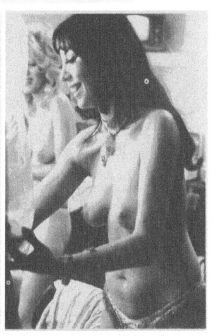

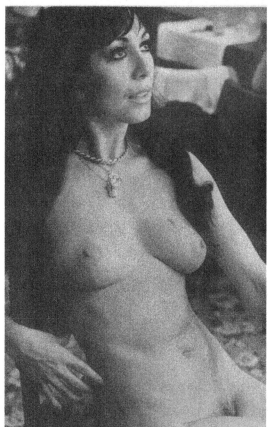

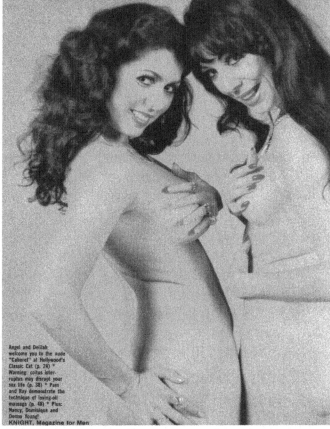

Angel and Delilah welcome you to the nude "Cabaret" at Hollywood's Classic Cat (p. 24) * Warning: coitus interruptus may disrupt your sex life (p. 38) * Pam and Ray demonstrate the technique of loving-oil massage (p. 48) * Plus: Nancy, Dominique and Donna Young! KNIGHT, Magazine for Men

Angel and I made it on the back cover of KNIGHT magazine.

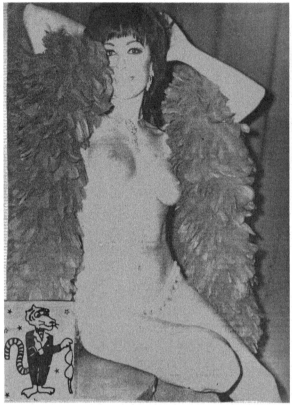 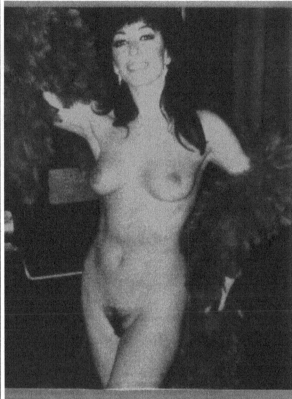

This is Delilah. She dances at the Classic Cat on Sunset Strip in Hollywood.

Delilah, once crowned *Miss Germany* (she was born and raised in Germany), stands 5'6½". She weighs 120 pounds, has brown eyes and black hair, and has recently closed in Las Vegas, performing at the Gay Nineties and Casino Royale.

She has· appeared on several television shows, and in several movies, and her hobbies include painting, dress designing, gardening, collecting antiques and Indian jewelry. She also related to MATE that she loves diamonds and minks, that she loves the desert and the sea . . . and that she loves to watch things grow.

Delilah likes her men tall, dark and handsome, and has two sisters just as pretty as herself. She travels quite often, headlining shows on the west coast, Mexico and Canada.

She enjoys dancing at the Classic Cat and is responsible for creating most of the costumes in the Classic Cat's new production number, Cabaret. But unlike the Broadway version of

Caesar Guest many photos of me in the nude.
MATE was a Hollywood Celebrity entertainment paper, where I landed a large centerfold in 1974, which would be my last one ever.
Ed came to visit me at the Classic Cat.

178

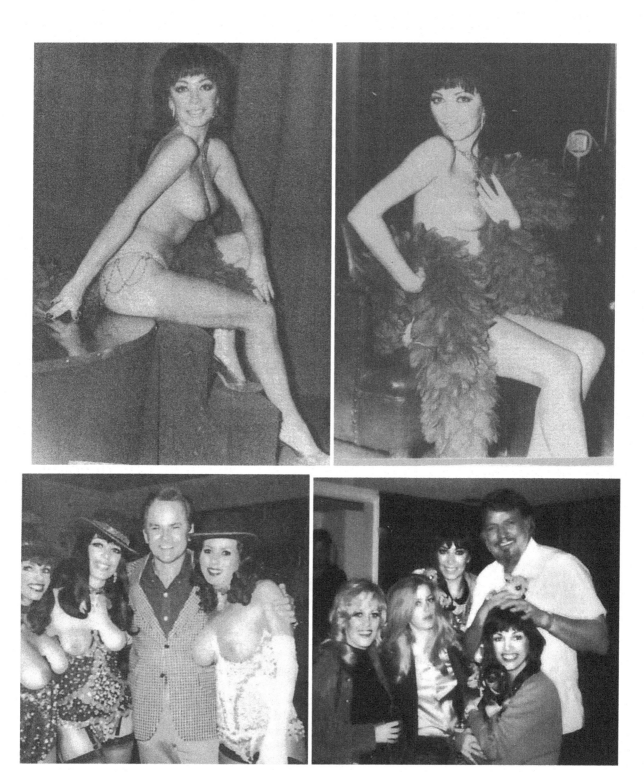

 Anneke, myself, Bob Crane & Angel-Lisa, Lacey, myself, our boss Alan
Wells & Anneke. Bob Crane was a womanizer and was nightly at the
Classic Cat, many times with his wife. Rumors were that the couple were
swingers. But he was always a gentleman, never out of line.

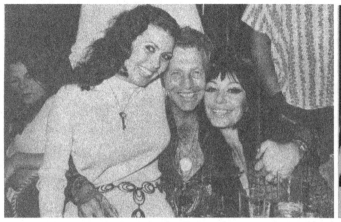
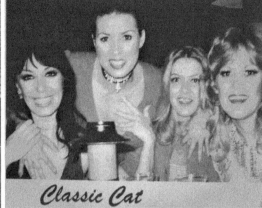

Classic Cat

With Angel and Evel Knievel me with Angel, Lacy, and Lisa

Between shows, we always found good times, like here with Evel Knievel, who was dating Angel at the time. Our show breaks used to be at least two hours or more. Plenty of time for fun.

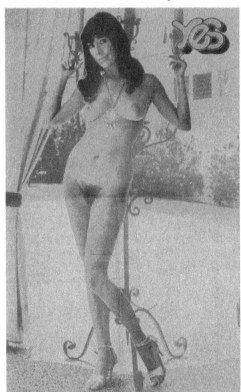

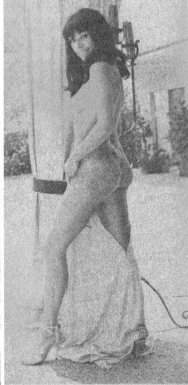

My last centerfold was in 1974 in YES entertainment paper, right: "Cabaret" magazine 1975. After the Classic Cat show was over, I decided to let Caesar take more nude photos of me for magazines.

MATE, YES, KNIGHT,CABARET, and many Adam magazines were some of them. Posing nude for magazines was something new to me, but I thought it was the right time. These photos were taken at the Silliphant's home. Because it was pretty and much privacy to shoot nude photos outdoors and around the pool. After my sister Margo was divorced from Stirling, she sold the house to Lamar Wilson, from Sanford and Son, for around $325,000.00. YES, a large Los Angeles entertainment paper.

The pages were newspaper-size.

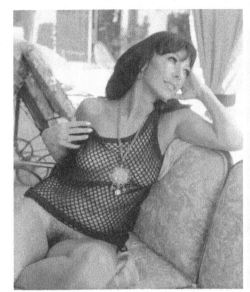

Delilah's artistry as a stripper has made her the current queen in a royal line that stretches back to Lili St. Cyr and Tempest Storm. A former Miss Berlin, the German-born beauty makes her home in Hollywood when she's not on the road. A temptress on stage, she's basically the homey type off-stage, a warm, friendly woman who loves dogs and cats and takes justifiable pride in her profession. ⌣

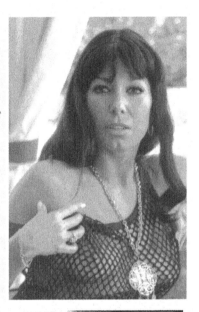

Playing peek-a-boo at my sister`s home in Trousdale, Beverly Hills.

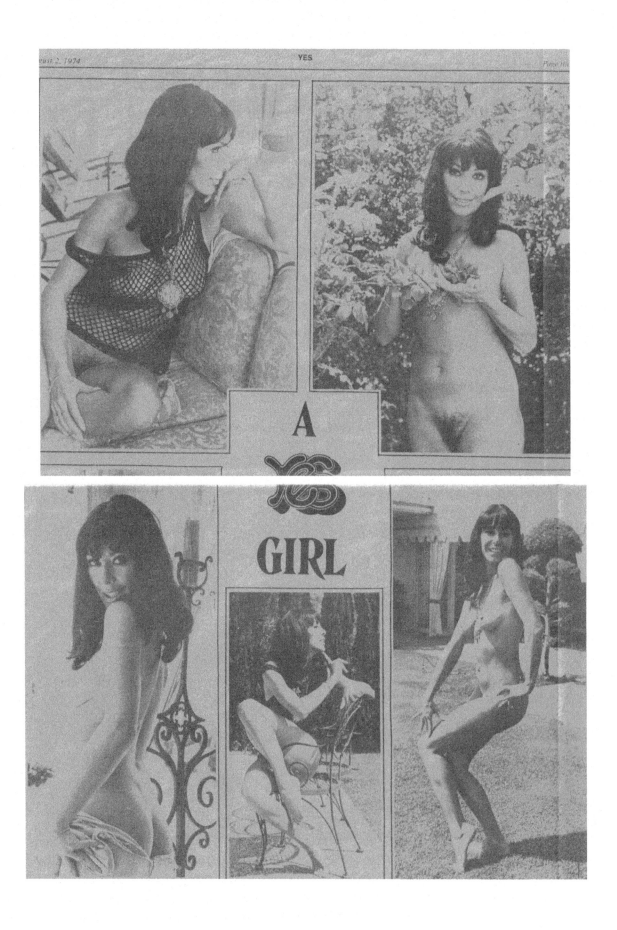

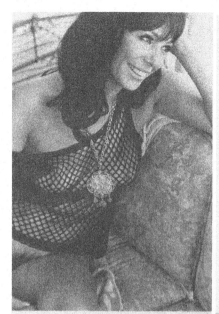

DELILAH JONES

viously, Delilah — our Delilah anyway — isn't out of the Bible, though no doubt she reads it, if only for the memories. Second, people, and especially women, don't wear clothes anymore — not in the movies, not on stage, not anywhere — so that when you see the latest in fashionable attire on display in equally fashionable show lounges and manicure parlors, you come to realize very quickly that chic has, at last, also become cheek. Third . . . well, we forget what's third, other than the fact that PR rules the world nowadays . . . which brings us, finally, back to Delilah, politely a dancer, professionally a stripper, a former Miss Germany and Miss Berlin rolled into one tasty wienerschnitzel. (Jawohl, anschluss!) Happily married, her vital statistics report, to a man named Jones, we must assume, because that's

14

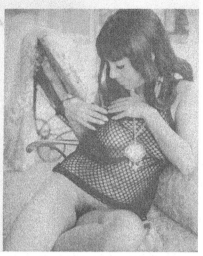

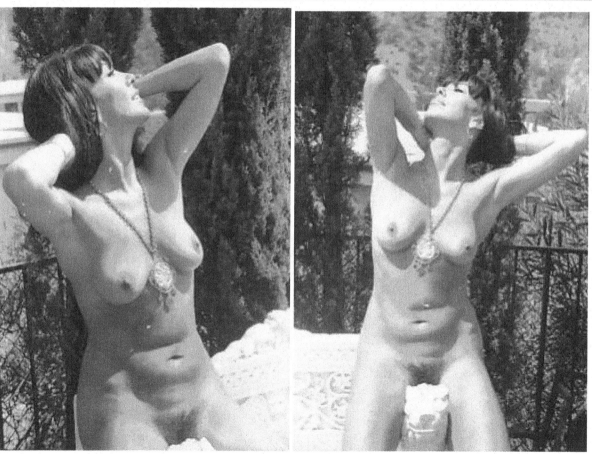

My only nudes were done with my okay, and they were sold everywhere. After Caesar Guest passed away, his wife sold ALL of his photos to an eBay seller, whom I got to know.

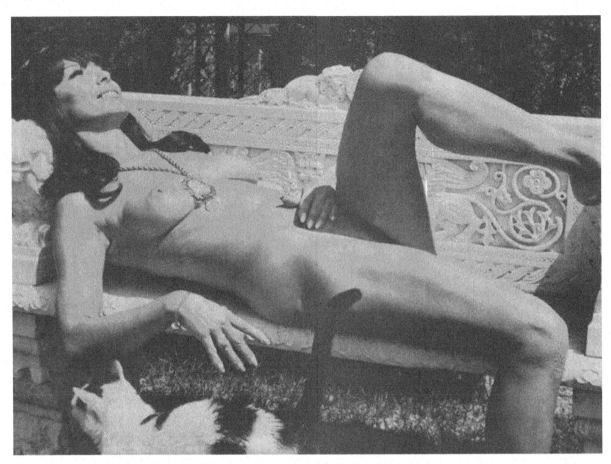

KNIGHT magazine 1974 double page.

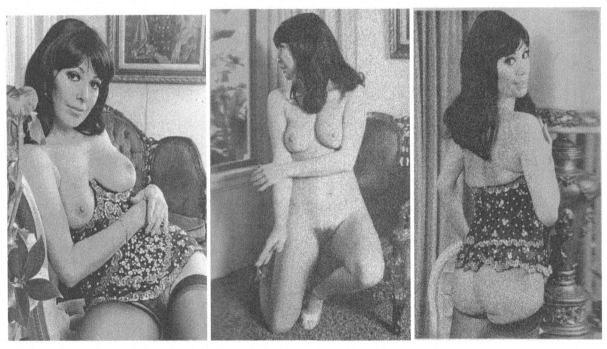

CABARET magazine 1975

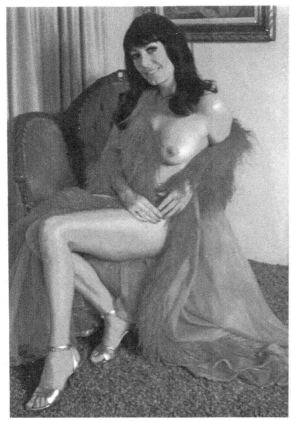 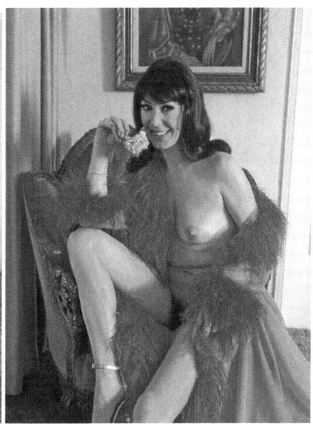

My original photos

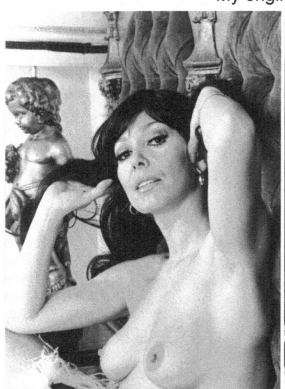 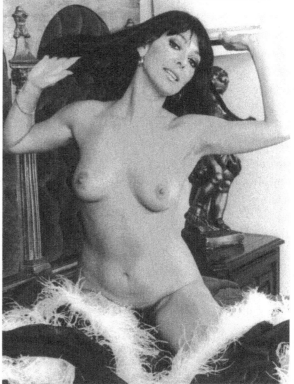

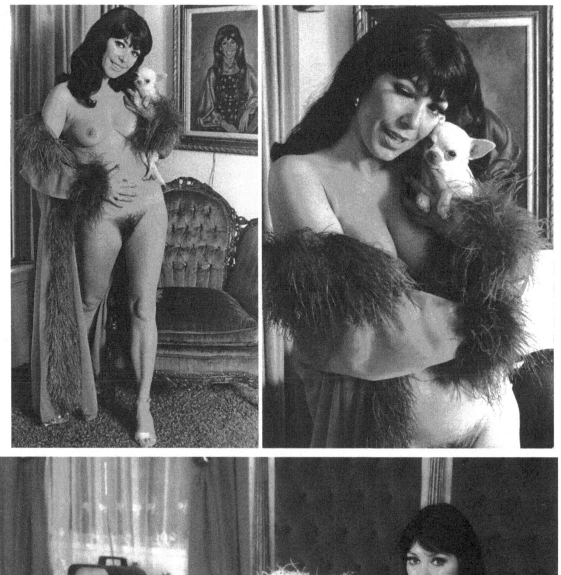

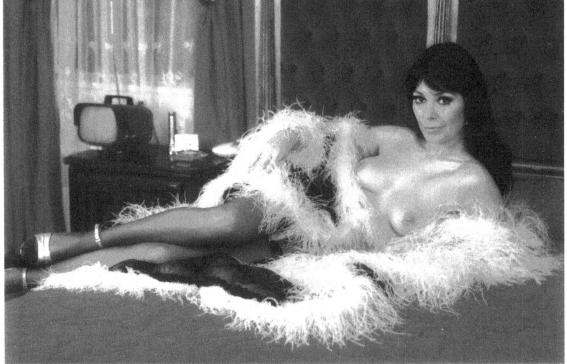

Assorted photos from Caesar, all my originals, and Polaroids.

186

magazine pictorial full pages in my master bedroom.

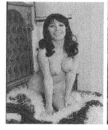
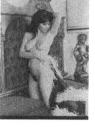

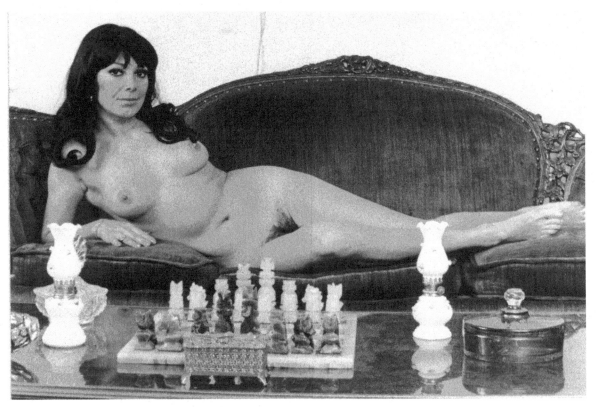

Posing on my red velvet antique couch, with a wood-carving frame.
In front is my marble chess game, which I bought in Mexico City.

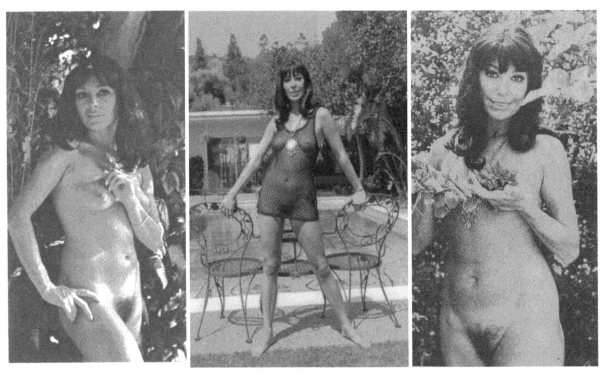

The backyard of the Silliphant's home.

188

Front inside back
My 8x10 flyers, inside are the places I worked.

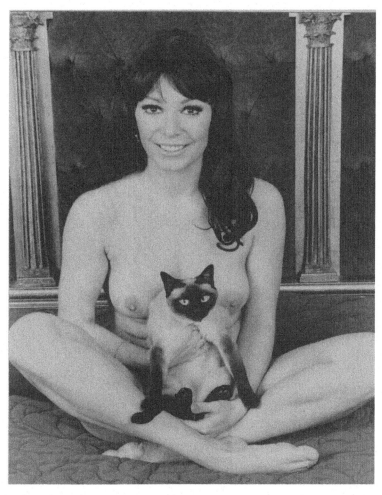

Now free again, I went back to Phoenix for a short time, and then on a long trip across the country. I put my advertising flier together and 8x10 photos that I gave out to the club owners or customers as souvenirs.
At the time, photos and pamphlets were given out for free.
 All photos and flyers and plenty of photos were sent out in advance to the club where I would appear in.
 At the time, all contracts were done over the phone.

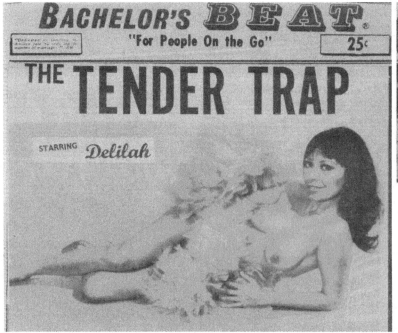

On my way back to Phoenix, mostly to see Ed again. Right: the newspaper clip and the original, and a full-size page.

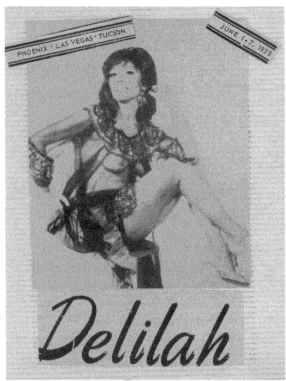

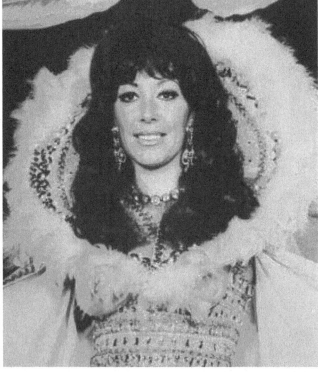

It always felt like coming home, whenever I arrived in Phoenix. Sylvia was always there to greet me, she was a great friend to me and kept Ed and me in contact throughout the years.

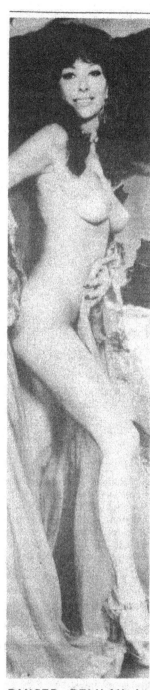

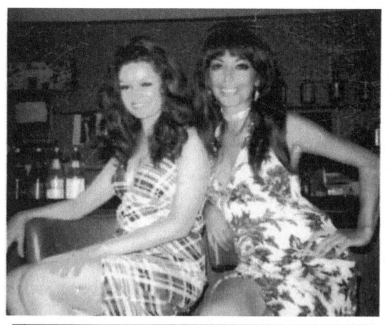

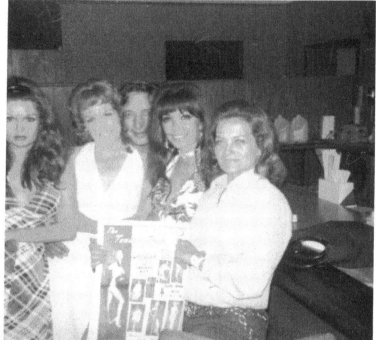

DANCER DELILAH is back at the Tender Trap in Phoenix. The sultry exotic is doing three shows nightly for a limited engagement.

With my boss Nancy and the two cocktail waitresses. Nancy died at an early age, rumors are that it was due to complications of plastic surgery.

She was around 50 years old.

One evening I had a surprise visit from Bob Crane. He appeared in his one-man show at the Windmill, where he was brutally murdered a few years later.

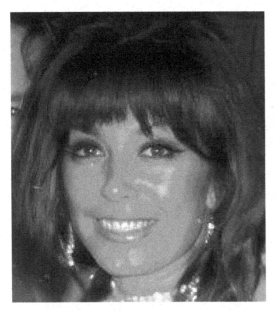

Bob had asked me out, but I told him that I was involved with Ed. He gracefully accepted the "no" and gave me four comps for his show, so that Ed, Sylvia, her husband Denny, and I could go to see him. That night at the Windmill he came out to greet us when we arrived. He was a class act. That following week I closed at the Tender Trap, spent a few days with Ed, and went on the road across the country. I always traveled with a AAA travel book that would show me the hotels, restaurants, and sightseeing spots, and a bag full of change to make phone calls, as I had to go through an operator for long-distance phone calls. I also traveled with a hotplate, so I could make breakfast and make coffee, and a plant that gave me a home-like feeling. My dogs were always important to me, so I would have one or two with me at all times. I also had to renew my California driver's license, good for four years.

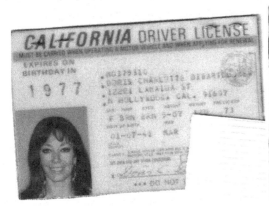

Crossing Missouri, I noticed the cutest fire hydrants, so I snapped some pictures. I also stopped along the way to visit some caverns and just for fun let my Pepe and Chico pee on every state I would cross.

Most of my bookings were for one week in different towns or different states. Nightclubs were closed on Sundays, which allowed me to travel until Mondays.

My first opening was in Evansville, Indiana at the Playgirl.

Evansville, Indiana :VANSVILLE PRESS

1973 THE EVANSVILLE PRES:

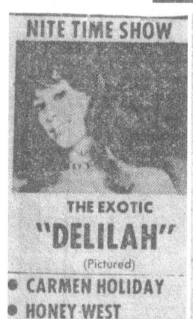

NITE TIME SHOW

THE EXOTIC
"DELILAH"
(Pictured)
• CARMEN HOLIDAY
• HONEY WEST
See These Exotics

DAYTIME SHOW
STARTS 12 NOON

BEAUTIFUL

EXOTICS

Featuring

DELILAH JONES
(pictured)
SEE: ALL THESE
GIRLS ON THE STAGE
AT ONE TIME!
• RAJA • VICKI
• JOYCE • LINDA
• MELODY • BABY DOL

NITE TIME SHOW

☆ DELILAH JONES
(pictured)
☆ CRYSTAL
☆ CHICAGO FIRE
PH. 422-1781
For Reservations
DAY OR NITE SHOW

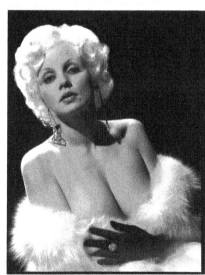

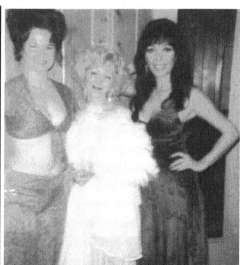

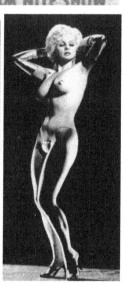

At the Exotic Playgirl, my co-feature was Harlow Angel. A petite girl and very fragile looking, barely five feet tall. A few years later, she was shot and

killed in Nashville circa 1979/80. While K.C. Layne, another dancer, was staying next to Harlow's room. The fatal gunshot was silent, because KC, being in the next room, did not hear a thing. Could have been a pillow over her head to break up the sound? KC, being a friend of Harlow, decided to do her make-up at the funeral parlor. A beautiful young girl in her twenties, lying there cold as ice. Before Harlow's death, In 1977, KC Layne and Harlow were working at the Black Poodle and were roommates. During that time, Harlow tried suicide a few times.

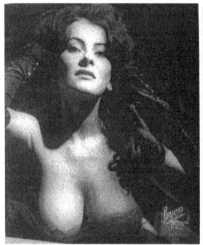 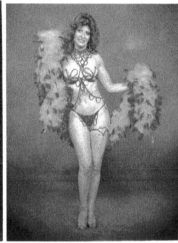 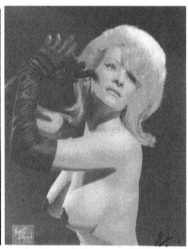

J O A N I L A Y N E
"MISS UNBELIEVABLE"

WEEK OF APRIL 17-24

Harry James and Joani Layne at the Plantation
See Page 6.

Feature Engagements

Rainbow Room Nashville, Tenn.
King Arthur's Kansas City, Mo.
T - Bone Wichita, Kansas
After Five Oklahoma City, Okla.
Blue Note Birmingham, Ala.
The Safari Dayton, Ohio
Westwood Little Rock, Ark.
Peachtree Atlanta, Ga.
Gay Nineties Minneapolis, Minn.
Silver Tap Omaha, Neb.
New Orleans Des Moines, Iowa
Crystal Palace St. Louis, Mo.
Damon's Indianapolis, Ind.

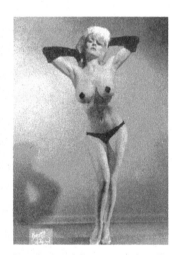

KC Layne was a brunette in the seventies and a blonde Joani Layne in the sixties. She was working with Harry James and a resume where she worked. I met and worked with K.C. in Las Vegas in the seventies, and became lifelong friends. One of the most annoying events at The Exotic

194

Playgirl was, the customers were given empty Coke cans filled with BB pellets, that they would shake for applause. The noise was horrendous, but the people were nice.

Next stop Rockford Illinois at Frank Gay`s Marquee Club

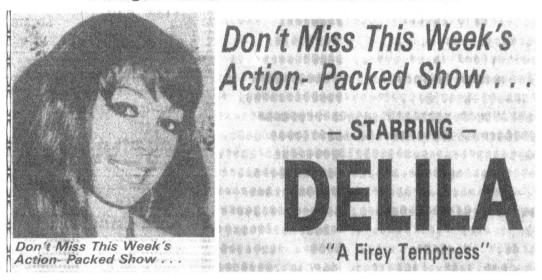

★ **ROCKFORD** Nite Times ROCKFORD

Topless Exotic Revues

Don't Miss This Week's Action-Packed Show . . .

— STARRING —

DELILA

Don't Miss This Week's Action-Packed Show . . .

"A Firey Temptress"

In Rockville, at The Marquee, I was surprised that the owner was from Germany and was also an immigrant. For some reason, we never saw eye to eye. Old school Germans were very strange, maybe it was because of the war, we spoke very little, but managed for that week.

I used my belly dance shows with authentic Arabian music,
This was my original bought 45 record, which I had taped on cassettes

of my Wallensak cassette player, which I used for my shows.
At the same time in 1973, we had a gasoline shortage, better known as the oil embargo. Because many gas stations were running out of gasoline, I had to buy 3 five gallon gasoline cans to avoid running out of fuel. In other words, I had 15 gallons of gasoline in the back of my Station Wagon, across the country, hoping I did not get rear-ended by a car and explode.

My next stop for one week is in SOUTH BEND, Indiana, with no advertising. Other clubs I don't remember or would rather forget.

The following week off to WHEELING, Illinois, at the "Cheetah 2", did not find any newspaper ads either. I had a problem with the manager, who gave his girlfriend top billing above me and would not let me do my regular show to make his girl look better. All that while the owner was out of town. I mentioned that to my mafia friend, Joey, who owned the motel that I was staying in, and he assured me that he would take care of it when the owner is back. Whatever he meant was okay with me. Joey took a liking to me and was very good to me, and gave me a break in the rent. He also bought dinner for me most of the time.

Then there was MADISON, Wisconsin one week, where I was surprised and fascinated by the Northern Lights "the Aurora Borealis". The most fascinating sight to see. Nature at its best. The club, I cannot remember the name, was huge, like a warehouse place, where the stage was in the center, therefore I had to look as perfect as possible from all angles. At that time, I traveled and used my make-up table for my show. It would show me getting dressed in front of a mirror. I practiced a few times to dress and undress in front of the mirror, seeing what would look the best. That was something new to me, and different.

Next stop: somewhere in DELAWARE CITY, Delaware.

I can`t remember the name of the club, it had a three-piece band. but I had a great time with my co-feature. She was a tiny blonde with a great personality. It's a shame that I do not remember her name. After our first night, the band asked us if we would like to come along cruising down the Mississippi River, on their houseboat. Both of us accepted immediately. When we were on the boat, the two of us would climb up on top of the deck, so we could nude sunbathe and relax.

When other boats would pass us, filled with people, they enjoyed the view and were waving at us. It was a day well spent and did a great show that night, while the band kept smiling through our shows. On another day, the other dancer and I went around town for some fun and decided to use the waterslide. Neither one of us was ever on one, so we wanted to try. Being naive and not knowing how to go about it, we just went downhill. By the time we reached the bottom, our backs were raw and bloody. Mine was not as bad as hers. We had to go to the drugstore and get medication. Now our backs were white, from medication, whatever was given to us by the pharmacist. Trying to do a sexy show that night was out of the question, we were both in pain, so we did most of the shows with the back turned to the band, who got a kick out of it.

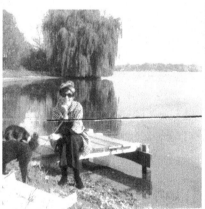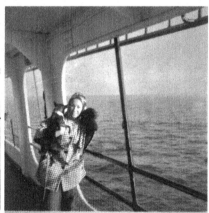

My postcard of the water slide. Waiting for the ferry. On the ferry crossing Lake Michigan. From Delaware, I drove through Wisconsin and took the ferry from Milwaukee, Wisconsin to Muskegon, Michigan. It was a cold breezy day crossing Lake Michigan with my Chico and Pepe. I stopped in Lansing Michigan and worked one week in Kalamazoo, a small German-Dutch town.

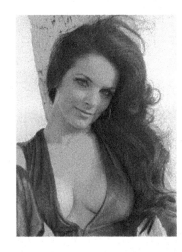

Diane Lewis

Crossing America from one state to another was the way of being on the road. Never know until a week or a few days before, where to open next. It was normal. On one of my crossings, while driving through Cleveland Ohio, I "bumped" into Diane Lewis at a gasoline station. I had not seen her since we worked at the club Largo. She was running away from a scary divorce. No one was supposed to know where she was. She was first scared to see me, thinking I would let her husband know where she was. But she relaxed.

Then I signed with Sparky Blaine and became part of his American Show Girls. Kitten Natividad was working for him and so were Kim Sommers, Tiffany Carter, and Liberty West. We all stayed friends throughout the years and eventually most of us moved to Las Vegas. It was a privilege to work for Sparky, the biggest known agency at the time, and he got the most money for his dancers.

•THE WORLD'S BEST EXOTICS FOR THE WORLD'S BEST CLUBS •

KITTEN
MISS NUDE UNIVERSE 1973

LIBERTY WEST

KATTY NOLAN
Miss Nude Argentina

The Elegance of
MISS JERI DEAN

Miss Shana Lee

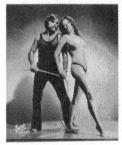
THE SUMMER AFFAIR

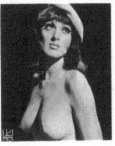
BRETT SCOTT

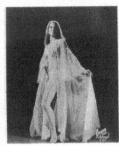
TIFFANY

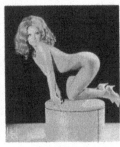
VELVET SOMMERS
Soft-Sensuous-Enchantment

DELILAH

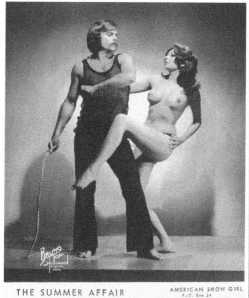

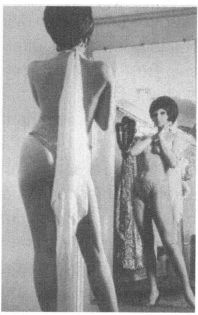

THE SUMMER AFFAIR

AMERICAN SHOW GIRL
P.O. Box 24
Newport, Ky. 41071
(606) 491-4384

Kim Sommers and her husband did a love act.

SENSATIONAL NOW APPEARING

RUBIN COSTA & KIM SUMMERS

Kim Sommers was a Barry Ashton girl in Vegas, then she danced with
Rubin, from the Body Shop, formed a love act, and went on the road with
him. When she met her second husband she formed another love act with
him. Thus became "The Sommer Affair". He became abusive and was an
alcoholic, when she met her last husband, Ed, a nuclear physicist, she

snuck out of the club where she was working, as is, and never looked back. She married Ed and was happily married to him for 45 years until she passed away. Kim never stripped again, but opened up a tap dance school for seniors.

Sparky booked me into Boston, Massachusetts, at the 2 O'clock club, where I met and worked with Tiffany Carter and Machine-Gun-Kelly, also Kitty Fontaine. Boston, the combat zone, was a challenge to me, but also interesting. It turned out to be a hustling b-drink club, a typical clip joint, and I was clueless. I had to order champagne, which was served with a spit glass. Tiffany helped me get rid of the champagne that customers bought for me. On the first weekend, Tiffany and I went to Salisbury Beach. The second weekend we planned to go to Salem, Massachusetts, but I got fired because I did not order enough champagne. I was supposed to drink the amount of my salary, so the owner would not have me for free. Sparky and I had a fallout over the b-drinking and so I changed agents and went with Paul Jorden, an agent out of Boston. One nice thing about the 2 O'clock club was, the owner's brother Teddy took a liking to me and always comforted me. He was a pleasant, nice gay man, and had a pawn shop next to the club. I bought a lot of gold jewelry from him at only $28.00 an ounce. Before Kim Sommers had met her last husband, she had followed me to Boston and had the same problem with the b-drinking. Only then did Sparky believe it, he tried to apologize to me, but I did not care and would never talk to him again.

MACHINE GUN KELLY

MACHINE GUN KELLY

TIFFANY

With Tiffany Carter and Machine Gun Kelly Tiffany Carter

My next stop was Newport, Kentucky known as little mafia, at the Brass Ass.

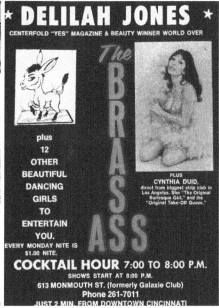

When I arrived, someone told me that the night before the owner was shot and killed by a hitman. Ironically, the owner shot back, killed the hitman, and both lay dead in the parking lot. That scared the living daylights out of

me. Mina, the owner's daughter, made me feel comfortable and let me stay at her place. I was well protected. The following week, Snowi St. Clair was added to the show. It took us a couple of days to get used to each other before we became friends. Must have been both of us are Germans and have a German pride and arrogant attitude. Because we both liked animals, we would visit the Cincinnati Zoo frequently, and buy a $5.00 bag of peanuts, to feed the animals.

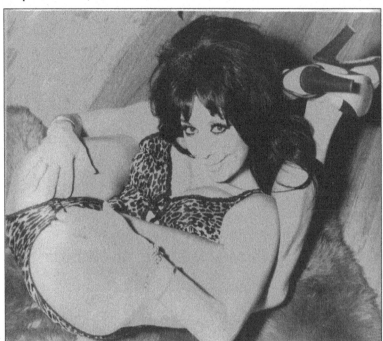

My contortion, in the dressing room at the Brass Ass.

In front of my LTD Wagon at Mike Fink's Riverboat restaurant. Right: The

The Cincinnati Reds stadium, which I watched being built in 1973, finished in 1974. I spent a lot of time in Cincinnati, Ohio, across from Newport. The two cities are connected by the Purple People Bridge. The only bridge that stretches 2,570 feet over the Ohio River. My favorite restaurant was a Chinese place on 7th Street where I would come for sweet and sour pork. I also entertain myself by reading Erich von Däniken's book "Chariots of Gods". It was an eye-opener for me.

I was held over in Newport and had a wonderful time. Newport, was known as Little Las Vegas, and a heavy mafia hangout. While I was there, I met and had a brief affair with one of them, who was from Dayton Ohio, his nickname was "Peanuts", which he told me. A gentleman and a hot Italian lover.

Then off to "Huntsville", Alabama for one week.

Huntsville Space Station is Dr.Wernher Von Braun's Office. This place was

off limits to the public, but I found an Air Force person that took me along to see everything up close. I had to hurry to take some photos. Another club I cannot remember the name of, but would rather forget it anyway. Some narrow-minded hillbilly did not like strippers, so he set the place on fire, while I was in it. The Fire Department came immediately and got the fire under control. The next day showed the damage to the buildings, which took quite a beating, but the show went on as usual. Now I needed to change agents again because I went into a different territory. I signed up with Wayne Keller. Then I went to Birmingham, Alabama for one week. Where there was extreme prejudice in 1973.

Nick Glenos'
PATIO LOUNGE ◆◆◆◆◆◆◆◆◆
1823 NORTH FIFTH AVENUE
BIRMINGHAM, ALA. – 322-9476

I was not supposed to smile at any black person or speak to them. Half of the audience was black. That much prejudice I had never experienced before. At the cafeteria in Birmingham, I tried to tip a young black girl, who cleaned my table, and I was firmly told not to do that again, wow, that's unreal.

Next came "The Great Smoky Mountains"

While I was in Birmingham, I met up with Kitten Natividad and her husband George. Kitten and I had the weekend off, so George decided to take us to the Appalachian mountains. What an exciting trip. Oddly, we did not take any photos or buy any souvenirs. George took us through all the old sightseeing places and paths, which were all filled with fog, due to the high altitude.

The following week Kitten and I were booked in a huge barn-like club, outside of Nashville. It turned out to be a house of ill repute. Kitten and I laughed so hard every night, but we also had fun with the "working" girls. They were such nice and gentle beings. Most of them were fourteen or fifteen. The idea was supposed to have been that Kitten and I got the customers excited and then they picked their girls for the good times. Each girl had their own bedpan, to wash the guy's dicks before giving them head. It was not necessarily legal, even though they had a red warning light, in case of a raid, but it never came on while we were there.

Afterward, we split and I went for one week to Columbus Georgia, at the Aztec lounge. Every night the club was loaded with servicemen because Fort Benning was just a few miles away. Of Course, I had to visit Fort Benning. The southern portion of the Georgia/Alabama state lines, about 1 mile North West, is Phenix City, Alabama, which has a rich history, way before I worked there.

Andrew Jackson's home and family cemetery.
I went up north again to Tennessee. First I stopped to visit President Andrew Jackson's home and the family cemetery in Lafayette Tennessee. The house resembles TARA from "Gone with the Wind". I took the tourist tour inside the mansion and was not allowed to take any photos.

Nashville, Tenn
Delilah

I finally arrived in the Music City of Nashville, Tennessee.
By now it was October 1973.
I stayed two weeks at the RED LION LOUNGE, then to Lexington Kentucky to open for a week or two at the sister club the Red Lion Lounge.
Then back again to Nashville. The "Banner' did the most advertising.

205

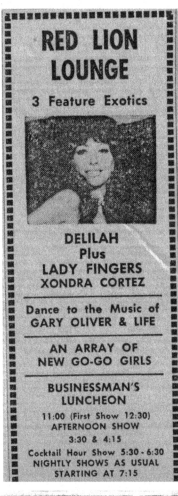
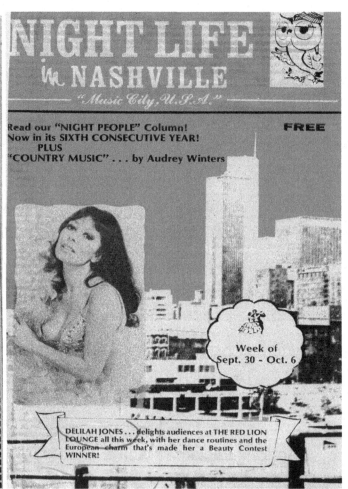
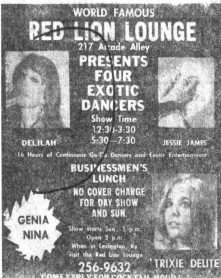

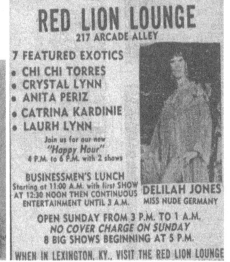
Here with Jesse James and Trixie. Jesse worked with poisonous reptiles.
One of her biggest attractions was her Cobra. She traveled across the
country with these wild and poisonous creatures. One day she had a flat

tire on the freeway and went to fix it. When she went into the car to move the rattan basket with her cobra, the cobra bit Jesse in the hand through the basket and Jesse died on the freeway.

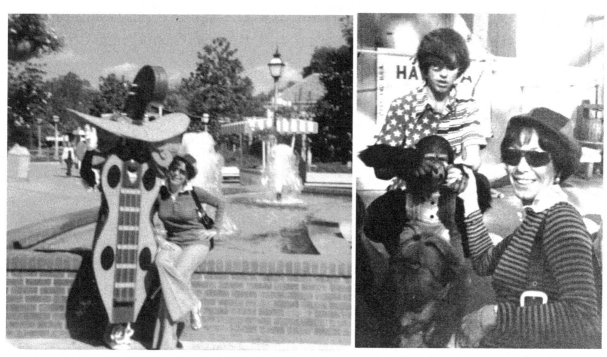

I went sightseeing in Nashville, playing with that cute little monkey.

For over two months I went from Nashville Tennessee to the sister club in Lexington Kentucky, always one week or two here or there.
The same photos were used many times. .

LEXINGTON

SUNDAY Dec. 9th. thru SATURDAY Dec. 15th.

Many times I stopped for lunch in Louisville, Kentucky, which was only a few miles away. I also stopped in Bowling Green Kentucky to visit a cave with my poodle Pepe, which had a shaft cart, to drive through caverns, like a mine shaft.

KENTUCKY

My motel in Lexington Kentucky was next to a racehorse farm, about ten feet away from the motel where the fences were. My Pepe loved to go near the horses.

Nashville, Tenn.

THE NASHVILLE BANNER, Tues., Dec. 18, 1973-

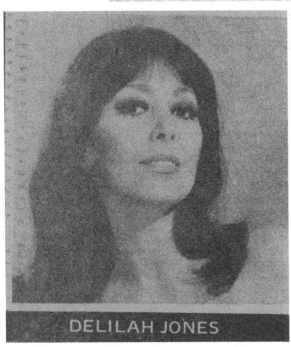

DELILAH JONES

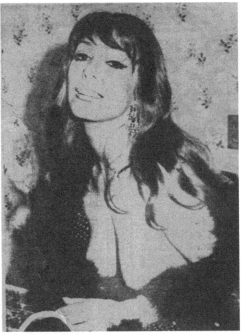

Nashville Banner

proudly presents Delilah ☆☆

NASHVILLE, TENN., SUNDAY, DEC. 2, 1973

208

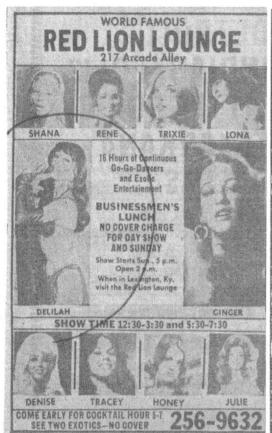
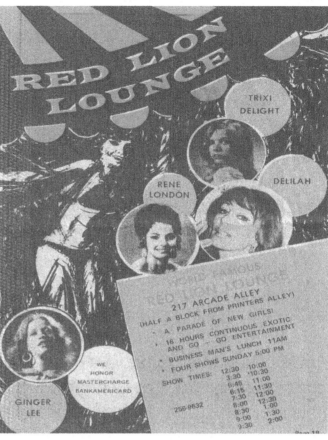

Appearing with Ginger Lee, Trixie, and Rene London
Now December 1973

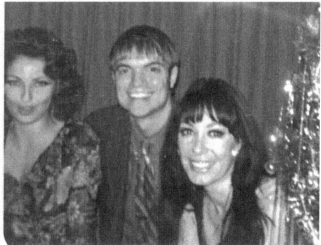

Nearing Christmas with Rene and Ginger, with Rene London and our
houseboy. Our houseboy took me around town anytime I wanted. I took
advantage of his kindness and spent afternoons with him, touring the city
and playing tourist. My main visit was to the Grand Ole Opry, it was

a memorable experience for me. There I met Tex Ritter, Stonewall Jackson, Dottie West, and Minnie Pearl, and some others I can't remember.

I bought these two postcards as souvenirs of the Grand Ole Opry.

 Many times I would visit our competition, Skull's Rainbow Room between my shows. It was in the next alley, Arcade. The Red Lion was on Printers Alley. Most clubs were in the alleys. This burlesque place featured mostly sex changes. They were the prettiest, hand-picked girls. Tall, gracious, statuesque, and had expensive costumes.

Another week, Georgette Dante would arrive with her fire show. A bit cocky on our first meeting, because her mother had the same name "Delilah". So what. But we became lifelong friends.

One lazy afternoon I went to Chattanooga, Tennessee to see Ruby Falls, an underground cascade waterfall off 145 feet in Lookout Mountain, in Chattanooga, Tennessee, with my poodle Pepe.

On December 18.1973 I was homeward-bound and stopped in Memphis at an off-road, uphill home-cooking restaurant. I only did that to feel good about Elvis having lived there. Now I was on a long stretch of the southern route, taking my time and driving about three days home. I spent a short time at home for Christmas and New Year's. A New Year began. anxious to see Ed again, I left as soon as I could. On Jan 4,1974 I was back in Phoenix at the Tender Trap, and with Ed.

Tender Trap JANUARY 4 - 10, 1974

TALENTED DELILAH has returned to the valley once more for a one-week stand at the Tender Trap.

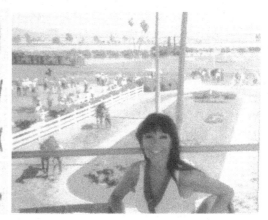

My last time in Phoenix and at the Paradise Turf, bye, bye to Phoenix. This time in Phoenix was bittersweet for me, I was now planning never to return again. It was breaking my heart, but I needed to do it.

The happiness I felt being with Ed would come crashing down every time I left. I never liked goodbyes. Just clean-cut out.

A promise was made, a commitment kept to me. I went back home and stayed at the Body Shop. At the end of July into August 1974 I went back on the road. I got a lot of recognition as a headliner.

Driving through many states, I stopped at many caves in Missouri, Kentucky, and other places. I stopped many times at KFC for dinner. In a Terre Haute, KFC I found rat hair in my chicken, and I would never eat at any KFC again.

My first stop was for one week, same club as last year, at the

PLAYGIRL in EVANSVILLE , Indiana
Then to Indianapolis

Indianapolis

Tuesday, August 13, 1974

DELILAH JONES

THIS WEEK THE UNPREDICTABLE "DELILAH JONES"
NO COVER WITH STATE FAIR STUB
MATINEE Tues., Wed., Thurs., Fri. 5-7
PLENTY OF GO-GO GIRLS
Town & Country Lounge
4451 N. KEYSTONE Phone 547-309

After Indianapolis, I don't remember my next booking, or what city, then I was booked in Green Bay, Wisconsin. I only remember that I drove 700 miles from where I was. It took me nine hours straight through. My longest haul ever. Never did I do that again.

Next was Lexington, Kentucky again

Sep 16, 94

SUNDAY, Sept. 29th. thru SATURDAY, Oct. 5th.

Oct 6

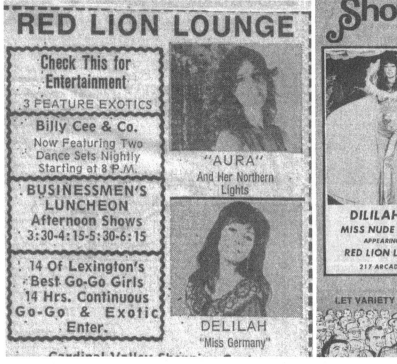

RED LION LOUNGE

Check This for Entertainment

3 FEATURE EXOTICS

Billy Cee & Co.
Now Featuring Two Dance Sets Nightly Starting at 8 P.M.

BUSINESSMEN'S LUNCHEON
Afternoon Shows 3:30-4:15-5:30-6:15

14 Of Lexington's Best Go-Go Girls 14 Hrs. Continuous Go-Go & Exotic Enter.

"AURA"
And Her Northern Lights

DELILAH
"Miss Germany"

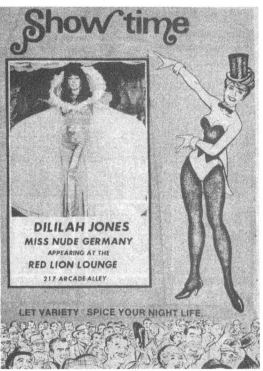

Show time

DILILAH JONES
MISS NUDE GERMANY
APPEARING AT THE
RED LION LOUNGE
217 ARCADE ALLEY

LET VARIETY SPICE YOUR NIGHT LIFE.

Next came Newport, Kentucky

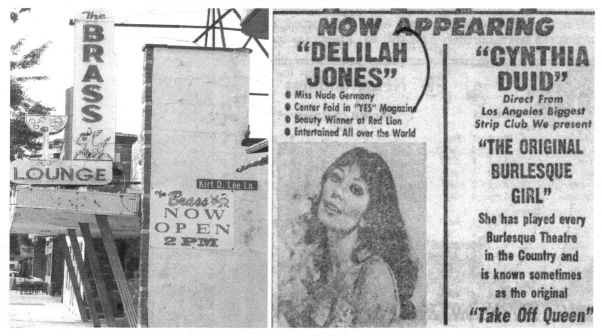

I was back at the Brass Ass, for a few weeks. where I also was the year before. This trip felt like a repeat, many of the same clubs, and I felt more at ease. I got a warm welcome from Mina, the owner. She let me stay again at one of the places. After I closed at The Brass Ass, I asked Mina if it was okay with her If I would open the "Mouse Trap", down the street from the Brass Ass. It was a new strip club that was ready to open. They wanted me to be the opening show. She told me to go for it, and so I did, one week for the opening. Then back on the road again.

213

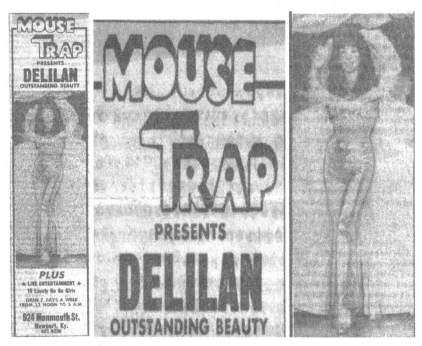

When someone opens a nightclub, they will never forget you.

Now going into NOVEMBER 1974

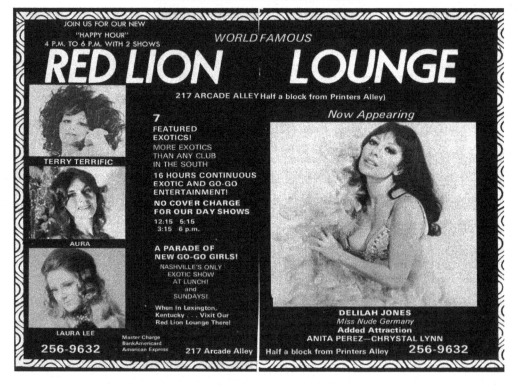

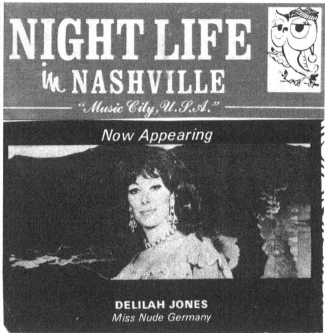

NIGHT LIFE in NASHVILLE
"Music City, U.S.A."

Now Appearing

DELILAH JONES
Miss Nude Germany

"DELILAH JONES"

RED LION LOUNGE

(Half a block from Printers Alley)

JOIN US FOR OUR NEW

"HAPPY HOUR"

4 P.M. TO 6 P.M. WITH 2 SHOWS

BUSINESSMEN'S LUNCH
Starting at 11:00 AM with first SHOW
AT 12:30 NOON THEN CONTINUOUS
ENTERTAINMENT UNTIL 3 AM

OPEN SUNDAY FROM 3 P.M. to 1 A.M.

DELILAH

MISS NUDE GERMANY

And back to Lexington

LEXINGTON
WORLD FAMOUS
RED LION LOUNGE

DELILAH . . . a former "Miss Berlin" . . . is a talented, German-born dancer who's currently in action at THE RED LION, downtown in the Arcade Alley. She recently performed in Las Vegas, and has appeared in top clubs across the country. Delilah does a sleek routine onstage . . . and offstage she readily talks about her collection of animals, including a friendly poodle she was leading around the club the other evening . . . several other dogs and cats she has at home . . . AND a sixty-five year old turtle! DELILAH is one of SEVEN dancers, currently featured at THE RED LION LOUNGE!

NOW APPEARING

1974

DELILAH JONES

I stopped at Gatlinburg, here at the tram. This time I finished my last trip across the country, it was getting cold and winter started slowly approaching. I took the southern route again. Driving back home was a long, draggy drive through Texas, and El Paso, and spent the night in Phoenix, without calling Ed. The next morning I left Phoenix behind for good. I took a deep breath and was now driving home to California, my home. I went back to the Body Shop, and never wanted to travel again.

Opening at The Body Shop was great for me. This was the new Body Shop, owned by Tony Mudara who people used to refer to as Tony, the Arab "Godfather". He had many of his relatives and friends working for him. They all came from Beirut. We liked each other right away and became terrific friends for a while. Nothing sexually.

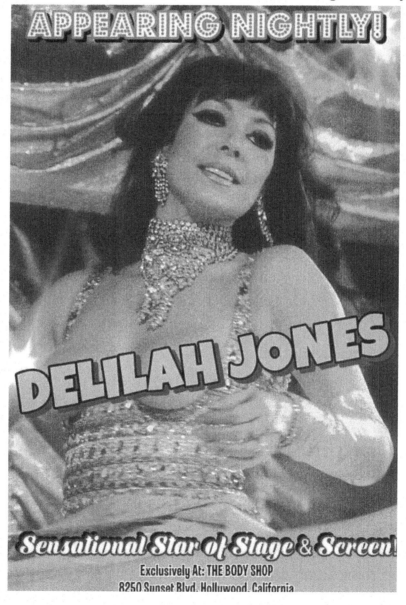

217

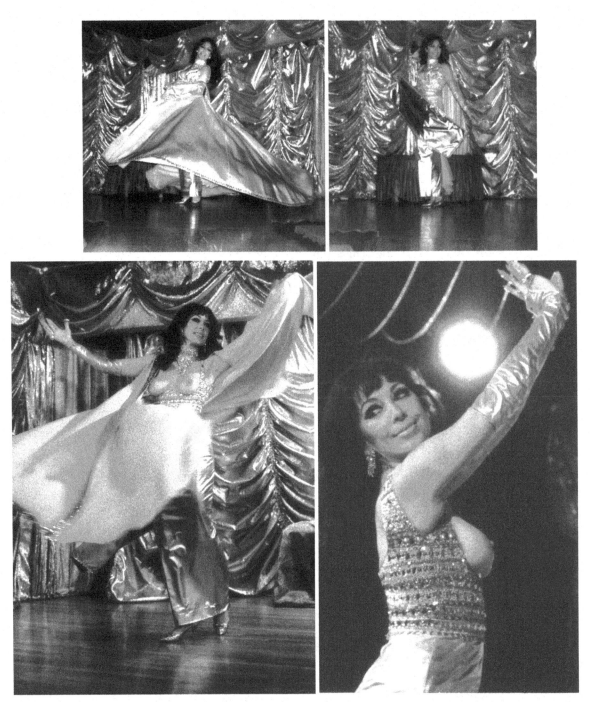

My wardrobe was spectacular, and it gave the club some class. This was one of my favorite costumes that I copied from my trip to Mexico. It was gold lame and yellow gold satin lining on the inside of the cape, adorned with aurora borealis stones and crystal beads, to give the effect of the sun, like the Pyramid del Sol in Mexico. It filled up most of the stage. I also hand-made the rhinestone choker. My costumes were mostly gold, black, or white. Occasionally I changed to something loud, like this costume.

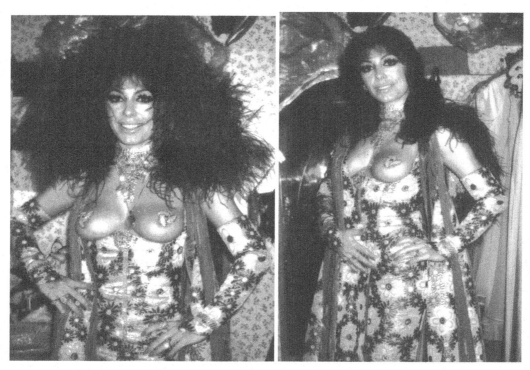

This was purple with white huge flowers and gold brocade, all studded with rhinestones. I added a purple ostrich feather hood. Also a matching cape. It was heavy but so unique. Alexis and I would streak nude across the stage while other girls were dancing when nights were slow. Illegal, because we were nude.

One night there was a shootout in the club. Shots came from under the tables where Tony's friends were sitting. It was about cocaine. No cops were called, and the show went on as usual. No one mentioned it again. Somehow that excited Alexis. She was a masochist. Mudara did not respect women, he always wanted to be above them and so he had a field day dating almost any of the girls he wanted.

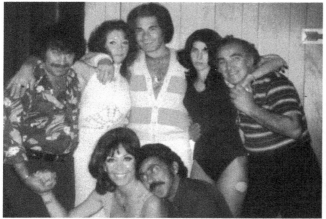

Picture: Sam, the cook, Nilsa, Tony Mudara, Vivian, our cocktail waitress, who became a lawyer, Charlie the bartender, and I.
Top right: Ronnie, (who appeared in the movie:" The Greatest Story Ever Told", with Jeffrey Hunter) our stage manager, and Charlie, we celebrated my birthday,

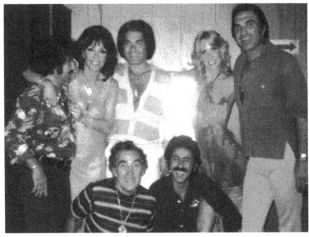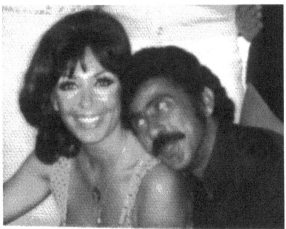

Lisa Jourdan, blonde. Tony was busy with all of them except for me. I had no intention to be one of them. Tony and I were good friends, and he trusted me. He told me one day how easy it was to get a new car every year, for free. He would have someone steal the car from the Body Shop parking lot, erase the vin number and drive to Mexico. Insurance would replace it with a new car.

Going back in time, My niece went to Beverly High School, in the sixties along with Jamie Lee Curtis and Shaun Cassidy. The school always had drugs available, at any given time, my niece said. She also had tried some of them. These were the Hollywood Elites' spoiled brats. I attended the graduation day and met Shirley Jones, the mother of Shaun Cassidy.

At the Pickwick Stable in Burbank and on Sunset Boulevard at the corner of Rodeo Drive.

Even though I had all I ever wanted, Ed never left my mind. It became a lifelong heartache. By now I had felt that Ed was my past, just a memory. My husband was a good man, and also my best friend. I was very comfortable with him and could talk about anything except other men. He was easygoing and loved me eternally, but I had lost the deep love feelings I once had for him. I kept busy working on my new wardrobes, new shows, and new music. I was sure that I would never want to travel again. I was offered another movie role, "The Assassinators", a dancing part with Angel on the same stage, but with two different cameras. Darren McGavin had the lead, but I don't know the name of the movie, because the title was changed, due to Sylvester Stallone already owning the name.

During the seventies, the rock group WAR celebrated the success of their song, "Why Can't We Be Friends" at the Body Shop. They made arrangements with Tony that the doors would be closed to the public, but our show went on as usual. Champagne was floating all through the night. It was an unforgettable night.

Tony Mudara gave me great publicity. I enjoyed time with him, even though we respectfully would flirt here and there with each other, but that was all. He also liked that I always updated my wardrobe.

The burlesque field had changed a lot, but Tony Mudara would try to keep it classy, and he did hire some nice, clean-cut strippers.

The following images are my next striking costume, it was red, white, and blue. Blue and red eyelet material along with sequins and rhinestones adorned with white feather boas, the back bottoms were cut in chaps-like. The top was a waist cincher. It had a lot of detail.

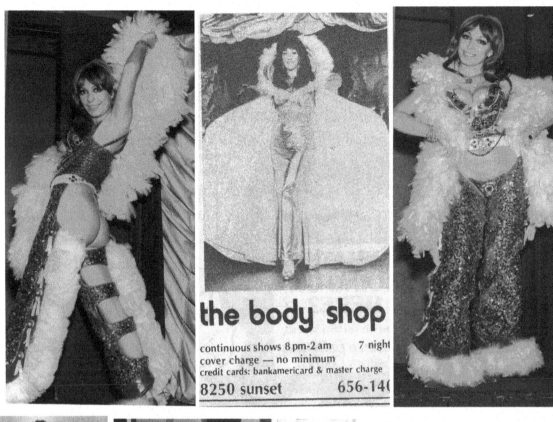

the body shop

continuous shows 8 pm-2 am 7 night
cover charge — no minimum
credit cards: bankamericard & master charge
8250 sunset 656-14(

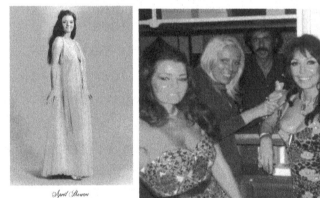

April Showers

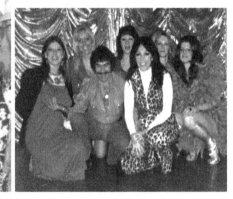

In the Body Shop kitchen at the waitress station, with April Showers, (pictured) who danced to Walt Disney music, "It's a Small World". Arlene, our cocktail waitress, myself, and Sharon Carr. Right: the new generation gang on stage with me for a group shot. I always considered them lost souls. They were all loving but so clueless about life in general.

Next: Arlene, Sam, and Larry Carroll, Los Angeles TV anchorman, had asked me to do a commercial for him, which I did. It was filmed in the Watts area, scary as hell for me, but Larry Carroll was black, which helped, and everyone knew him.

222

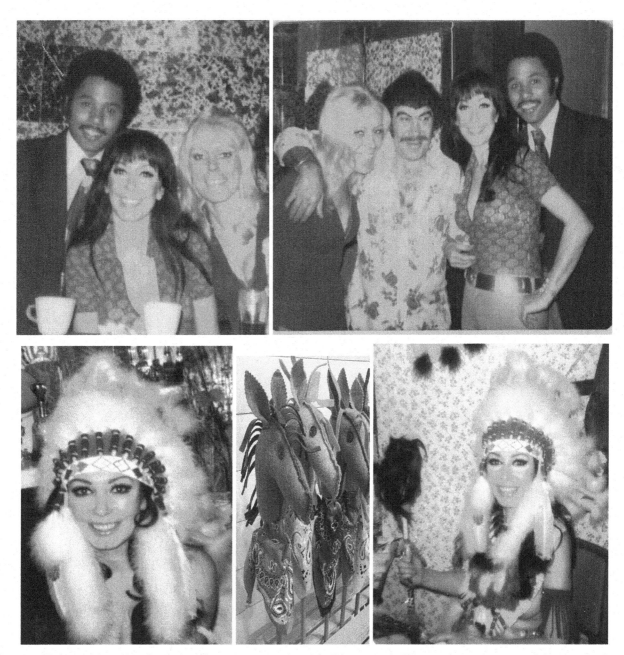

A different kind of show for me as an Indian and this costume, and I made it by hand and used all original and authentic beads and feathers, making it as realistic as possible. This was a fun show. I called my "Mr.Custard " show.

I had a horse head on a stick that I came riding out with for the show. On slow nights Alexis and April Shower would also have a stick horse, and we all would come riding out to the song "The seventh day of history, the day when the Seventh Cavalry came riding in,", and the three of us were on our so-called horses. It was really a fun show, and it kept our sense of humor.

With my poodle Pepe, my white German shepherd, and at a Hollywood Movie set.

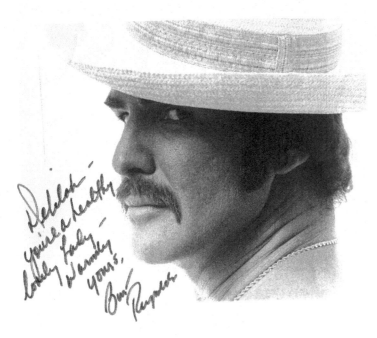

The mid-seventies were important years for me. I was well-respected and known around town by the movie industry. After all, elites and celebs would always appear at the Body Shop. Kevin Mc Carthy who always had a smile on his face was one of them. Another wonderful man was Richard Boone, who would always dress in black and a cowboy hat.

One day I got an unexpected call from Burt Reynolds, asking me if I was interested in doing him a favor. It was to be a surprise walk-on stripper for Dinah Shore's TV show, and I gladly did. When I arrived at the studio, Dinah knew that something was up and she got up to greet me and laughed. Afterward, she invited me to the cafeteria for lunch and to meet the producer, and other actors. Burt sent me a thank you note, along with his photo. I kept the photo, but not the note.

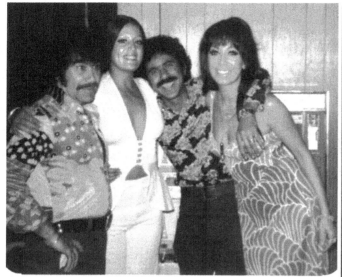

Sam, another dancer, Charley, and I. Nabil, Tony's nephew,
 another one of my birthdays, and Arlene.

Still, in the mid-seventies, great surprises happened often. Left, babysitting with my niece, for Anthony Quinn and Friedel's son Sean. Friedel was our German girlfriend. Right, Linda Cristal, (High Chaparral), my sister's friend, we had a garage sale together in the Hollywood Hills, at my sister's home. Linda was dating Adam West, Batman, at the time, who lived down the hill from my sister's home.

Playing tourist with my niece, at the ghost town in Knott's Berry Farm.

Safari at Knott's Berry Farm My cousin Erika, and my aunt, who
came for a visit from Germany.

Back at night at the Body Shop, we had a new dancer, one was Veronica, from Hawaii, who was a complete sex change. So beautiful that I stared at her. As we became friendly, and me being curious, I asked her how the surgery was performed. To my surprise, she asked me if I wanted to see it. My eyes opened wide and I smiled and said "yes". She then lifted her skirt, while sitting on a chair. I looked and said: "You look just like a girl", a short

laugh, which she was. We both laughed and then she explained in detail how her manhood-sensitive areas were introverted, and where her clit is now, all reconstructed so she can have the same orgasm as before.

Mele Kalikimaka

Veronica was a statuesque good-looking stripper, very few people were aware of her past because she did not advertise it.

She gave me this photo of her.

And then there was Wilbur Mills.

LOS ANGELES
Volume 20, Number 1

JOYCE HABER

Fanne—Not 1st Fox in Mills' Life?

And he fell hard for the art of ecdysiasm. Once, during his '72 campaign, he had to be re-strained from climbing onstage with a stripper at a Los Angeles joint called The Body Shop;

The second article ran also in 1975

According to an ex-waitress, Rep. Mills, perhaps slightly under the weather, would leap on the stage and imitate the girls' routines. Mills' favorite: a German stripper called Delilah. Well, Rep. Mills could never be called a longhair. Foxe, was not the first stripper who ever caught Rep. Wilbur Mills' eye. It seems that two years ago Rep. Mills paid at least five visits to the Body Shop, a striptease club on Hollywood's aptly titled Sunset Strip.

WHAT'S UP
NOTES ON TRENDS IN LOS ANGELES

WILBUR MILLS' FIRST LADY: Annabella Battistella, a.k.a. Fanne Fox, isn't the only stripper to catch Wilbur Mills' fancy. In 1972 Mills visited The Body Shop, a small strip joint on east Sunset Strip, at least five times with a clutch of businessmen. A cocktail waitress there at the time vividly recalls how Mills, apparently quite tipsy, would jump up on stage each time and mimic the girls' routines. "Nothing vulgar," she says, "just clowning around." Mills' favorite was a German stripper named Delilah. It seems the club ran a promotion called the Ballot Box Revue, giving politicians' names to strippers, and asking customers to vote for their favorite stripper/politician. At week's end, the winning stripper got a bonus. Guess whose name Delilah wore?

December 30, 1974 Newsweek contacted Tony Mudara to write a story about Mills.

When I found out from my friend, who was a Vice Detective, who was also one of my witnesses for my citizenship, that the FBI was watching me, I canceled everything. That scared me. That was the end of Wilbur and me.

Newsweek

3812 WILSHIRE BLVD., SUITE 710, LOS ANGELES, CALIFORNIA 90010, (213) 385-6521

December 30, 1974

Mr. Tony Mudara
The Body Shop
8250 West Sunset Boulevard
Los Angeles, California 90069

Dear Tony:

As promised, here are some clippings about The Body Shop and Wilbur Mills.

The Newsweek one is from a few weeks ago. It mentions that Mills once tried to get onstage, but for some reason the editors in New York did not use the full story about his actually jumping onstage; so I gave that part of the story to my wife, who placed it in a column she writes in Los Angeles magazine (see the clip, "What's Up"); and this in turn prompted the item in Woyce Haber's column. Now Newsweek may use the full story and a picture of Delilah, too; this was originally scheduled to run on our "Newsmakers" page in this current week's issue, but has been postponed to next week. If and when it does run, I'll send you the clip on that, too.

Thank you for all your help and cooperation, and best of luck. Regards to Louise, Delilah and everyone at the club.

Yours sincerely,

Martin Kasindorf
Staff Correspondent

228

Newsweek

3810 WILSHIRE BLVD., (Suite 711), LOS ANGELES, CALIFORNIA 90010, (213) 386-8381

item in Joyce Haber's column. Now Newsweek may use
the full story and a picture of Delilah, too; this
was originally scheduled to run on our "Newsmakers"
page in this current week's issue, but has been
postponed to next week. If and when it does run, I'll
send you the clip on that, too.

Thank you for all your help and cooperation, and best
of luck. Regards to Louise, Delilah and everyone at
the club.

Yours sincerely,

Martin Kasindorf
Staff Correspondent

Owner Tony Mudara, a slight, dark man who dresses like a Los Angeles version of Frederico Fellini, took over the club almost a year ago. Mudara's ideal was to present a tasteful, yet erotic show with the best looking broads in town. Total nudity is once again allowed, so his girls are able to strip down completely while the clientele contentedly sip their $2.50 drinks—two drink minimum. But, as most of the men leaving the Body Shop will tell you, 'the broads are worth it.'

The broads, or girls, who strip down to nothing on stage are a rare mixture indeed. There's Delilah Jons (covered last month in ADAM), a Germanic beauty of ultimate wit and charm whose dancing recreates the finest moments in burlesque with shades of St. Cyr. Then

Adam Magazine had a nice pictorial about me at the Body Shop.

Midsummer I had the surprise of my life when Ed showed up and wanted to know what happened to me. Sylvia and Denny also came along.
We spent the afternoon at the beach and the evening at the Veil belly dance club, which Tony Mudara also owned.

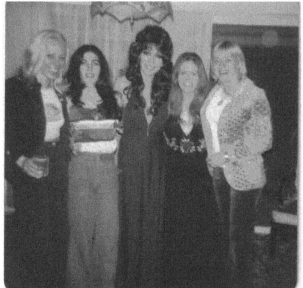 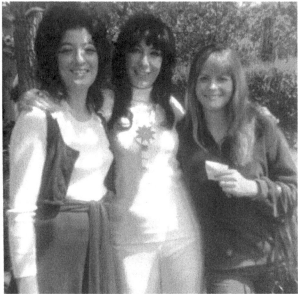

The dancers and waitresses at the Body Shop kept a close relationship. Even though the atmosphere in public was looking good, the tension between Tony Mudara and me was building up.

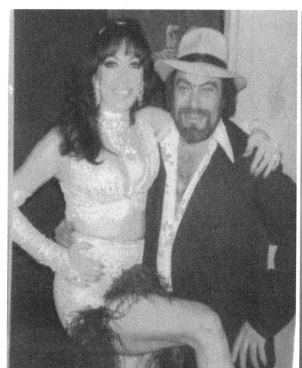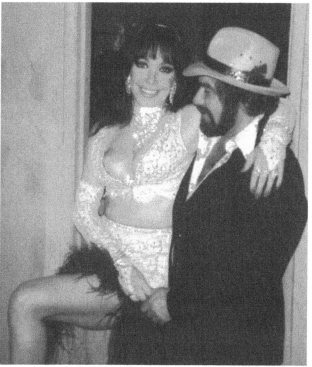

Sam, our cook, was a nice man.

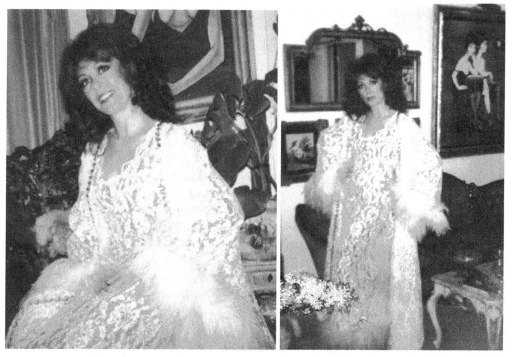

At home in my newly finished costume, white lace set off with Austrian rhinestones, silver & white sequins, and finished with ostrich feathers on the sleeves of the cape and on the bottom of the dress.

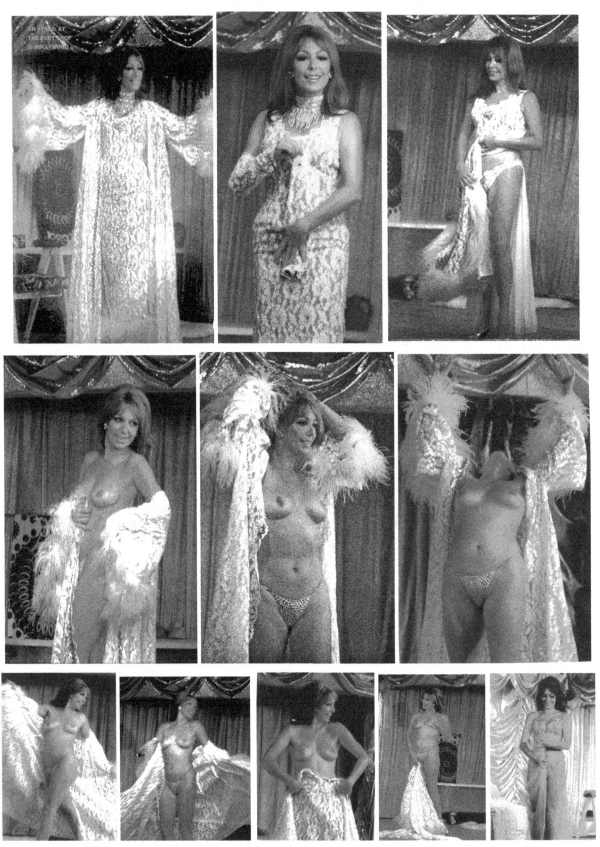

Trying out my new accomplishment and show on stage.

232

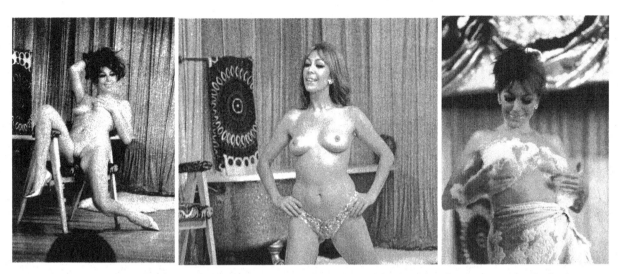

On stage at the Body Shop nearing my last time on that stage. A few more shows and was on my way out of there.

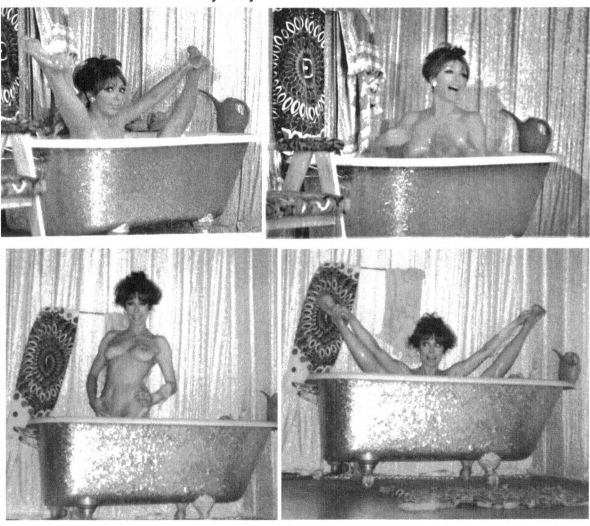

After my dance, into my bathtub.

While I was still at the Body Shop, Angel got married to Chase Cordell, a Hollywood actor, in March of 1977, while I was getting really annoyed with Tony and Charlie the bartender. I found out that Charlie, our bartender, had spat in my drink. The place started to become a hostile environment. George the Arab, my good friend, always comforted me and was always on my side. He eventually would move to Las Vegas and dated Barbie Doll. We remained good friends.

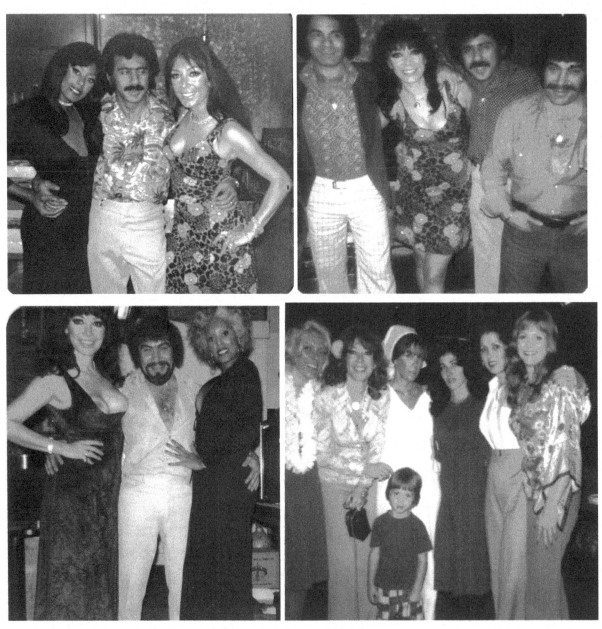

top: last photos at the Body Shop of the Arab gang.

Left: me with Sam and Tracy King, she was known as the Black Marilyn Monroe of Burlesque. I was now planning on leaving for good, Never to return to the Body Shop.

Right: Arlene, Delilah, Louise, Vivian, Angel Carter, and Debbie Di Georgio, All our cocktail waitresses and my good friends.

Tracy King and I also worked at the Classic Cat in 1973. She had major plastic surgery on her body for a tummy tuck, which turned out great. Her belly button was moved to another place and a newer one replaced the old one. Also, her nipples were rearranged. As I was looking at her scars I noticed then that black people`s scars are the opposite of whites. Scar`s color turns darker, whites turn lighter. Interesting, I thought.

Now nearing the end of the springtime of 1977. On my last day at the Body Shop, Tony Mudara would not allow me to take the bathtub out from the stage. I called the police on him, and they gave him an alternative, either pay me or release the tub. He paid me, and I then bought my Champagne glass. A short time after I was gone, Tony went to jail for 15 years for income tax evasion. Karma, I thought, works in mysterious ways.

I was now asked to go on a three-month tour through Canada, which was coming up soon. I told Angel about it and she eagerly wanted to come along. I also called Nancy Lewis to join us at my home. She wanted to come along, but it was too long of a trip for her. That was the last time I saw Nancy. She, later on, moved to Utah and became a recluse, a hermit, but Tracy King wanted to come along also and did.

A new photo shoot by my friend Sandy Fields, for my Canadian tour.

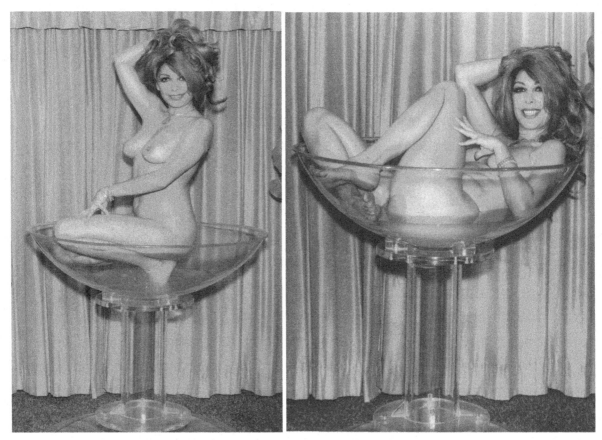

My new stage prop is a Plexi champagne glass.

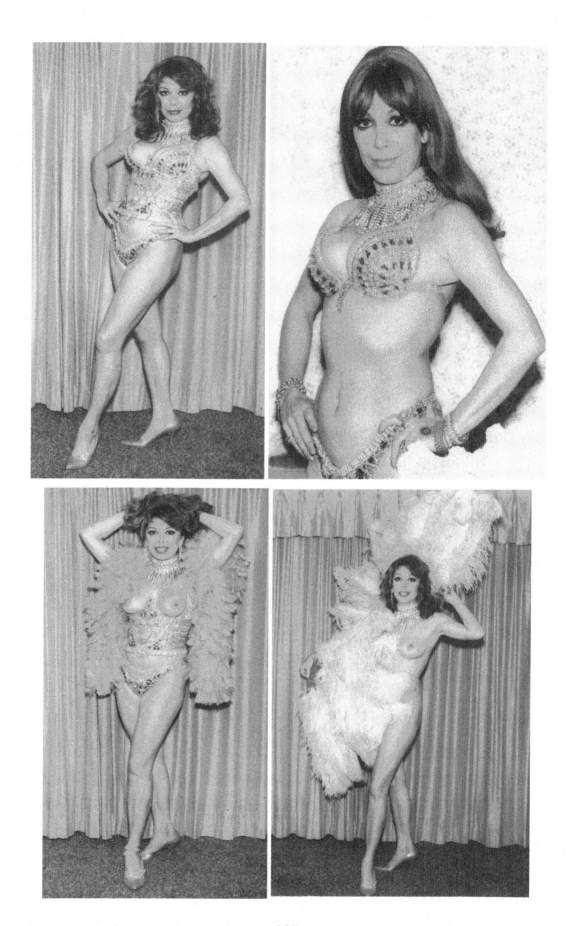

237

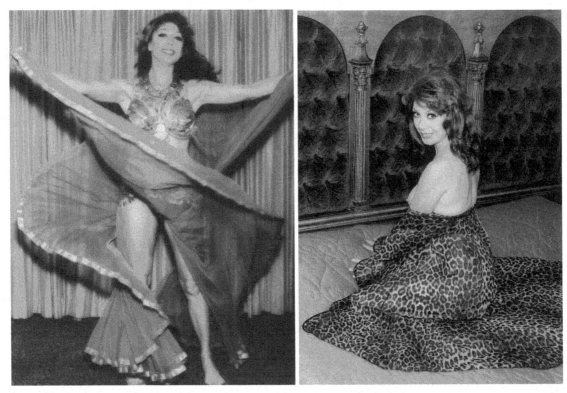

My belly dance was always a nice added attraction. I made it out of royal blue chiffon, with gold trim. The belt was made of gold coins and so was the bra. It was all hand sewed.

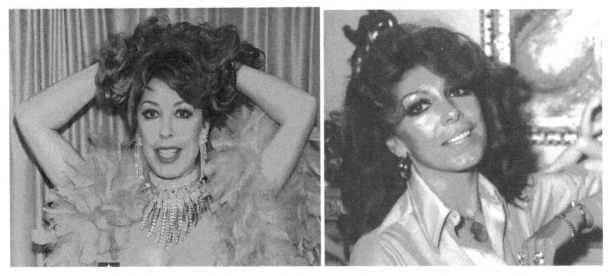

At the time, now the beginning of the summer of 1977, I did not know that this would be the last photo shoot. Right: my last snapshot in my California home, my once happy home, would become obsolete. Just another memory.

I still had some time to "kill" before leaving for Canada.

I decided to work at the Hat, in El Monte, California, for a short time. Angel came along. The club was a low-class strip joint, of mostly Mexican clientele. It turned out to be a heavy mixing club, so Angel and I left early.

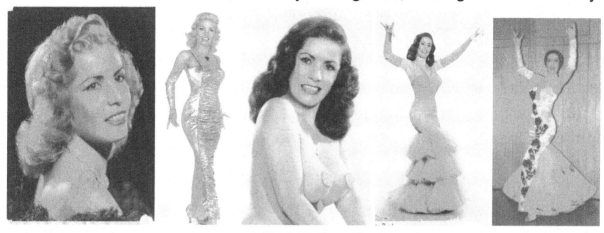

TANAYO - Costa Rica! Costa Rica's Dream Girl

The gowns were made by Gussie Gross, my original photos.
One of our co-dancers was Tanayo. We did not like each other, because she was always buzzed, and vulgar. In later years, when she overcame her drinking, we became lifelong friends. She was then a caring, sweet person. Once she retired from dancing, she would come to Las Vegas from California to sell burly undies in nightclubs for the dancers, and she always stopped at my home to visit my mother. A few years later, she came down with cancer, which progressed fast. We stayed in touch until she lost her battle with cancer.

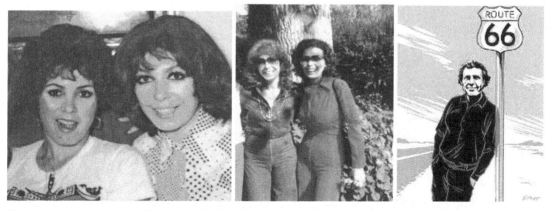

The last photo was taken with Angel before leaving for Montreal, Canada. We had carefully planned our trip now and were ready to go. All of us entertainers met at my house now where we were ready to leave. It was

early in the morning, we had two cars. Angel and I were in my Bobcat station wagon and the "love act" drove in their car, and took Tracy King along. We left California and went East toward Flagstaff, where we spent the first night, taking part of our route on RT 66, like the TV series that my brother-in-law Stirling Silliphant produced.

Then off through Albuquerque, Amarillo, Oklahoma City, Tulsa, Claremont, OK, Springfield MO, St. Louis, MO to Detroit, into Windsor, Canada. We separated with the love act in Joplin, Missouri, and met a few days later in Montreal, Canada, where Piere, our manager, was waiting.

 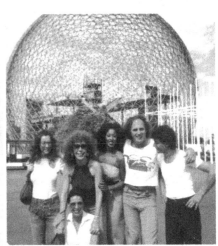

Group shot on arrival in Montreal, Tracy King, In front of the Biosphere Dome. with Angel Carter, Tracy King, the love act, and our manager Piere. My hair was copper red, and a tight perm, so I styled my hair in an afro.

Now in Montreal, snapshots with Tracy King at the St. Lawrence River, in the back of the Jacques Cartier Bridge. Taking advantage of a couple of

extra days by going sightseeing, and playing tourist. My once home Montreal, where I immigrated in 1957, used to be just like America, is now all French Canada, and it was very hateful towards Americans. Many of the French let us know many times that we were not welcome in their country. They refused to fill up my car with gasoline unless I spoke French, and they also damaged my car a few times, also broke the antenna of my car.

With Tracy at the Olympic Stadium and somewhere unknown to me.

The next day I met up with a Mountie. He was nice enough to stay still for me for a snapshot.

Once we started working, we were all split up and booked into different clubs, and I requested the most isolated towns available. It was a good way to get to know Canada and the pay was better.

In Ottawa posing for a few snapshots in front of the Parliament Building and holding this little boy's chihuahua.

My opening night in Montreal was at the Dracula Disco (Dracoola)

The Gazette **Montreal**

🤸 **DELILAH JONES**

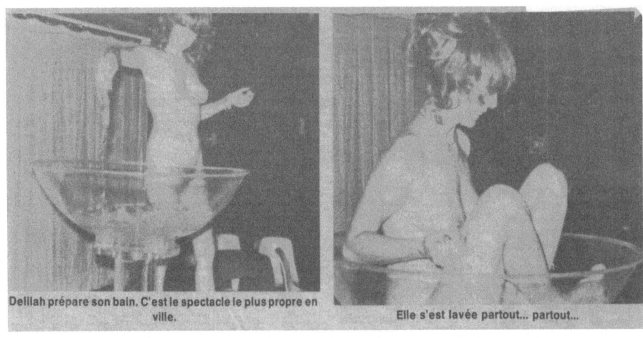

Delilah prépare son bain. C'est le spectacle le plus propre en ville.

Elle s'est lavée partout... partout...

My champagne glass was something new for Canada at the time.
It came apart in three sections, the top, the stem, and the base.
I traveled with a screwdriver and a footrest.

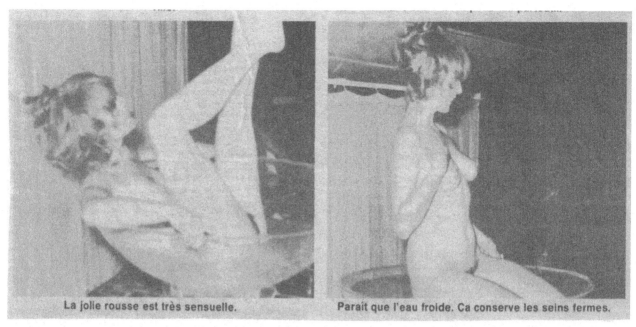

La jolie rousse est très sensuelle.

Paraît que l'eau froide. Ca conserve les seins fermes.

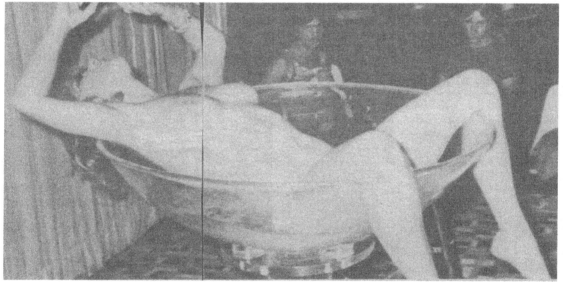

Les spectateurs à l'arrière | -plan sont bien intéressés.

The Canadian shows were rough and vulgar, they wanted me to do my contortion in the nude, how disgusting I thought, I refused and kept my g-string on, which the club owner did not like, I did, however, go totally nude. The house girls would do splits and spread their legs wide open in the nude, while customers were eating lunch, even women.
The following week, I went to a small town, in the outskirts of Montreal. Most French Canadians were rude, even to their own kind.

My champagne glass was a success. I traveled weekly by car from one club or town to another and did out-of-town gigs. The further away, the more interesting it was and the pay was better. I also worked in different clubs in Montreal, Ottawa, Ontario, and whatever was available.

Tu vois, papa; est-ce qu'elle n'a pas l'air d'une belle cul- de- jatte?

Tu vois, je ne te mentais pas!

Viens!"
Tu vois, papa, Montréal ne compte pas que des Dalilah Jones.

Seven Isles or Sept-Îles, in Quebec, this was my only advertising.
It was a table placemat, in a coffee shop.

SEPT-ÎLES

I was now booked into Seven Isles - Cote`- Nord, the very tip of the eastern region of Quebec, near the Atlantic Ocean. There, I had to take a small propeller engine airplane, because I could not drive through the mountains, they had no gasoline stations for 175 miles. The club was underground and had utility pipes and other pipelines on the ceilings, but in general, all clubs were kept clean and so were the clientele, so clean-cut, that most of them were boring, stone-faced. They rarely applauded, even though they seemed to have enjoyed themselves.

Trois-Rivieres THREE RIVERS QUEBEC, CANADA.

My next flight to three rivers was the last one out, due to a snowstorm. This place was a shock to me, as I was the headliner and had six totally nude Go-Go boys in the show. To me it was hilarious. They would do splits and somersaults, and whatever else all in the nude, while all their "privates" were dangling and flying from side to side, and no one spoke a word of English. So, most of the time we were just grinning at each other.

One of the go-go boys was dangling on a ceiling pipe, with his feet near his hands, so that all I could see was a huge brown eye with two balls, one on each side. I laughed so hysterically, that I was asked to go to my dressing room. That was not funny to the Canadians.

Then off to the Atlantic Ocean

Labrador Newfoundland

My next booking was in Labrador. The vast nothing, I could see forever all the way to the horizon, the end of the world. Only one hotel was in sight, the Fermont, which looked deserted, but that was where I was staying. No people in sight, because everything was underground, like shopping centers and metro stations. A unique way of staying warm. This place had no stage, just a dancing floor on the ground floor, where I did my show. I had to use an elevator to the top floor, where I was staying, in my gown, dressed for the show. Very little applause from the audience. They were as cold as the weather. Frozen stiff. I spent a lot of time in the kitchen, where my meals were served. The cook always made special meals for me.

My contract was signed in Montreal for Labrador.

It was now August and being way up north, it snowed, and it was cold. I found a second-hand store that had this fur coat, pictured, for $5.00, which was actually in really clean and good condition.

Then back to Montreal.

Arriving back in Montreal, the temps were in the nineties and humidity was close to it because it was still August. I gave the fur coat to one of the gay boys, the one that always treated me nicely. I liked him a lot. One day he asked me for one of my tampons, while he came to visit Angel and me in my hotel room. Dumbfound Angel and I looked at each other and I asked him, "What do you want one for"? He smiled and said that he had the runs and wanted to plug up his butt hole, before going on stage. How funny, we all smiled and laughed out loud. That had never entered my mind.

Now I stayed with Angel for the rest of the trip and stayed as full-fledged roommates. We stayed in a huge hotel and our doors were always open to the ones that liked us. The small gay boy was our steady visitor. He came daily and borrowed our makeup and I always gave him extra tampons, just in case. He liked to chat with us.

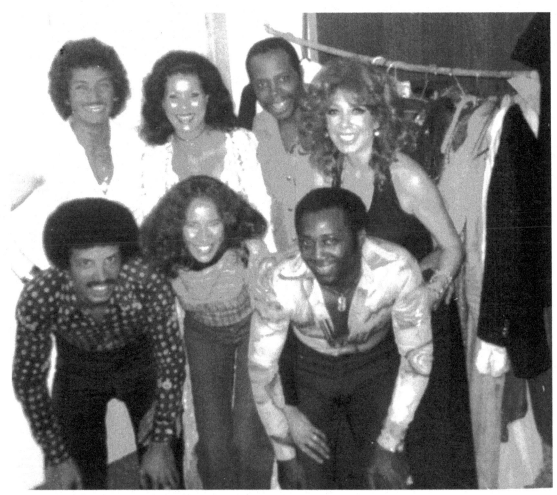

The final week was the best. End of summer 1977, I worked with Angel and the singing group the Platters. This engagement was fun. We had connecting dressing rooms. Finally, we were all Americans and we got along so great that we all would go out for lunch together. What a stroke of luck to be in the same show with the Platters.

Now on the way back to America the Beautiful, passing Windsor, and leaving Canada, I took the wrong turn on RT 3 into Detroit, to the Harlem slum area on Jefferson Avenue. But we made it home again in one piece, a few days later.

I vowed never to leave my home again.

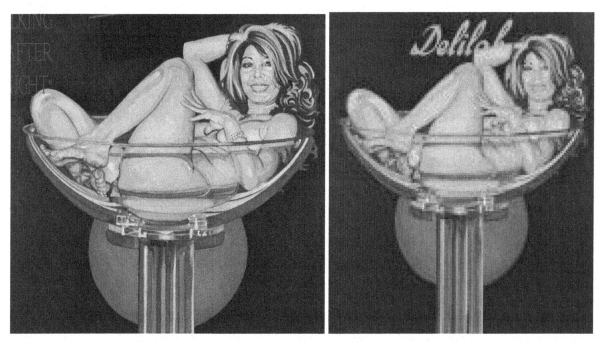

John Burge made this picture of me for a church that posted sinners.

249

I was done with traveling, but Alexis pestered me daily to come to Las Vegas because Paul Perry had just opened a day shift, at the Cabaret Knowing that Paul never hired anyone, unless they auditioned, I was hired under the agreement that if Paul did not like me, he would take it out of Alexis' salary. So all was agreed and after three weeks home, I started packing. Being hired by Paul Perry was a privilege. Around Oct 1977 I arrived in Las Vegas at the Cabaret Burlesque Palace. I am still with red hair from Canada, but the perm started to grow out. I was now with many of my old friends again. We all came to Las Vegas to work and we all stayed. Liza met Lovey Goldmine`s brother at the Cabaret and married him, only to lose him to a tragic plane crash. They did however have two beautiful children. Liza was single for the rest of her life.

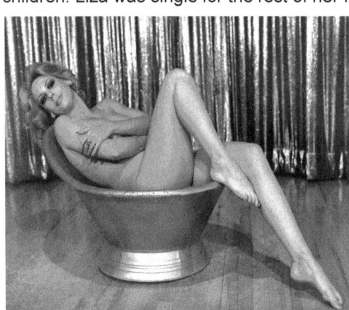 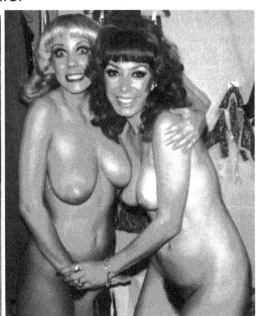

Liza in her tub. Fun with Liza in the dressing room.

I not only reconnected with Liza but also with Dusty Summers, whom I worked with in Phoenix in 1972. Alexis got me the job, if it was not for her, I would have never come to Vegas. I was thinking of staying home and never going back on the road again.

I must have passed Paul's qualification, as it happened I stayed on with him

for nineteen years until after Paul's death, when I retired in 1996.

I was to be on the day shift, while Alice had the night shift. This trip to Las Vegas changed my life forever. Being now comfortable with my new environment and job, I bought a new house in Las Vegas in 1979, across from Jan Fontaine's home. I made Las Vegas my new home and did not want to go back home to my husband or California anymore.

Articles by Dusty Summers about Kitten Natividad, and me on November

11.1977 was my first Vegas ad. Angel Carter followed me to Vegas. Kitten and Angel working together was scary at times. Both had a drinking problem. Which they eventually overcame in time. There would be an occasional brawl between them. One time over a guy. Later when they were both sober, they laughed about it.

"Jumping forward": Angel had silicone injection breast

enlargement that almost cost her her life when around 2010 she had to remove all her breasts and needed a skin graft from her butt. It took many months to heal. In 2022 she passed away from a stroke while I was with her. I was the first and the last one to see her in the hospital.

About "Kitten Natividad", she had many breast enlargements, throughout the years, which eventually got the better of her. Russ Meyer always told her, the bigger, the better. Kitten had cancer and passed away in mid-2022.

Here are some of our dancers and little stories.

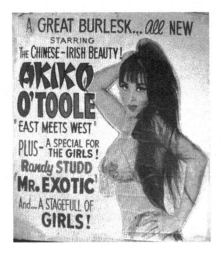

Then there was AKIKO O`TOOLE, a slender Eurasian, a Chinese American beauty, who used to come on stage dancing to:" Your kisses take me to Shangri La". She was married while working at the Cabaret and became one of Paul Perry`s harem. When her husband found out, he shot her in the stomach. After she recovered she came back to the Cabaret as a dancer and stayed with us for a while. Eventually, she went back to her husband and turned to religion. I saw her again in the mid-90s, at the Palomino. She was still married to the same guy and they had 6 children. She still looked as beautiful as ever. Here is my newspaper clip of Akiko.

At the Cabaret, we had six girls during the day and 6-8 at night. If a customer would come in at the beginning of the day shift, he could see fifteen stars without repeating. So many naked girls in the dressing rooms. We were very fussy about anyone sitting on our chairs, naked. We always had a towel on the seat of our chairs.

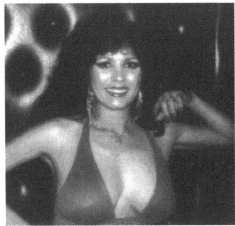

LARRY GATLIN

Angel Carter Larry Gatlin

Angel and I shared a hotel room for the first few weeks. One night, she surprised me with a visitor that she brought to our motel. It was Larry Gatlin. She was crazy about him and wanted his body, I only wanted his photo. So Larry spent the evening at our pad. Both of them were buzzed

while having a sexcapade on the floor. I often wondered if they remembered anything. We were free as the wind, live and let live, no cares in the world, and no one tattled.

Gina Bon Bon Snowi Sinclair Gypsy Louise

Snowi and I had lost touch since the Brass Ass, in 1973. Now in 1977 being reunited again, we stay in touch, thanks to the internet. Snowi became a government engineer. Gina Bon Bon lives nearby and we get together for lunch or parties.

Gypsy Louise aka Lulu and I became friends instantly. After work we would paint the town. Everything was always free for us girls during the mafia era. We spent a lot of time at the Tropicana, where Lulu was dating Rocky, the manager of the Tropicana lounge, while Alice aka Alexis was dating the CEO of the MGM. After he broke up with Alexis, she stalked him and he put a restraining order against her. At the same time, Alexis was dating the owner of the Hacienda hotel, who eventually talked her into another profession, as a jailhouse warden. She went through six weeks of training and became a fully fledged warden. Angel went back to Los Angeles for a while, so I moved in with Alexis for a few months.

One evening, Lulu and I were invited to Wayne Newton`s penthouse, where we spent the evening with him and his pals.

CHRISTINA DARLING

The Vegas Vampire & Satana

I met Christine Darling first at the Cabaret. She also worked in New York City as a stripper and did a hell of a great novelty show as "Mae West". She was also a "straight" act in the "Olde Tyme Burlesque" show at the Maxim, and also was our light tech at times, and worked the Palomino. She is now a casino employee.

PJ Parker and her husband Jim Parker "The Las Vegas Vampire" from the TV show in Las Vegas 1970s. When I met PJ she avoided me, because she thought I was stuck up. That changed fast when we discovered our mutual love for Chihuahuas. PJ eventually divorced Jim Parker, married a magician Pellegrino, and divorced him after I introduced her to Dan Hauser, who became her third and last husband, and they lived happily ever after to this day.

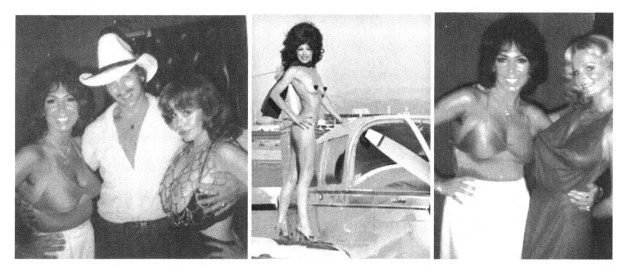

Me, a friend, Kitten Natividad, Jan Fontaine, our pilot, and Alexis & I

Sometimes in December 1977, Steve Miller took some of us dancers to the McCarran Airport for a photo op. He owned this plane and had a school for flying lessons. One of his students, and pilots, was Jan Fontaine, who worked hard to get her commercial pilot license. She also bought one of Steve's planes. Steve went on and became a Las Vegas councilman.

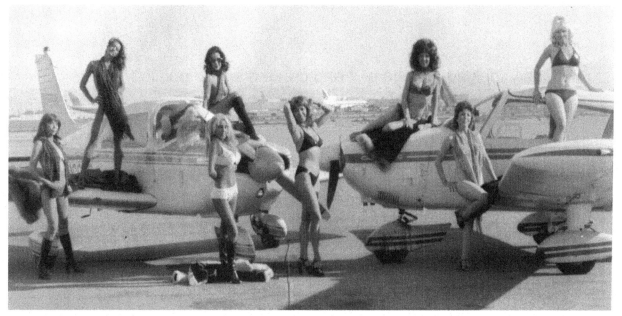

Angelique Pettyjohn, Terri Thomas, Odessa, Jody English, Delilah, Jan Fontaine, Teri Starr, and Dusty. Steve took this photo of us, and some topless while commercial airplanes were coming down the runway, ever so slowly, and watching. We all waved at each other. Next is the topless one.

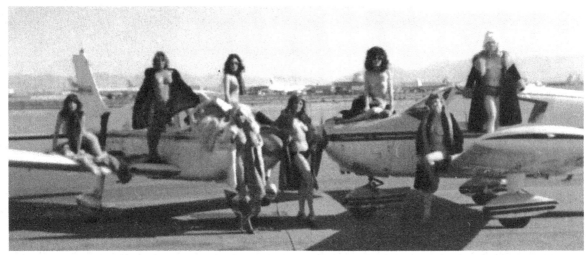

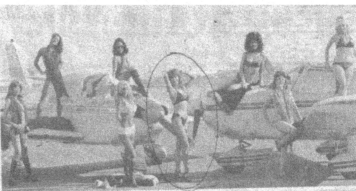

The most spectacular line-up of exotic talent in the world make their debut every afternoon on the runways of the PALOMINO and CABARET CLUBS at 2 p.m. continuous until 4:30 in the a.m. Some of the pictured here as they make preparations for their scheduled performances. Flight Captain is licensed pilot/exotic JAN FONTAINE, of Fontaine Airlines — and her crew includes yours truly, backseat navigator and all the girls invite you aboard for a trip out of this world! Our photographer was STEVE MILLER who is a and owner of the two airplanes in the photo. Photography is his favorite side line second only to ??? If you'd like instruction, in him at 736-2226 734-8236.

Pictured from left right are: Angilique, Te Thomas, Velvet Odyss Jody English, Delilah Jon

Dusty took advantage of it and created a nice publicity article.

Lovey Goldmine, half of me, Angel Carter, Angelique Pettyjohn, and myself.

At one convention show for Mazda, Lulu and I were asked to do a special private show for them, at the penthouse of the Tropicana Hotel. The Mazda went mmmm. We did, and It was respectable and we got paid well.

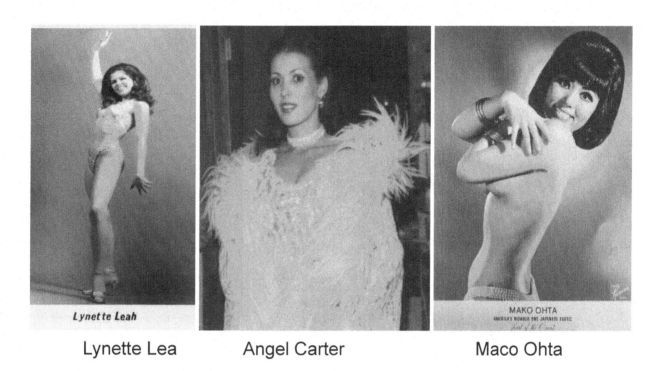

Lynette Leah

Lynette Lea Angel Carter Maco Ohta

Maco Ohta married a Las Vegas detective. But that did not last long. She strongly believed in Buddha and was set in her own way.

Angel Carter talked me out of this white lace costume that I made and wore at the Body Shop. Eventually, she got most of my gowns. Angel with her drinking problem, and Angelique with her drugs, both decided to go to AA meetings. I went along to see how that worked. Angelique and I had a certain closeness, I understood her and I never judged her. Eventually, drugs got the better of her. She came to Vegas from Santa Barbara, while she was going through a divorce. She told me that she climbed through the window one night at her home, to get some antiques out, hoping that no one would catch her, she was not allowed to take anything out.
Lynette Lea was a very attractive, young country-like girl, and so was her show when she did a hillbilly act with "juggle up". We had good laughs with her. A native of Nebraska.

She BABETTE
MISS NUDE NEW ORLEANS
"The Electric Flame of '78"

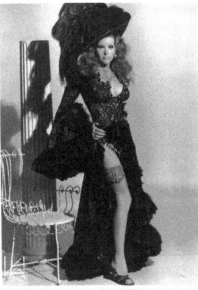

She BABETTE
The Electric Flame of '76

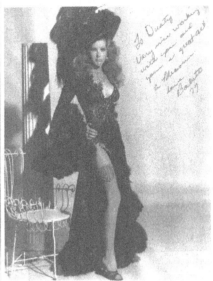

She BABETTE
The Electric Flame of '76

NOW APPEARING

She Babette
"The Electric Flame of '76"

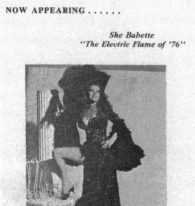

NOW APPEARING

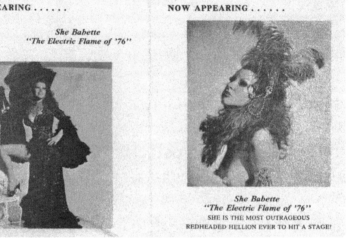

She Babette
"The Electric Flame of '76"
SHE IS THE MOST OUTRAGEOUS
REDHEADED HELLION EVER TO HIT A STAGE!

Souvenir table card and some photos. She Babette, was a newcomer to the show

Bambi Leigh

Bambi Leigh arrived at the Cabaret in the late seventies. She was a small build girl, perfect in every way. Not long after she left for her next gig, we got the terrible news that she had passed away from suffocation. The silicone, from her breast implants, traveled to the lungs. So many dancers had such bad repercussions from silicone.

258

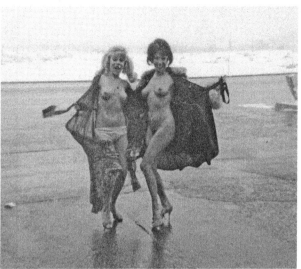

From December of 1977 into January 1978, it snowed in Las Vegas. We had a blast and took the opportunity to have some fun. What was better than to streak on Paradise Rd, with Tracy Sommers? In the background, you can see the strip. It was all about having fun. We had snow on the palm trees, how funny. Making snowballs in the driveway of the Cabaret. Alexis, Michelle, Tracy Sommers, and I.

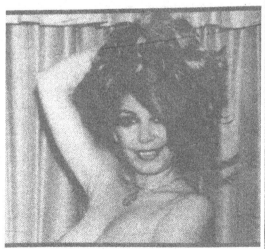

DEBILITATING DELILAH — *Delilah Jones is one of the featured exotics at the famous Cabaret Burlesque Palace where all-nude acts may be seen from 2 p.m. until dawn daily alternating with hilarious top bananas*

December 1977

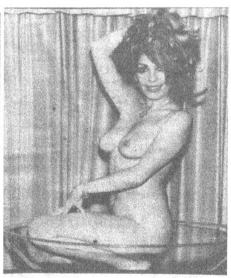

DEBILITATING DELILAH — *Delilah Jones is one of the featured exotics at the famous Cabaret Burlesque Palace where all-nude actsd may be seen from 2 p.m. until dawn daily alternating with hilarious comics*

February 1978

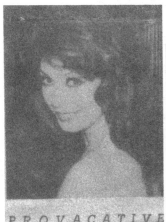

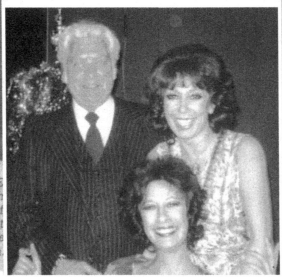

March 1978 1978 with my future husband, and Gypsy April 1978

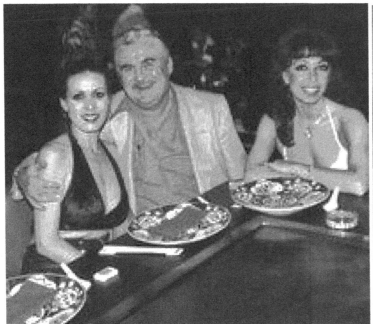

Going out for dinner with conventioneers was a common thing to do.
We did that often and never had any problems with men. Here with
Angel and a convention salesman for dinner at Caesars Palace.
Right, it was dinner with Gypsy. We cut the photo in two, she has the other
part.

DELILAH JONES (picture)

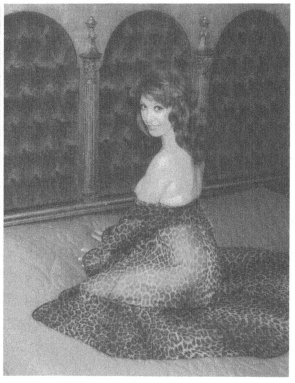

SUGAR & SPICE — Beautiful, provocative Delilah Jones entertains at the nude Cabaret Burlesque Palace on Paradise Road along with a host of International exotics from 2 p.m. until dawn daily.

April 6th 1978 newspaper ad original photo

Myself, Chester, our light tech, Teri Starr, and KC Layne aka Knight.

Teri and I were both working on the road across America, always following one another in different cities and clubs. We also had the same agent, so we knew of each other but did not meet until we both wound up in Las Vegas at the Cabaret. We became friends forever. She kept two boyfriends at the same time for 30 years, without them ever knowing. Years later, her roommate Mary, a "druggy" robbed Teri of all her money, and belongings, maxed out her credit cards and beat Teri half to death, then tried to kill her over the deed to her house. Teri survived the attack but suffered two strokes during the ordeal. She's been living in an adult facility since, in Dana Point, California, near her daughter

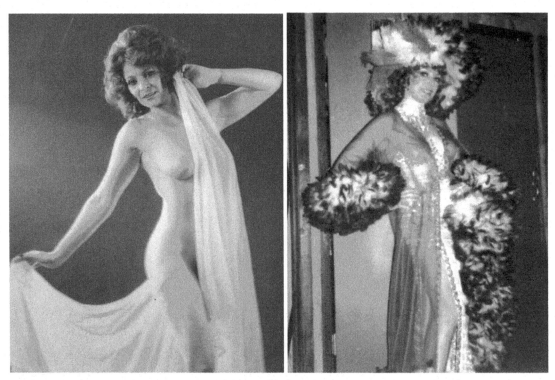

K.C.Layne aka Knight. My newly finished costume.
Neon Green chiffon cape, trimmed with white and green feather boas.
Silver and white sequin strands, matching feather hat.

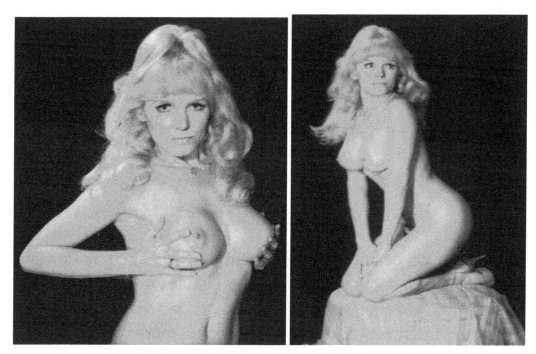

Dusty Summers.

Another one of my own creations.
This one was one of my favorites. Black lace adorned with large Austrian
rhinestones, black feathers, and a solid rhinestone choker.

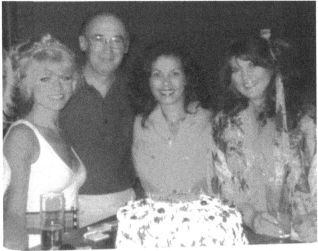

On June 8, 1978, we celebrated Angel's birthday, with Tiffany Powers our emcee, and me. That same year Angel and I got invited to Frank Sinatra's Birthday party at Caesars Palace where he was performing, given by his friend Jilly. Herb Eden was our escort. The whole room was so full of celebrities. The outstanding one was Barbara Eden, who Herb introduced me to, making a joke about both having the same name EDEN. Angel was nowhere to be found. As it happened she got too buzzed and started to cause a scene, and we were asked to leave. Angel did not remember anything the next morning or maybe did not want to.

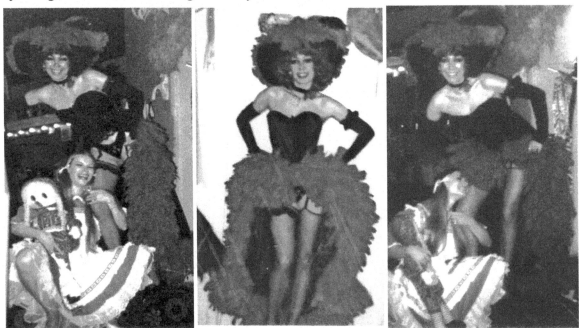

My "Queen of the Silver Dollar" costume and Michelle Monet backstage.

VEGAS VISITOR — June 16, 1978 — PAGE 17

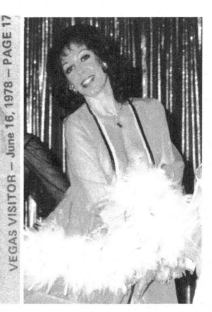

Michelle backstage, in her Jungle costume, stayed with us for a while as a dancer, then moved on to a different life. She studied and became a registered nurse, while she was dating a male nurse. During that time she developed breast cancer and went on public TV news to talk about it. Kudos to her. I saw her last in the nineties at a swap meet, then we lost contact. Center: another ad.

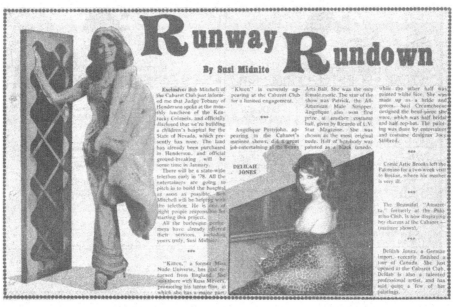

Susie Midnite, another one of our dancers wrote for the Panorama paper for Las Vegas, Nevada, California, and Arizona, tourists. She also wrote many of Liberace's advertisements, they were great friends.

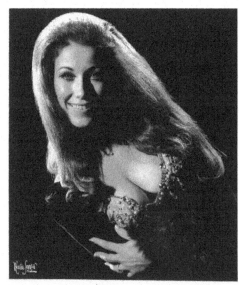

SUSI MIDNITE

Susie a native German like me, was in a concentration camp in Germany during Hitler's reign when she was six years old. She had a number tattooed on her arm showing that she was one of the prisoners, but was ever so fortunate that she got out, because the war had ended, and she swore never to talk to another German again in her life, but she made an exception with me. We stayed friends throughout the years. Sometimes in the eighties, someone broke into her condo and robbed her of everything valuable. Among that was a $15,000.00 huge diamond ring. She had no insurance. I was with her at that time, and she went through hell from stress. As luck had it, the cops that knew her did a big-time investigation, and she got most of her jewelry back including her ring. After she left the business, she went to work at the Diamond's department store and sold fine jewelry. Later on, she found religion. From stripper to bible study. She is a content person and lives alone.

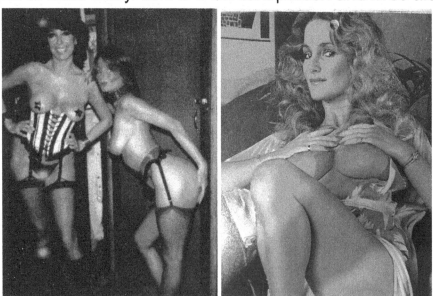

Snapshot backstage with Alice aka prima "cuntola", and my Calendar 1977 with Alexis, who named herself after Alexis Smith, the actress. She would many times greet me, sitting nude on a chair with her legs spread open.

 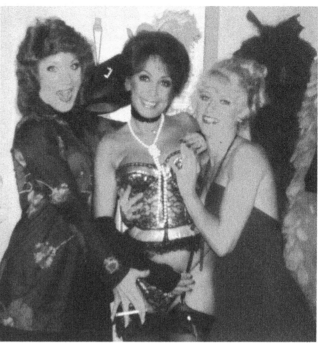

Left: Angel and I having fun at the ticket booth. Right: Brandy, myself, and Tracy backstage. Brandy and I are still together in Vegas. Tracy became a manicurist at the Meadows Mall and passed away from a sudden heart attack circa 2014. She was healthy and had no health problems. While at the Cabaret she got the awful news that her brother had drowned from scuba diving. She was devastated. We all became like a family.

 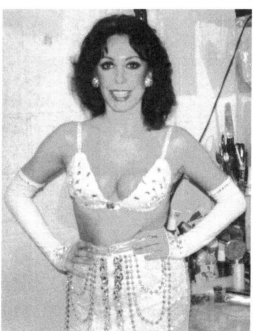 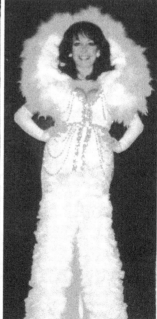

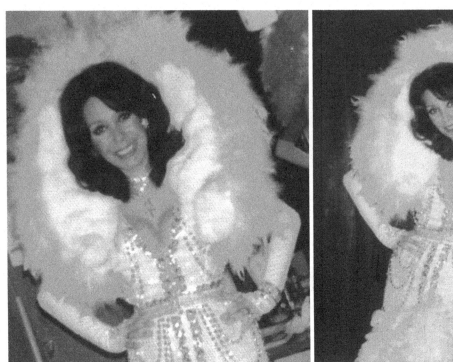
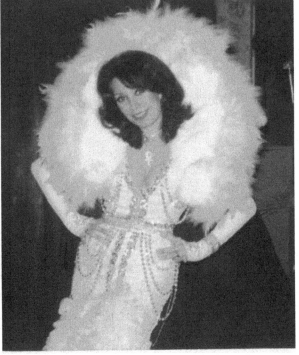

Working on a new costume, all in white, and the undergarment had to match. Here is the finished project. I made the head-neck gear out of wire hangers because they bend so easily, and a white feather boa finish. Crystal beads and rhinestones were a must. It had to glitter and shine.

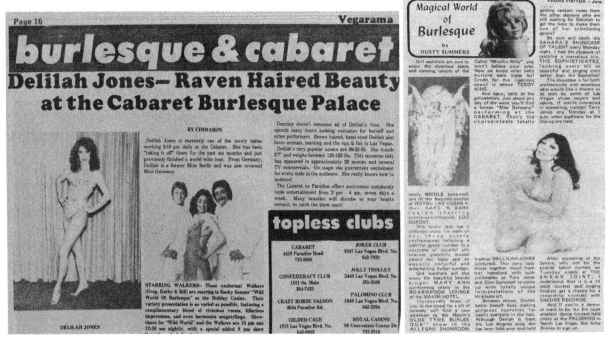

JUNE 23.1978 One of our dancers, Cimmaron, wrote this article about me for Vegarama, another magazine. Right: Dusty Summers's article.

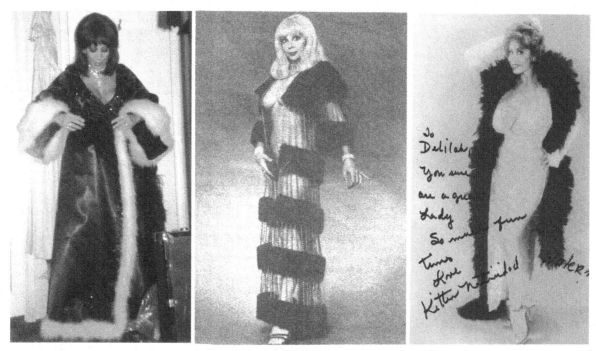

Two new costumes, one for me, the other for Angelique, that I made.
A replica from Bobbie Gerston, who was okay with it. Angelique photo by
R. Scott Hooper, and a Kitten Natividad photo, right, signed to me.

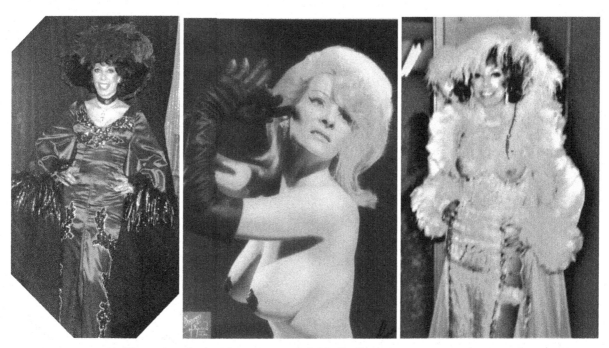

Two new costumes and K.C. Layne
We all worked together at the same time, sometimes on different shifts, day
or night shifts. Sometimes at the sister club, the Palomino.

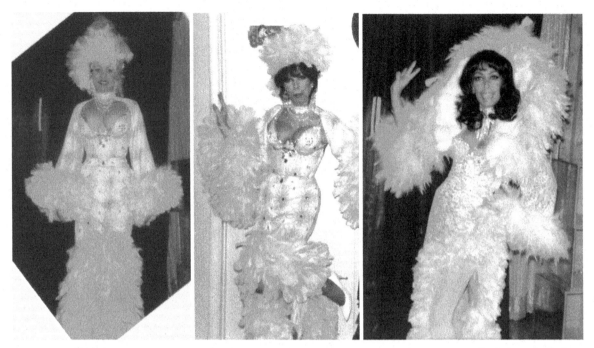

Angel Carter wearing my other new costume, one I had just finished. It had gold stars in the material, and another new white one, with the same feather headgear. They were all different and I sold them as soon as they were finished.

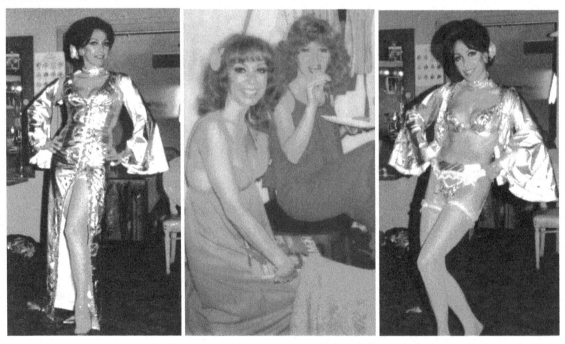

This one was gold lamé with aurora borealis crystals, yellow-gold stockings and matching gold garter belt.

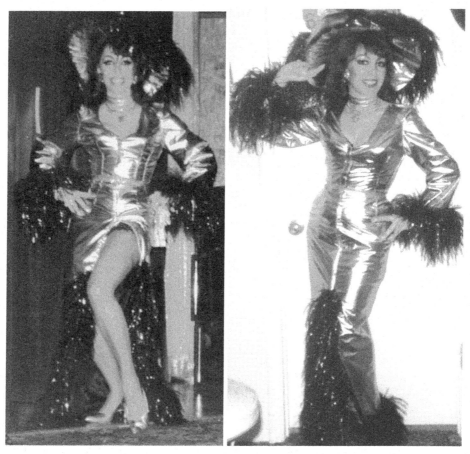

Another gold lamé costume with black and gold metallic ostrich feathers. I used this for my "hooker" show, "Never on a Sunday". I also made the hat, and the base also from wire coat hangers, and the same material as pasties. I always got lucky to have shoes to match my outfit. My shoes were always the same style, in white, black, gold, silver, and one pair of red ones.

Things to do when the dancers would get tired. We would look for places to snooze. The best were under the tables. We would pull doubles, often, therefore, long hours. We also would cook for each other, and take turns. It was a real family feeling. Left: PJ Parker napping between shows and her write-up about the Bostonian Sandy O'Hara and me. Sandy was part of a traveling duo with her husband.

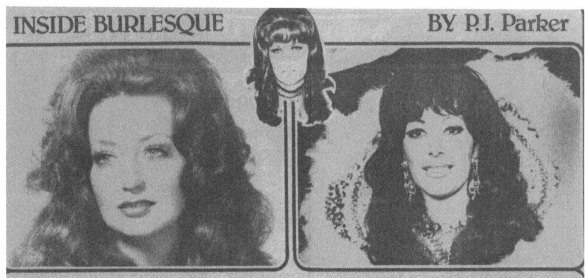

INSIDE BURLESQUE BY P.J. Parker

Can a burlesque star be sexy and still maintain an air of class? Of course! And a fine example of this can now be found in ROCKY SENNES' production "The Wild World of Burlesque" at the Holiday Casino. They call her "The Improper Bostonian" and racy SANDY O'HARA has the ability to blend these two qualities into her act, sex and class.

I take some personal pride in SANDY's performance. My sister AMBER and I helped SANDY break into the business. If you want to learn the exotic dance business the hard way, try

Palace. Under the direction of hubby DAVID HANSON, SANDY now has a complete production show built around her. The show is seen in many of our Nation's finest supper clubs. At the Holiday, SANDY is features in ROCKY's very popular burlesque production.

It's nice to see SANDY and DAVID back in Las Vegas. I'm sure the Holiday patrons will enjoy her show and also be glad to have 'em back in town.

eyes. With over 20 motion pictures to her credit, the German beauty now makes her home in Hollywood.

Off stage, the seductive DELILAH is not what one might expect her to be. DELILAH is a warm, happy person. She loves life, people and has also taken in more than her fair share of stray cats and dogs. You'd expect the exotic temptress to be an animal, not an animal lover.

Witty Palomino Club comedian ARTIE BROOKS tells us about the Polish farmhand who was out riding in a buggy with his girl.

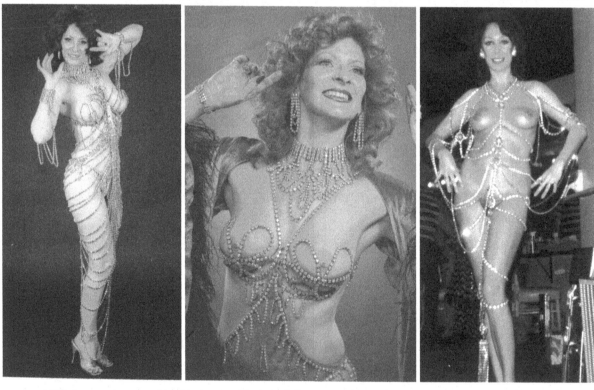

KC Layne the special solder work she did and I modeled it

The new rhinestone costume she created was all solid rhinestone soldered by the yard, and some loose stones, it was hideous work, but so effective.

272

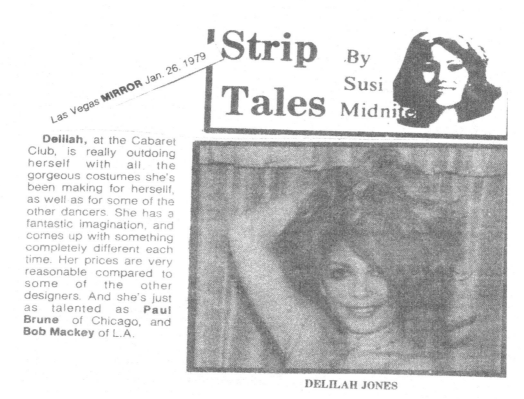

Las Vegas MIRROR Jan. 26, 1979

Strip Tales

By Susi Midnite

Delilah, at the Cabaret Club, is really outdoing herself with all the gorgeous costumes she's been making for herself, as well as for some of the other dancers. She has a fantastic imagination, and comes up with something completely different each time. Her prices are very reasonable compared to some of the other designers. And she's just as talented as **Paul Brune** of Chicago, and **Bob Mackey** of L.A.

DELILAH JONES

Susie Midnite's ad about me was in January 1979

And celebs were always present.

Mel Tillis would visit the Cabaret every time he was in Vegas. Such a funny and happy man. We both loved chihuahuas, and he had fun talking to me with his stuttering, sometimes he would sing to me, without stuttering. It's weird that it would disappear with singing.

Don Knotts also would visit occasionally. He would always politely sit and talk to me. Many times with his famous laughter, and most of the time with his serious side. His eyes were piercing blue.

Next: April 1979, an ad with Angelique Pettyjohn, and another write-up from Dusty, about Jody English, and me.

In 1981 Dusty Summers left Las Vegas for Texas and opened her own strip bar, married a Texan pharmacist, and lived happily ever after.

In 2006 we would meet again at the Burlesque Hall of Fame reunion, and stay in close contact.

In 2010 she would appear at the Orleans in the Burlesque Hall of Fame show, with her "magical" show, where she uses white doves.

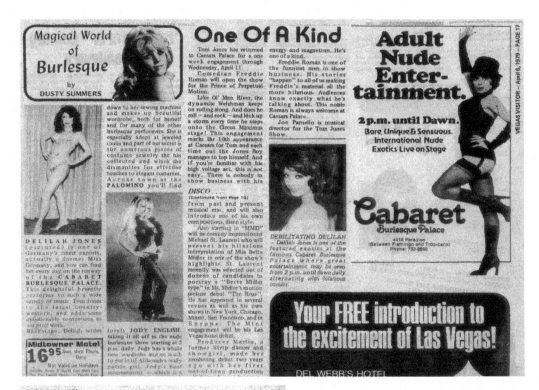

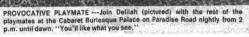

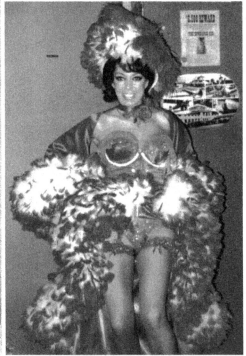

October 26.1979 ad A different kind of costume

This one was blood red, with red and white feathers.

Two other white costumes, right, white lace with Austrian rhinestones, set off with white metallic ostrich feathers.

Left: silver eyelash material, with silver sequins, and strips, adorned with rhinestones. Wearing my handmade rhinestone choker. Our twenty-minute shows, three times a night, took a lot of energy out of us, but our bodies got strong and solid.

On slow nights, we would exchange shows and costumes along with the music, to keep our spirits high, and we all were a similar size.

Next: Me sewing backstage. Center: I am in Tracey Summers's costume, for her show: "You're so vain". Right: Here I am in Teri Starr`s "Cat Show" costume.

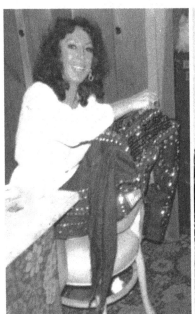 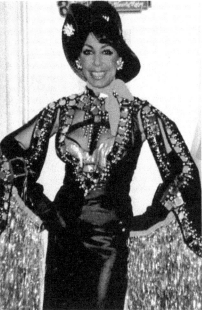

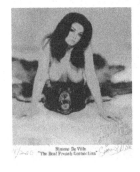

Left: Simone De ville, signed photo to me.
Next:: Cindy Malette, Angel Carter, Gypsy Louise, myself, and Alexis. On top of the prop is Tiffany Powers. She died at an early age of cancer. This was the last professional photo taken of me as a dancer.

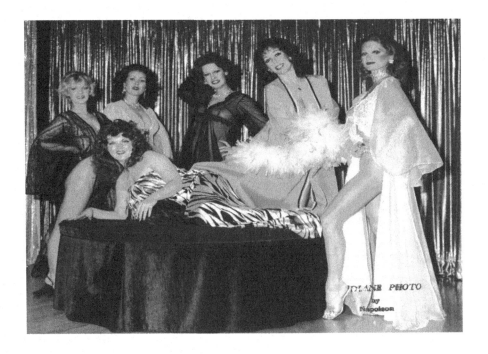

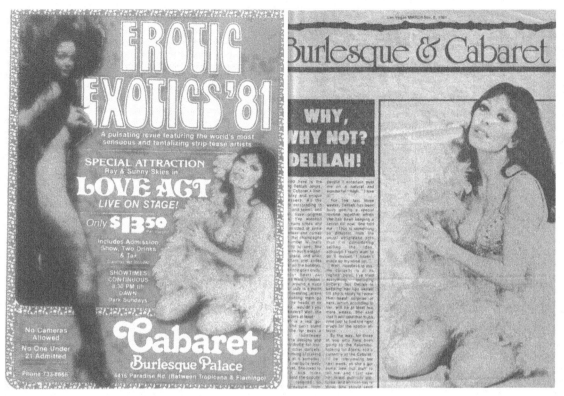

Getting close to the end of my dancing career, some last minute advertisements. Left: Simone De Ville and myself, this full-size ad came out just as I retired. Simone has a happy family life and owns horses. She is also an artist in drawing and painting. We are in contact with each other. The MIRROR ad 1981 was my last ad as a dancer by Susie Midnite.

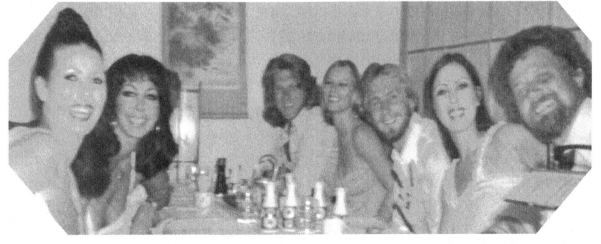

Out with the gang at Osaka's. Angel Carter, myself, Michelle Monet, her friends, Akiko O'Toole, and our shift manager.

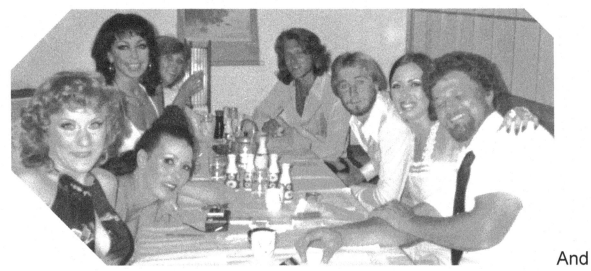
And we partied. The day shift was always ready because we finished early. This night was one to be remembered, where some of us started with Tequila Gold at the club and finished off with Saki at Osaka on Sahara Ave. Needless to say, some of the girls started to fight, some got sick in the bathroom, and it became out of control. Somehow Angel wound up on top of the hood of our car and held onto the windshield wipers for dear life, while someone was driving the car down Sahara Ave.

Picture: Brandy Duran, Angel Carter, myself, Caprice, two unknowns to me, Akiko O`Toole, our day shift manager, who was let go after this night, from the Cabaret and taken to the Palomino. because he was having an affair with Akiko, that was a no-no. Paul now thought that this would be a good opportunity to have a female manager at all times and that I would be good for the job, but if I accepted, that meant I would give up dancing. He prefers a woman so there would not be any intermingling between the male manager and the dancers, (his harem). So I did. That is why I retired so early, while I was at the height of my career.There were still a lot of THINGS to be done for the managing job like the police department getting checked for any violations, the health department, a TAM card for serving alcohol, and gaming ID. Now I was the manager at the Cabaret until it sold in 1993. I worked from eight to nine hours every night, with four days off a year.

Circa 1985 Angelique and I went into business, during my management time. We had matchbooks made, T-shirts, and advertising for the Pussycat.

We would sell her photos and posters, also at the Star Trek convention.

Entertainer, actress dies

Review-Journal

Angelique Pettyjohn, a Las Vegas entertainer who appeared in several Elvis Presley movies and an episode of Star Trek, died Friday at a local hospital. She was 48.

"She was a star, but she didn't act like it," said Pettyjohn's best friend, Joanne Loring of Las Vegas. "She was as down-to-earth and wonderful as she could be, but she was a star in every way. She had the heart of a lion."

Loring lived next door to Pettyjohn and cared for her after the entertainer discovered she had terminal cancer.

"She was the bravest woman I ever knew," Loring said. "She went through hell. She really did. It was a real hard way to go."

Pettyjohn's movie roles included parts in "Clambake" with Presley and "Heaven With a Gun" with Glenn Ford.

One of her most well-known roles was that of Shahna in the Star Trek episode titled "The Gamesters of Triskelion."

Pettyjohn was born March 10, 1943, in California and was raised in Salt Lake City, where she attended college for three years. She lived in Las Vegas for 25 years.

She got her first local job at 19 as a belly dancer in "Cleopatra's Nymphs of the Nile," then showing at the Flamingo.

Pettyjohn went on to star in "Ziegfeld's Follies" at the Thunderbird, Harold Minsky's "Burlesque" at the Silver Slipper and Barry Ashton's "Vive Paris Vive" at the Aladdin.

"I've never been shy about my figure," Pettyjohn was quoted as saying in a Review-Journal article in June 1986, when she began performing in the Marina Hotel's "Old Burlesque" show. "Nudity didn't offend me, although the first time I walked on stage I felt as if everyone was staring at my nipples."

Pettyjohn left Las Vegas for

ANGELIQUE PETTYJOHN
Las Vegas entertainer

Hollywood, where she landed parts in scores of movies and television shows.

For awhile, she toured Europe as an exotic dancer.

She returned to Las Vegas to star at the Cabaret, which is now The Pussycat, in what was considered one of the classiest strip shows in the city.

Pettyjohn is survived by two sisters, Diana Kay Bourgon of Las Vegas and Janice Marie Salazar of Salt Lake City, and a newphew, Real Sean Bourgon of Las Vegas.

A memorial service is scheduled for March 4 at Davis Funeral Home.

A few years later she was diagnosed with cancer. Shock and chills went through my body when she told me. She needed to go to California and spend time in the "City of Hope' Cancer research. After the treatment, her cancer went into remission.

When she returned to Vegas, she was anxious to show me her surgery. We both went to the bathroom at the Pussycat. Everything in her body was removed. Her intestines inside her body were now converted into an introverted catheter and had to pee through her belly button. It had a little plug on top to close the belly button. She had to keep very clean to prevent infection.

Then life took a disastrous turn when her cancer came back with a vengeance.

It was now a matter of time. I helped her the only way I could, by giving her money for drugs, to stay high so she could cope with it, and she appreciated it and was thankful. When she died, I was in California for the weekend, but Caprice aka Joanne Loring was with her, at the end.

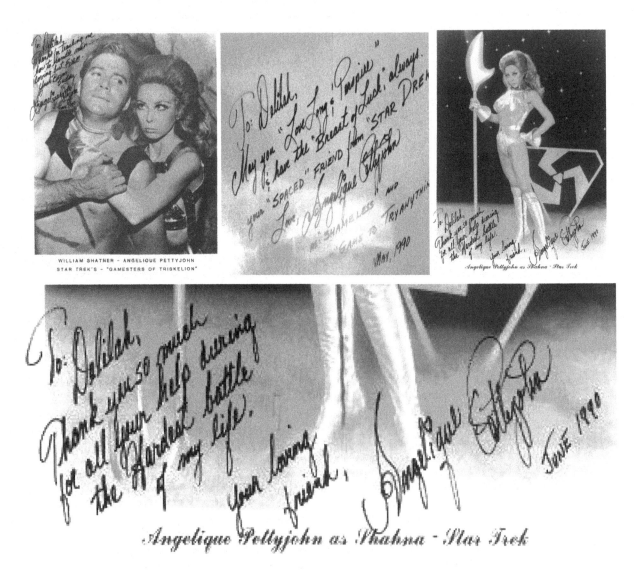

Angelique wrote this note to me, thanking me for helping me at the most critical time of her life.

These are her posters that we sold at the Star Trek convention, all signed.

PALOMINO

Brandy Britton worked at our sister club the world-famous Palomino. She was Paul Perry's pride and joy. Brandy was special in Paul`s "Harem". One morning Brandy and Paul ate at BlueBerry Hill pancake house on Flamingo, and as they were leaving, Brandy got shot in the stomach with a shotgun by a stalker from Nebraska. After the first shot, Paul grabbed Brandy, and both hid under a nearby car near the exhaust pipe. Brandy was severely damaged and was on life support for several weeks into months. Most of her organs were removed or partially. She miraculously survived. Years later she got married and then we lost contact. While Brandy was dancing, I made several of her chiffon capes and negligees. She was tiny and fragile.

Left: Souvenir table card of Brandy.

I also made Merkins. What is a "merkin"? It's a g-string with hair, or a pubic wig to cover up the vagina, which will give the impression of nudity.
I would buy all kinds of colored wigs, trim each row from a wig, and sew it on a flesh-colored g-string, which is made from nylon stockings. Akiko O'Toole, our Oriental girl, had straight pubic hair, which created a small problem. I had to fit everyone, personally, in other words, I was getting to know each one of them very personally and knew everyone's vagina.

Each one was trimmed to the vagina's size.

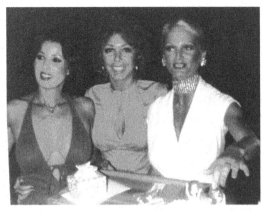 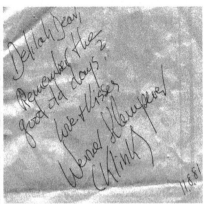

1980 with Angel Carter and Alexis aka Alice (in Wonderland), it was Angel`s birthday party, center: my husband's badge. Right: a note from Colonel Klink, Werner Klemperer.

This year brought a lot of changes in my life. While I was working in Las Vegas, my second husband Tony died of a massive heart attack in Hollywood. I took off for four days to go back home to Hollywood and took care of business. I had my husband cremated, sold my black Cadillac, sold all my antique furniture, and once my happy home. Now there was nothing left for me in California. My new life is now in Las Vegas.

That same year I married for the third time. The dress I'm wearing in this photo is the one I got married in, it was powder blue. We got married on Larry's lunch break, while he was working for Judge Gary Davis in the NLV courthouse. He took the rest of the day off. That was my honeymoon, willingly, and something that was unnecessary, as we both were workaholics.

With Jan Fontaine, our pilot, me, and Lynda, our cocktail waitress

282

Both vests that I'm wearing I made by hand, with kid sheep skin, all authentic beads, conchos, feathers, and turquoise.
Alexis had a cocaine problem, and she was always supplied by someone. One time there was no coke available, so one girl gave her baking powder. Alexis did not notice the difference and thought this was one of the best she ever had. It was a joke, and a well-kept secret until now.

I started at the Cabaret as the day shift manager, and later on the night shift. Then in 1984, we switched names from "Cabaret" to "Pussycat" I had to be licensed for many new things.

Gaming for Las Vegas Gaming for North Las Vegas TAM for serving alcohol, because I was
the manager. I also needed to have a HEALTH card, NO picture

 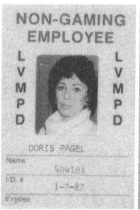

Gaming The Pussycat Logo none Gaming another picture I.D. snapshot

Unknowingly at the time, I was the only person in Nevada who held a liquor manager theater license and never realized how many guys were after my job. Paul Perry mentioned that to me on several occasions, and these guys even tried to talk badly about me.
1984 The Pussycat was born. Many of my friends I used to dance with are

now working for me. Paul Perry handed me the key to this club. I was now in charge of hiring, firing, payroll, inventory, etc.

I mentioned to Paul "I hope I can handle it". "He replied, You can, honey, don't underestimate yourself", and that was it.
I hired Alexis and P.J. Parker as my cocktail waitress.
K.C. for ticket selling and hostess.

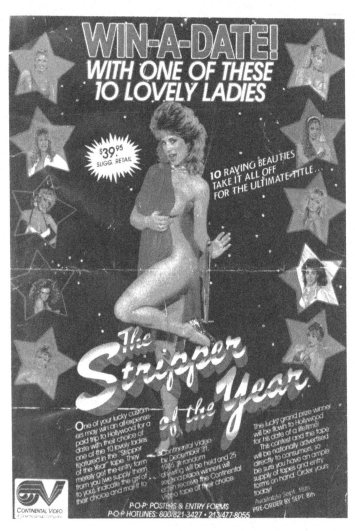

Then I hired Terri Peake, (a penthouse model), as one of my dancers. When she found out that she was pregnant, I let her sell admission tickets in the ticket booth. She loved to read books and one of them was "Rosemary's Baby" during her pregnancy. After Terri Peake had her baby, she moved to Hawaii.
My next cashier was a gay girl, a lesbian. Her girlfriend wanted to become a man but could not make the $40,000 for the operation. One day I asked her how the operation from girl to man works. So she explained.
The clit needs to be stretched at about three inches, that was the most at the time. A small dick would have made her happy, better than none.

Sometime in the 80s, I met Bambi Jr. at the Cabaret. Her mom was Bambi Jones, a stripper from back east. Around that time, my husband needed medical help and became friends with Chuck, who was married to Bambi Jones; he owned a pharmacy on Charleston Blvd. They spoke a lot about their wives being strippers. I did not meet Bambi until 2003 when we had a living legends reunion for Jane Briggeman, at the Imperial Palace, that is when we became friends. Chuck had passed away by then and Bambi showed me her home that she shared with Chuck, they called it the " Gypsy Love Ranch". Ironically, my husband and I called our home our "love nest". Top it all off, it was on the same street where I lived, only a few blocks away. She lost everything in court after his death, it all went to the former children. We got a kick out of our names, which were DORIS, both our maiden names, and JONES our stage names. Bambi told me that she walked in on her husband at his office while he was engaging in his pleasure with Angelique Pettyjohn. Bambi was actually laughing about it.

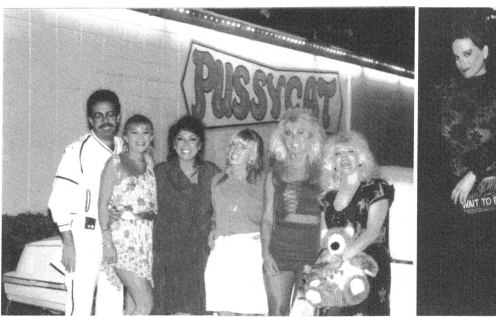

Some of my dancers. Alan, our mutual friend, and Anna, my German cocktail waitress, were in front of the new PUSSYCAT sign.
Next left: Anna, my waitress, dancers Kim Ritter and my niece Sharee.
Right: With Alexis, now my waitress, and bartender from Hollywood, and in the lobby.

One night Lee Horsley from the TV show "Matt Houston" visited the Pussycat. Alexis flipped when she saw him and made advances toward him, so they had a short fling.

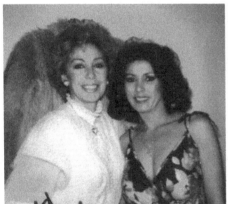 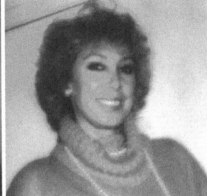 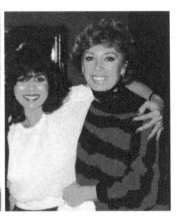

Angel Carter, now living in Canada, came to visit me every year. Me with short red hair.

Paul was happy with the way I ran his club. Here are some notes he left for me in the safe, which he would leave many times for me, along with a bonus. He also told me never to leave messages on the phone or with any person, only talk to him directly, (the chief, not to the "Indians",) which I did. No one was supposed to know where he was at any time. He also kept cameras in his office, like an eye in the sky, or a big brother watching. I kept two sets of books for him.

DELILAH,
THANKS, BUT SINCE I DON'T GIVE YOU THE OVERAGES, YOU CAN'T GIVE ME THE SHORTAGES.
Paul

DELILAH;
I TOOK A COUPLE OF THESE SHEETS FOR THE PALOMINO. I WANT YOU TO KNOW THAT YOUR INTEREST IN THE BUSINESS HAS NOT GONE UN-NOTICED OR UN-APPRECIATED.
THANKS,
Paul

DEL;
KEEP UP THE GOOD WORK. I'M VERY PROUD OF YOU!
Paul

DELILAH;
THANKS; THIS IS JUST THE WAY THE AUDITORS LIKE THE BAR TAPES DONE.
Paul

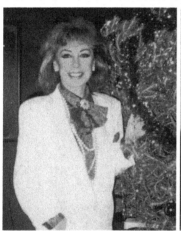

My first Christmas with the Pussycat.

With my two cocktail waitresses, Angie and Leanne Ritter Right: My protectors. LVPD. Al Spriggs, who became a good friend of mine and gave me his gun for my protection.

287

Georgette Dante in our lobby, my license in the back.
Right: With Kim Sommers, backstage at the Tropicana Hotel Casino at the Folies Bergere show, posing with headgear. We were guided by security. Kim, my party girl in the sixties, was also a stripper for Barry Ashton in the 60s.

A real surprise was when Billy Idol visited the Pussycat, and spent that evening with some of the girls. Carina, Billy, my niece, and right, Ruby Tuesday. I took the photo.
Now the turn of the nineties. Life was good, and the show must go on. The Pussycat was doing well and the girls were doing well. Lynda, our cocktail waitress for many years, got a bust enhancement and became one of my dancers. I added a dance floor on the balcony, so the girls could dance with customers for $5.00 a dance, no more 10 cents a dance. It was good extra money because I did not have pole or lap dancing.

SEACRUISE SAN DIEGO STARLITE CRUISES

On my day off, I decided to go to Mexico with my husband. I always wanted to take a picture with the Mexican Donkey, and so we did.
In 1991 we made it to Tijuana, Mexico. The donkey was for the tourist to be photographed.

The following year 1992 my husband and I took a tour to Ensenada, Mexico.

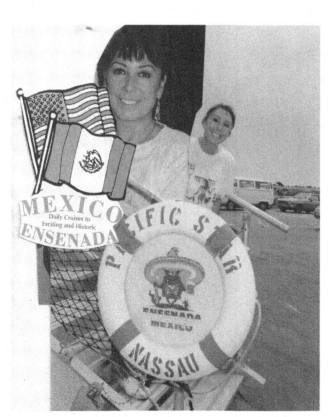

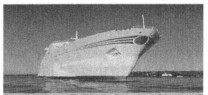

That same year we went to San Luis Obispo to visit Kim Sommer in my new convertible Maserati, a present from my husband.

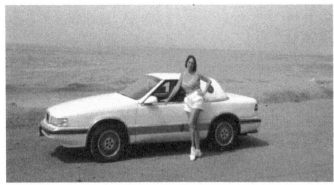 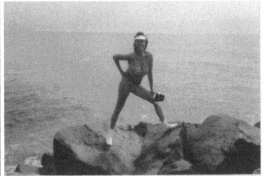

Here near Point Mugu and on a California beach.

In the nineties, I got involved in all kinds of exotic animals, something I was deprived of in my childhood. Larry wanted me to have anything I never had, so I don't feel left out in Life. This was also a childhood dream, which was fulfilled now.

In 1993 the Pussycat was sold, and I took a month's vacation, before moving to the Palomino. I was once a month at the California beaches while working at the Palomino. My husband, Larry, being a Marine in Okinawa, preferred Oceanside, California because he liked Camp Pendleton, where he had boot camp in 1944.

Puff and Bertha, my Iguanas. Right: my Jackson Chameleons mating.
Next: My Macaw Leo. San Diego Zoo. Hiking at Red Rock Canyon, Nevada

Oceanside, California, now in my fifties.

1993 Back to work as one of the managers at the Palomino, the World famous strip club. Paul, my boss, gave me a small sub-club lounge to run by myself. Upstairs was the "Lipstick Lounge", left. With an unknown to me boxer and maitre-d. The next year Paul gave me the downstairs club "Lacey's. a nice and quiet place. Next: with Arte Brooks and my crew.

 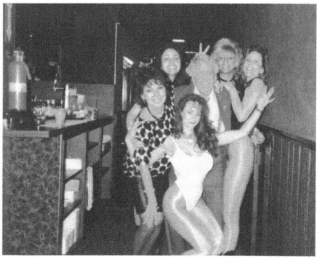

When Paul gave me Lacy's, it was a different kind of place. We had lap dancing, and we had a separate area for clock-in time with my dancers and the customers. It also had a dance floor, so that the dancers could dance with the customers, and charge accordingly. It was 30 minutes for half an hour. The girls got tipped by the customers. One customer was the "postman" from the TV show "CHEERS ". He was thankful for the wonderful time he had.

In 1994, while at the beach, My husband and I experienced another earthquake, the Northridge 6.7 on the Richter.

Then Paul Perry passed away, a sad day in my life. and the Palomino went down the drain.

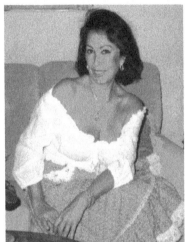
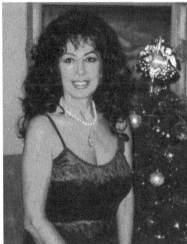
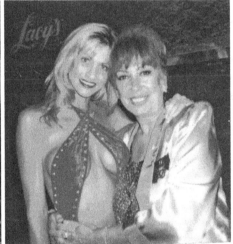

Snapshots before going to work. My last Christmas at the Palomino, with one of my "Lacy's" dancers

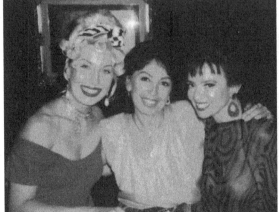
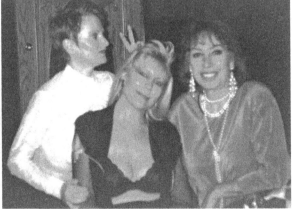

Millicent Sheridan, Delilah, and Toni Alessandrini.- Alexis, my dancer, and I.

Then I hired "Madison" aka Donna D'Errico, best known from the Baywatch TV program. Donna was also a limo driver in Las Vegas at the time. She was arrogant. Center: Axel Schultz, the boxer who fought George Foreman in 1995, came in with his entourage from Germany. They spent the entire evening with us.

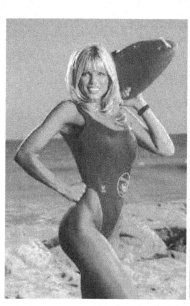

My Baywatch postcard Axel Schultz me with my body board

On Mother's Day 1996, I left the Palomino and retired for good. Alexis became a warden at the female facility in North Las Vegas. Slowly her Multiple Sclerosis started to develop. She is now being taken care of in a Sacramento, California facility.

Another present from my husband was this convertible LeBaron. It was candy apple red, with white leather seats and top.
Here in Mission Bay, San Diego, it was mostly foggy that year.

The owner of the Olympic Gardens, a friend of Paul Perry's, asked me to come work for him, as a manager, along with six other males. I did one night and quit. It was a smog filled hustle joint.

293

Years went by and now another year went by, and a new century 2000.
In 2001 on Good Friday my third husband Larry suffered an aorta burst. It was replaced with a gauze one, but he suffered two strokes during this ordeal. The surgeon used twenty-eight pints of blood, to replace all the lost blood. I became his caretaker.
Somehow in this new era, a reawakening of burlesque came about. It was meant for the "old timers", who now became the legends of burlesque. How interesting that somebody wanted to see us old-timers. But it became years of fun-filled times and seeing so many of my old stripper friends again. I attended my first reunion in 2002 at the Gold Coast Hotel, and lo and behold, so many of the Cabaret from the seventies were present.

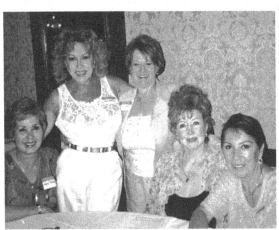

2002 at the Gold Coast Casino. Angel Carter, Gina Bon Bon, K.C. Layne.Teri Starr, and me at a reunion. Center, me with Teri Starr, right: Me doing Steve Rossi's TV show and co-anchor.

The following year 2003 a reunion was held at the Imperial Palace for Jane Briggeman's "Living Legends". I was asked to do a TV interview with Steve Rossi, and I accepted. Left: with Ricci Corvette.

Then I noticed an old familiar long forgotten face, standing before me taking photos of us. It was none other than my good friend Sandy Fields. He was hired to take photos of the legends.

 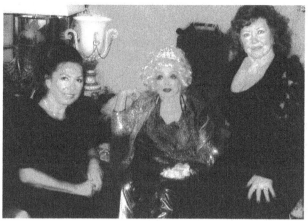

2003 myself, Diane Thorne, Bambi Jones. Right April 2006 Liz Renay's 80s birthday party with Teri Starr, at Grant Phillipo's Showgirl Museum.

A new burlesque life opened for me.

On 9/11/ 2003 my husband Larry passed away from a massive stroke.

2004 life goes on and I started dating Sandy Fields after forty years.

2005 Sandy Fields proposed marriage to me, but I did not accept it.

2006 The Burlesque Hall of Fame (BHoF) opened in downtown Las Vegas. Laura Herbert produced this first show. So many of my old friends reappeared, like Dusty Summers, Angel Walker, and Tiffany Carter, and it was Liz Renay's last appearance on stage. Every year brought new excitement to the legendary burlesque life.

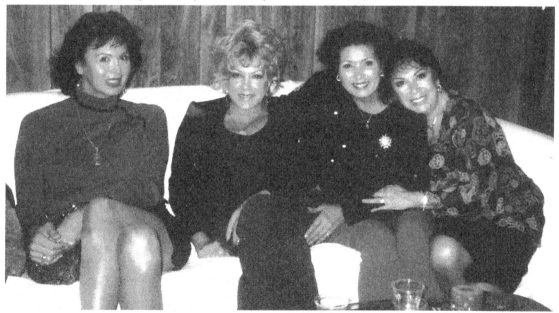

2005 Marinka, Gina Bon Bon, Angel Carter, and me at a party.

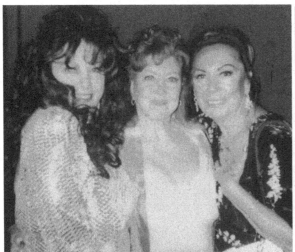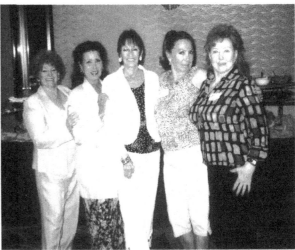

Left: Angel Walker, Teri Starr, and I, at the Burlesque Hall Of Fame aka BHoF reunion. Right: That same year 2006 was the last Living Legend Reunion at the Stardust Casino with Jane Briggeman. K.C. Layne, Angel Carter, Kim Sommers, myself, and Teri Starr. Also, Lady Midnight was there, whom I have not seen since 1959.

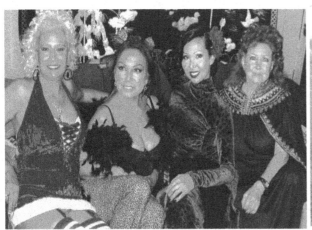

2006 Gypsy, myself, Kalani, Teri Starr. Grant Phillipo's Halloween Party. Right: January 2007 Liz Renay passed away. Gypsy, Tempest Storm, and myself at Bunker Brothers in Las Vegas for Liz Renay's funeral. Watching the casket being lowered brought a big chill over my body.

Next: 2007 At the Plaza Gypsy, Gina Bon Bon, Delilah, Gypsy, and I, one of the Burlesque Legends reunions. I was a guest as usual.

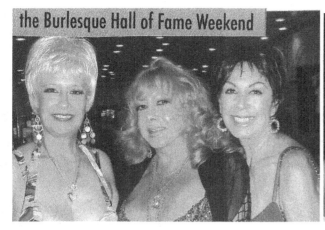

2008 BHoF at the Palms. Left: Me, Angel Walker, Tiffany Carter. Right: Sunday pool party, Gypsy, myself, Tura Satana, Tiffany Carter, Tempest Storm.

2008 Angel Walker, Tura Satana, myself, Gypsy, Tiffany Carter, and Tiza (Gypsy's daughter). The same weekend, on the top floor at Binion's for the pool party. Here with Tiffany Carter and Kitten Natividad. Afterward, we had comp dinner at the Cloud Nine, which has been closed since, and I do not remember the casino. After my last four days with Tura, we only stayed in touch via mail and phone calls. Kim Sommer was also there. 2009 Ed came to see me after being apart for thirty-seven years. We spent the week together.

January 2010 at the Silverton Casino with Dusty Summers, Angel Carter, myself, Gypsy, and Tiffany Carter.

2010, my photographer friend Mike Crist, and the before and finished bridge at Hoover Dam. Mike had exclusive rights to the photos.

The same year KC's painting exhibition opened near Hoover Dam, on the same day that the Hoover Dam Bridge opened.
Right: K.C., Dusty Summers, myself, Angel Carter, Brandy Duran, and Lynda

At the MGM a comp invite with Gypsy. Myself, Gypsy, Teri Starr, and Dusty.
Next: 2011 top of Binions again, with Angel Walker and Tiffany Carter.

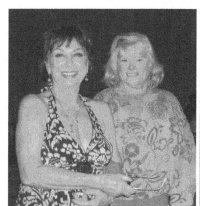 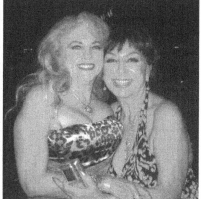

Last: another great BHOF 2011 weekend reunion with Laura Herbert

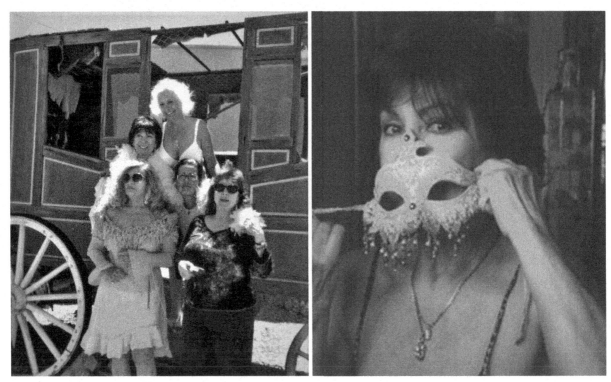

Having fun in Pahrump at Angel Carter's home, and her stagecoach. With Bambi Jones, Teri Starr, myself, and Gypsy. Right.
Photo for a burlesque book by a French photographer Marie Baronnet.

Marie Baronnet, Tiffany Carter, Summers, myself, Dixie Evan, and Gypsy Louise.

The last photo I took was of Dixie Evans holding a dove.

With Gina Bon Bon and Bambi Jones, for lunch.

 2011 at the Olive Garden celebrating my seventieth birthday. With Angel Carter, Dusty Summers, myself, K.C., and Tiffany Carter.

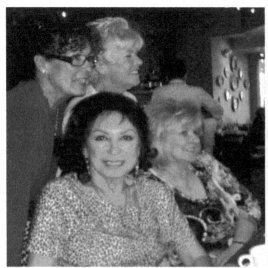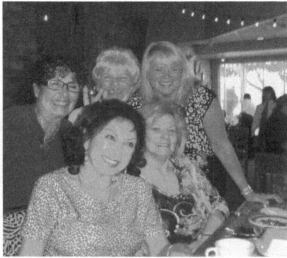

At Olive Garden and at

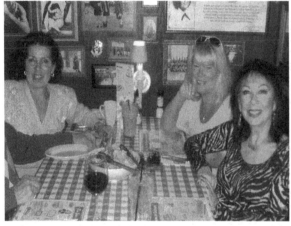

The following year 2012 at the Italian restaurant Bocca., with Angel Carter and Tiffany Carter, The following year 2013 another birthday party at Dusty's home. Right: Gypsy, Bambi Jones, Dusty Summers, Tiffany Carter, myself, Angel Carter, Torchy, and Teri Starr.

In May 2012, I had toe surgery and had to be off my foot for 6 weeks. I used a wheelchair until I received my scooter. The year before I dropped a brick on my toe and it crushed the insides of my toe, thus shifting away from the bone. I now have a screw in my big toe.

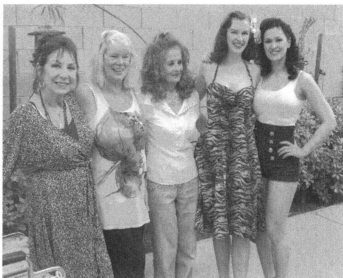

Tiffany Carter party: Angel with me in my wheelchair because of my toe surgery. Me, Tiffany Carter, Tempest Storm, Bettina May, and LouLou D'vil.

San Gennaro Festival, Angel Carter, Tiffany Carter, hubby Bob, and I. Our gatherings were always like family affairs. We have all stayed lifelong friends since the seventies.

At the Royal Casino in Las Vegas, for a Burlesque show, with Forever Amber, Dusty Summers, myself, Gypsy, and Georgette Dante. Next: with Tempest Storm, myself, Dusty Summers, then Angel Walker, and I.

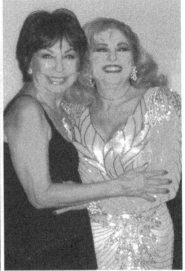

A 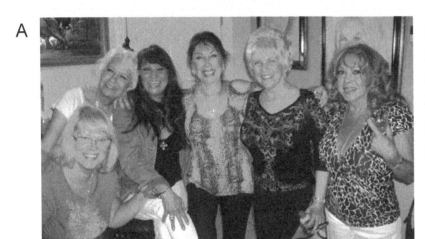 party at Gina Bon Bon's home with Tiffany Carter, Gypsy Louise, DiAlba, myself, Dusty Summers, and Gina Bon Bon.

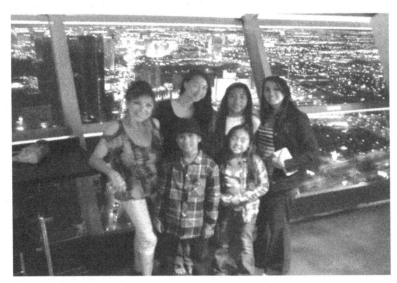

On Top of the Stratosphere with Tanya's family.

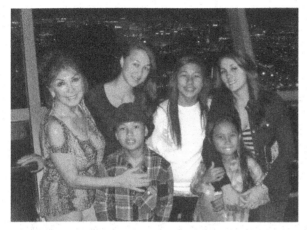

Day and night on the Stratosphere, overlooking Las Vegas, with my Hawaiian family, my niece's daughter Tanya, right, with her children, she has since had another baby boy. She is a registered nurse, in San Diego.

In June 2012 BHoF reunion, like usual, had a 4-day burlesque festival at the Orleans. I met up with many of my "old" friends again. Here with Rubberlegs, Angel Carter, and Kim Sommers, who flew in from Washington.

Kim and I.

Toni Alessandrini, Kitten Natividad, and me.

Myself, Gina Bon Bon, Dusty Summers, Kim Sommers, and Angel Carter.
At the night's end, I decided to go on stage with my medical boot for a
photo-op, Gypsy, Haji, Myself, Gabriella Maze, and Angel Carter.
Every year we would take a photo of all the legends on stage.

Gypsy Louse, Kitten Natividad, and myself.
The second night was "Titans of Tease" for the legends.

Me, Kitten Natividad, Derek Jackson, Gypsy, Tiffany, Lynda, Shannon Doah, and Angel Carter at the Orleans one evening.

 Kim Sommers, myself, Haji. Gina Bon Bon myself, and Di Alba.
Sunday brunch was the last day of the weekend. at the Orleans for BHoF. It was a most wonderful atmosphere being with all my dancer friends from so many years ago.

With Bambi Jones, visiting Teri Starr in an adult facility.
Right: Kenny Kerr at a party. It was Kenny`s last appearance, he was ailing.

Lunch with Gypsy, her grandchild, Tanya, myself, and Tanya's oldest daughter, Sanoe, visiting from Hawaii.

Last: 2012 Halloween Party at Grant Philipo's Las Vegas Showgirl Museum. Left, with Tiffany Carter, and right, with Gypsy Louise.

Christmas evening 2012 at the Venetian was spent with Tiffany Carter, Dusty Summers, and myself. We would spend most holidays together. It was like a ritual.

2012 New Year's Eve party, with Gypsy's for her birthday Dusty Summers.

Another year is ending and I'm looking forward to 2013.
The year that brought so many happy changes in my life.

In 2013 there was significant change in my life. In January my mother at the age of ninety-six passed away. I was her caretaker for 10 years. That February, I left my home for the first time, in nearly forty-five years, by plane, for Albuquerque New Mexico, for a burlesque festival.

This was a new beginning in the burlesque field.

February fourteenth 2013 at McCarran Airport, on our way to Albuquerque, New Mexico, with Gypsy and Tiffany Carter. Right: Tiffany and I are in our hotel room.

Our hotel **The Hotel Blue** www.thehotelblue.com was formerly the Aztec, I believe..

2013 back in Albuquerque, where I worked forty-three years before. Brenda Williams, Tiffany's hubby Bob, and I.

We had a four-day stay for the festival.

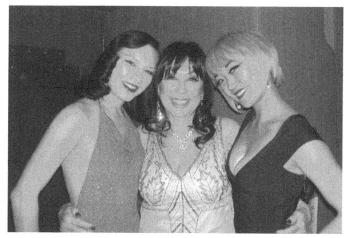 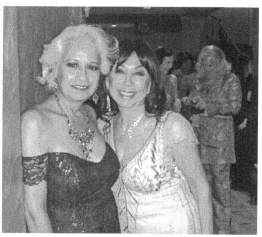

Orchid Mei, myself, and Midnite Martini.
First day of the Burlesque festival.

Lulu aka Gypsy Louise and I,

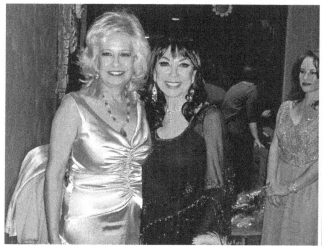 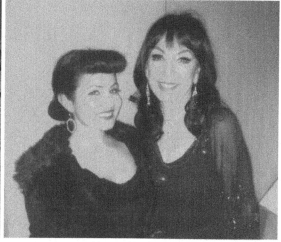

Gypsy and I

Ruby Champagne and I

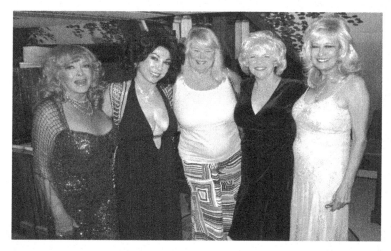

Once back home, I had a
mini facelift.

Gina Bon Bon, myself,
Tiffany Carter, Dusty
Summers, and Gypsy
Louise at Grant Philipo`s
Showgirl museum.

With Gina at a party at Boomers with Dusty and Gypsy

Gypsy, myself, and Diane. Bambi Jones, and I visited Dixie Evans in rehab.

At the swap meet with Tiffany Carter, Thomas & Tempest Storm then, three of us at the Peppermill.

I spent a day at the Zen with Bob Sandford and stayed for a ceremony.
A peaceful and tranquil day. Left: Statue of Kwan-yin.

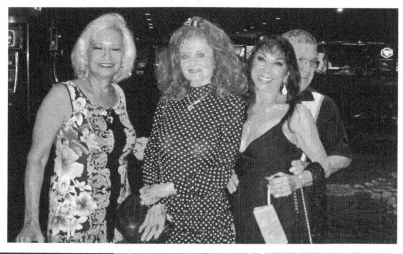

At the Plaza having fun with Gypsy, Tempest Storm, Bob and me.

Gypsy and I. Right: Tiffany and I, me getting ready for my first show in
thirty-eight years, at Boomers.

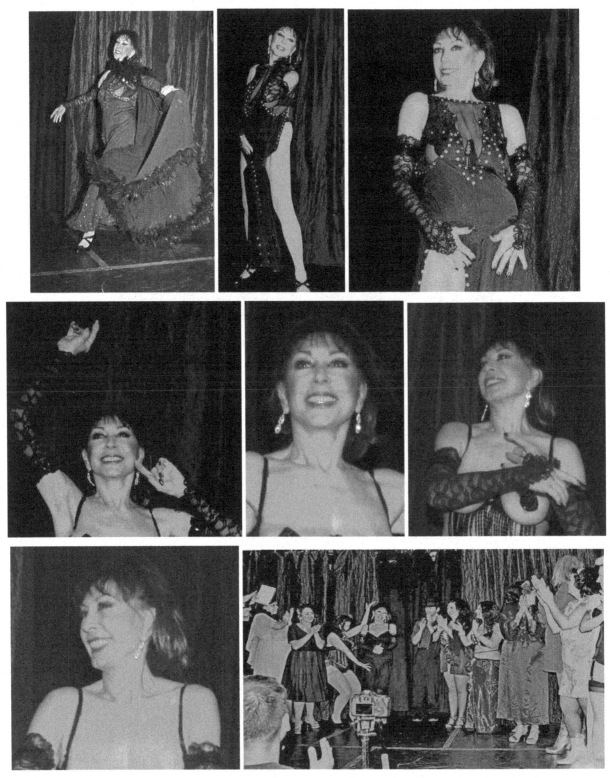

At Boomers, April 2013, my so-called warming-up show for the main one at the Orleans, the following month. My opening and the finale.

The after party with my friends who came to support me. Tiffany Carter, Lovey Goldmine, her family, Liza Jourdan, myself, and Gina Bon Bon.

Bambi Jones, myself, Brenda Williams, Gina Bon Bon. Right: Tiffany, Marinka and Georgette Dante, and Gina Bon Bon. Next: Same night.

June 2013 at the Sublime Boudoir party with Gina Bon Bon and Ezy Rider. The private party the night before the grand opening at the Orleans.

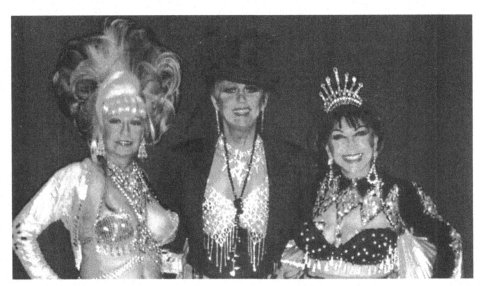

The dressing room at the Orleans before show time, with Gypsy and a male dancer. This was my one and only show, ever.
Friday night was the Titans of Tease, all legends night.
My costume from the Las Vegas show "Into the Night" was lent to me by Grant Philipo, who owns the Las Vegas Showgirl Museum.

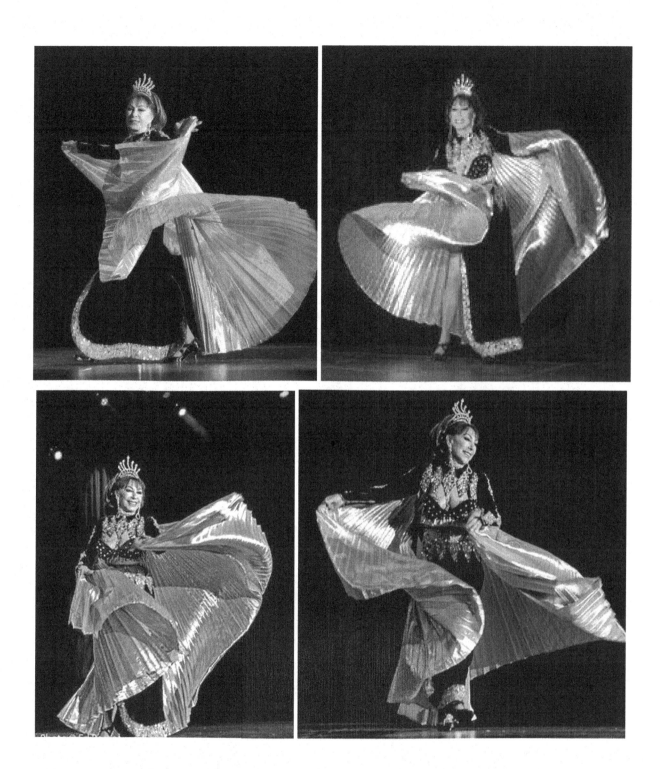

The finale was so perfect, nothing like I had expected. The photo op with all the legends had Bambi Jones, Kitten Natividad, Dusty Summers, Gabriella Maze, Gina Bon Bon, Toni Elling, Gypsy Louise, Marinka, Ezi Rider, Viva La Fever, Holiday O'Hara, Bic Carrol, April March, Tiffany Carter, Julie Mist, Camille 2000, Tai Ping.

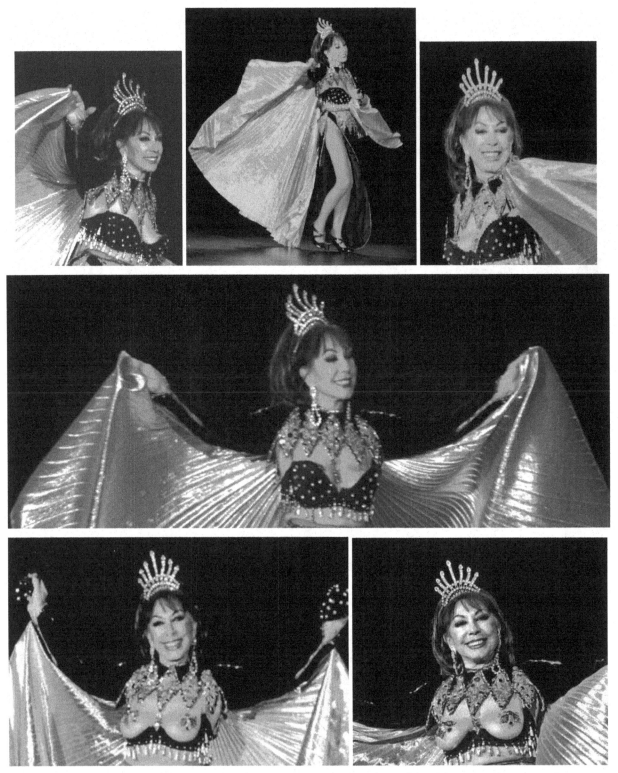

On stage at the Orleans Casino, dancing to "Pretty Woman".

After the finale and with three more days of parties, I celebrated my return.

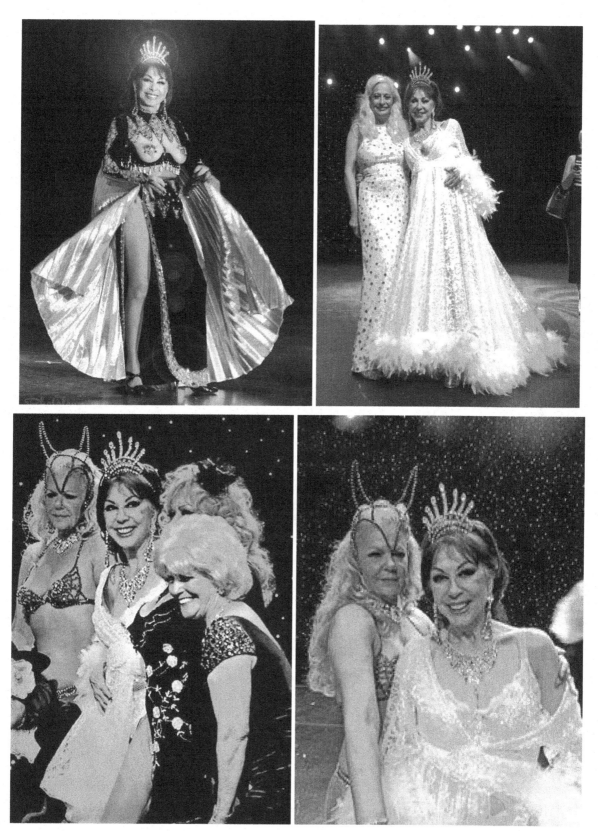

The Finale

This #InternationalWomensDay we salute the BURLESQUE LEGENDS and all the STRONG, BEAUTIFUL WOMEN in our lives

It was a rare event that these many legends were all present.

Top: Gypsy and I, having fun in the lobby. Paul Frederick. Bobbie & myself.

Midnite Martini, myself, and Deirdre, and Deirdre, Gina Bon Bon and I.

Last: Myself, Dusty Summers, and Gypsy. And Kalani and I are in the lobby

Dusty, myself, and Tempest Storm are in the lobby. Right: On Sunday, the last day, I gave lessons to the eager Neo wannabees.

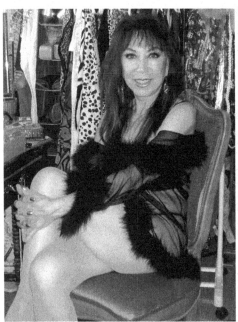

Monday I did a photo shoot with Canadian producers at my home.
The next day, Ed arrived to be with me forever.

On August 3rd, 2013 Dixie Evans died.
Left: Dixie`s Obit.

Tempest Storm giving a speech about Dixie`s life.

At Dixie`s mausoleum After the service in the parking lot.
Toni Alessandrini, Dustin, myself, Gypsy. Right: Bambi Jones, Marinka.

After Dixie's ceremony, we all got invited for brunch by Luke Littell at
Oscar's Restaurant at the Union Plaza. Tempest Storm, Bambi Jones,
Kalani, Gypsy and I.

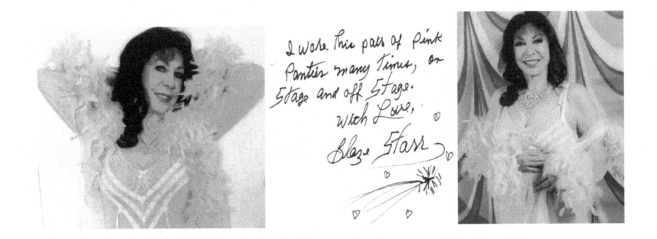

I wore this pair of pink
Panties many times, on
Stage and off Stage.
With Love,

Blaze Starr

2014 Backstage at the Orleans wearing my new gift from my friend Blaze Starr. She sent this pink ensemble of negligee and undies for me to wear for my next appearance at the Orleans, which I did.

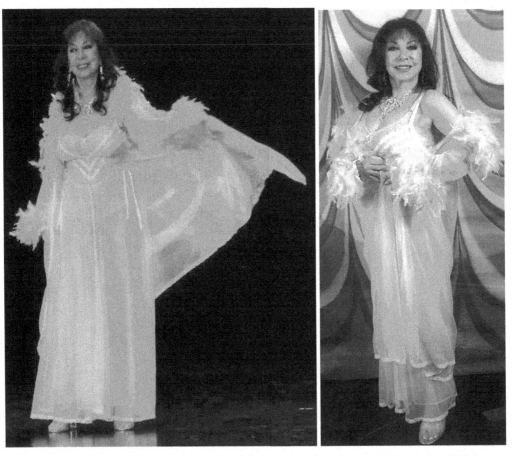

At the "Walk of Fame" on the Titans of tease night, on Friday

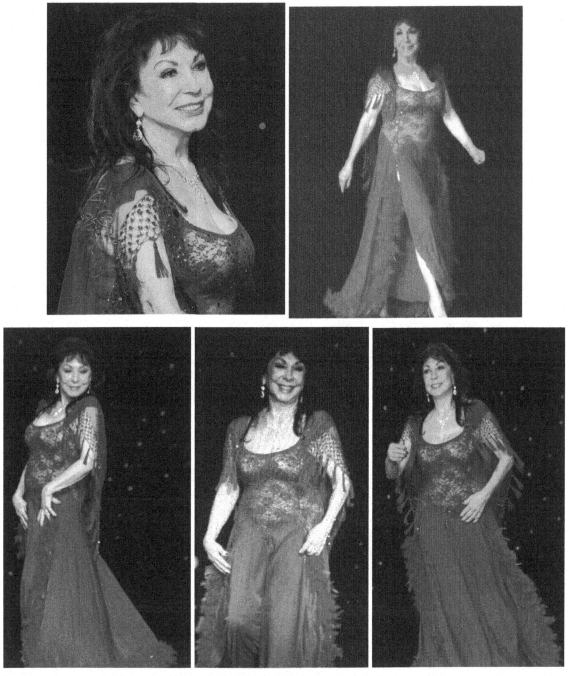

The following year 2015 again doing the "Walk of Fame".

I hand-stitched this blood-red lace and chiffon costume and added ostrich feathers. In the same year, 2015 in November, I was invited by Burlycon to come to Seattle as a legendary guest of honor, for a four-day stay. I gave a seminar, school for neo wannabees, and did a book and photo signing.

Legend
Delilah Jones

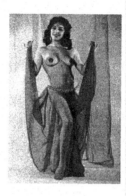

Delilah Jones was born in Berlin, Germany at the stroke of midnight on a full moon in 1941.

She began performing in 1959 and worked with Lili St Cyr at the El Rancho in L.A, Sally Rand in 1965 in Hollywood, Tura Satana, and many other luminaries. She toured North America for two dazzling decades and retired from burlesque in 1980. Sally Rand and Tempest Storm both worked with Delilah, helping her learn the fine art of dancing with fans and giving her suggestions for her act. Her specialties were belly-dancing and contortion routines. She also did an act with a large champagne glass. (She has a great nude photo available in a champagne glass!)

Delilah performed in burlesque into the late 1970's, working all over the United States, Canada and Mexico. However she regularly performed at the world famous "Palomino Club" in Las Vegas. After retiring from the burlesque stage she appeared in several movies and TV shows. BEFORE her career in burlesque, Delilah worked as a pin-up model, appearing in 75+ magazines under the name Doris Gohlke. She was also Miss Teenage Berlin in 1955 and the second runner up in the Miss Germany Pageant in 1957.

Her knowledge of the different eras is extensive and her perspective is wry and insightful, with a clear understanding of context, time, and place. She is part of a lovely crew of Las Vegas local legends who make sure to spend time together in the spirit of striptease sisterhood.

"I captured a bit from everybody and formed my own style. I was able to watch and learned from the best. I was fortunate that I was at the right time at the right place in 1959."

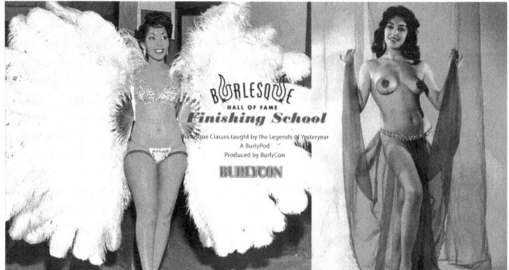

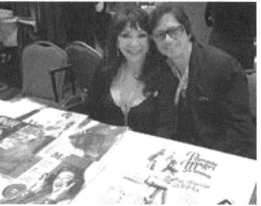

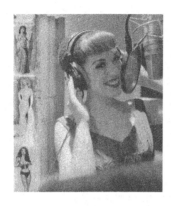

Book and photo signing with Ronnie Magri, a musician, the other guest of honor.

I did an hour seminar and an hour lesson in "The Art of Stripping". Showing a neo-dancer some movements. I also did a live interview and posed with one of the strippers. And leaving Seattle on Southwest Airlines, on the right.

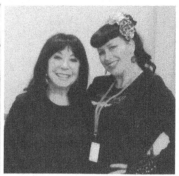

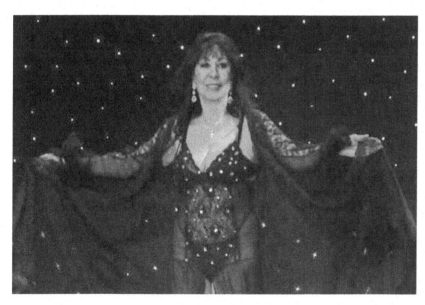

2016 another year, another show. Back at the Orleans for another "Walk of Fame", and another new creation, a black chiffon, see-through lace bodice adorned with rhinestones, black glossy sequins and feathers.

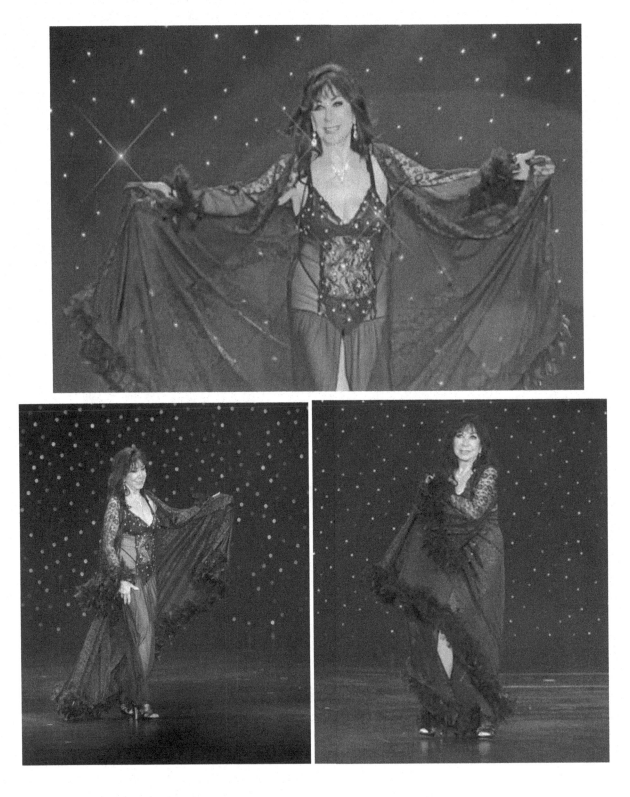

July 2016 "Walk of Fame" at The Orleans.

Backstage at the Orleans with Tempest Storm, who was also in the same show.

right: Georgette Dante, Julie Mist, Rubberlegs, Camille 2000

Left: my last finale ever. After this year I never attended any more.
Right, with my German friend, another burlesque performer, Meta.

With Midnite Martini Miss Catwings and I

Brandy Duran, Catwings, and I

Another year with Toni Elling.

My good friend Bonnie Logan, a famous pinup model from the fifties. I did my book signing. right: me courtesy of Ed Barnas.

At the Bazaar in the Orleans with Snowi Sinclair, and Camille 2000.

Next left: Snowi Sinclair, Gypsy Louise, KC Layne, and I. Next right: The private party before the show Sublime Boudoir with Ed and Mister and Misses "DuBarry", who own the largest costume and accessories store for show people, in Las Vegas.

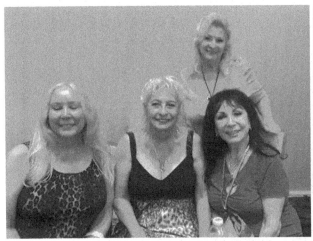
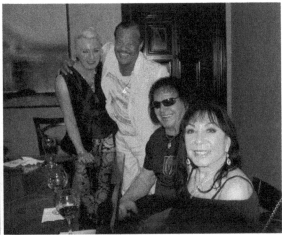
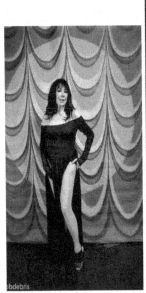
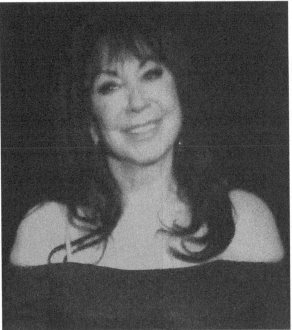

2017 is my last Walk of Fame. I had already avoided the finale photo shoots, which were getting out of hand. Some "wannabe" legends, we knew as "house girls". They were not supposed to be with us in the photo shoots. They were shoving and pushing to get in. No one tried to correct anything. It was becoming a clique, nothing that should be. I did not feel the usual excitement, that is why I wore a plain black dress, I was in mourning. Not one stone or sequin, and I did not remove any of my clothes. Backstage became a "clique" of gays and sex changes that treated regulars as secondary.

333

Backstage 2015 with Julie Mist.
This became a goodbye for my burlesque career.

April 2018. The opening of the Burlesque Museum was a great success.
I think it's being run very poorly, as Dustin, who runs the museum is a
pushover and caters more to mostly clueless neo strippers (again that
clique).
But this was fun being with all my old friends.

Bambi Jones, Marinka, our Las Vegas Mayor Caroline Goodman,
Lovey Goldmine, myself, Tempest Storm, Gina Bon Bon, Rita Alexander,
and Dusty Summers.

Gypsy, myself, Bambi Jones RIP, Marinka RIP, and Tempest Storm RIP.

In September 2020 Ed passed away. Dementia took him away from me.
Our last goodbye.

Ed`s project in Phoenix "Leisure World" and "Street of Dreams".

BURLESQUE BINGO 2022

Tiffany Carter, Eleanor Elliott, myself, Bambi Jones, and I

VIVA Las Vegas 2022-Rockabilly Event at the Orleans. On the first day, I had a booth outdoors, and on the second day, I was inside the Orleans, selling my books and photos.

First day at the ROCKABILLY 2022 Show "Viva Las Vegas" Book signing.

LIFE is LOVE, and LOVE is LIFE